IN THE FLESH

The Cultural Politics of Body Modification

Victoria L. Pitts

For Joe

First published in 2003 by PALGRAVE MACMILLAN™
175 Fifth Avenue, New York, N.Y. 10010 and
Houndmills, Basingstoke, Hampshire, England RG21 6XS.
Companies and representatives throughout the world.

PALGRAVE MACMILLAN is the global academic imprint of the
Palgrave Macmillan division of St. Martin's Press, LLC and of
Palgrave Macmillan Ltd. Macmillan® is a registered trademark in
the United States, United Kingdom and other countries. Palgrave
is a registered trademark in the European Union and other
countries.

0-312-29310-0 hardback 0-312-29311-9 paperback

**Library of Congress Cataloging-in-Publication Data Available
from the Library of Congress**

A catalogue record for this book is available from the British
Library.

First Palgrave Macmillan edition: May 2003
10 9 8 7 6 5 4 3

Printed in the United States of America.

CONTENTS

ACKNOWLEDGEMENTS

THIS PROJECT COULD NOT HAVE BEEN COMPLETED WITHOUT THE generous assistance of many people. Foremost among these are, of course, the women and men who agreed to share their "body-stories" with me, to whom I am very grateful. I would also like to thank the Brandeis University Graduate School of Arts and Sciences, which awarded me a dissertation fellowship during the early stages of this project. Later, the Research Foundation of the City University of New York awarded me a PSC-CUNY award that helped me in the final stages of the project. At Brandeis University, I would like to thank Stefan Timmermans, Peter Conrad and George Ross for their encouragement and mentoring. Stefan and Peter each had a particularly vital role in supporting this work from the beginning, for which I am especially grateful. I thank Stephen Pfohl for agreeing to be an outside reader. My colleagues and friends at Queens College, City University of New York have been very receptive. Patricia Clough and Lauren Seiler offered careful feedback for chapters 1 and 3. Hester Eisenstein and Joe Rollins offered valuable advice about the writing process as well as regular encouragement. Nicole Cooley has enthusiastically supported my work on this book and helped me to edit chapter 1. Colleagues in my department and across CUNY who helped in other ways include Charles Smith, Dean Savage, Andy Beveridge, Eugenia Paulicelli, and Lisa Jean Moore. I thank my students at Queens College (as well as those who were in my feminist theory course at the Graduate Center of CUNY, co-taught with Lisa Moore) for their enthusiasm.

Mike Featherstone and Norman Denzin (and the anonymous reviewers) helped me prepare my work for publication in *Body and Society* and

The Sociological Quarterly by offering insightful criticism. A version of chapter 2 appeared in the former journal and a version of chapter 3 in the latter. Roberta Sassatelli offered editing advice for an article that was translated into Italian for the *Rassegna Italiana di Sociologia* journal. I used the English version of this article as a starting point for writing the conclusion. Other body modification scholars whom I know virtually (or met at the 1998 BSA conference on the body in Scotland) have shown enthusiasm for this project, and reading their work has been helpful and interesting. They include Lee Monaghan, Paul Sweetman, Angus Vail, Neal Curtis and Nikki Sullivan. In addition, Suzanne Hatty read the entire manuscript at one stage and helped me prepare it for publication by offering her smart critique, and Marty Schwartz has offered me helpful advice for many years. My editor at Palgrave Mcamillian, Kristi Long, provided enthusiasm, invaluable critique, and support.

I am very grateful to my friends and family, too numerous to name, who have helped me in multiple ways. A few of them I must especially thank. Elizabeth Wood has been an intelligent sounding board and critic of my ideas for the past decade. My family, especially my mother, Marietta, and my sisters, have offered praise and encouragement. My sisters, Angela Pitts and Jennifer Gosetti, have read and critiqued parts of this book many times. Jennifer also taught me Merleau-Ponty, debated with me about postmodernism, and helped me do research at the American Museum of Natural History, and Angela made her way to multiple cities and countries to see me during the writing of this book. Over the past six years, Joe O'Meara has contributed immeasurably to my progress, offering humor, good advice, wonderful conversation, and daily encouragement. He also helped set this project in motion when he urged me to pursue my interest in this topic, joined me several times on long-distance research trips, read multiple versions of the manuscript, helped me with many editing and manuscript preparation details, and offered many other kinds of support. To him I am especially grateful.

INTRODUCTION

BODIES OF POWER

New Body Art Technologies

The body is . . . a point from which to rethink the opposition be-
tween the inside and the outside, the public and the private, the self
and other, and all the other binary pairs associated with mind/body
opposition.

—Elizabeth Grosz (1994: 21)

In body modification, you can take control of what you otherwise
could not.

—Andrew, East Coast body modifier

ANDREW, A YOUNG BODY MODIFIER IN HIS 20S, HAS UNDERGONE
hundreds of hours of tattooing, body piercing, scarification, branding,
and self-surgery. He studies anatomy textbooks and has performed
surgery on his own body using laser technology, scalpels, sutures, and
local anesthetics. With these and other implements, and with the assis-
tance of other body modification artists, he has carefully modified his
face, back, arms, torso, earlobes, genitals, wrists, and ankles, and has

added over one hundred various piercings to his body. Some of his body alterations are modeled after those of non-Western, indigenous cultures—for instance, his stretched earlobes and a genital subincision (a practice of partially slicing the penis undertaken by Maori tribes). Others are "invented"—the piercing of the uvula at the back of the throat, for example. His attitude toward the body is postmodern and cyberpunk—he mixes tribal and high-tech practices to create a hybrid style and sees the body as a limitless frontier for exploration and technological innovation. To many observers, he is visually shocking, and this influences many aspects of his life. In our interviews, he described to me how he is unemployable in most sectors of the job market (he makes his living as a self-employed body piercer), has had difficulty seeking medical care because he worries about being labeled mentally ill, and is by some considered a freak. In a particularly telling example of this, he described being detained for hours while trying to cross the U.S.–Canada border on a trip to visit a body art studio in Toronto. The border patrol had apparently decided on the basis of his appearance (which includes, among other alterations, a number of facial scars that would be virtually impossible to hide, if he wanted to) that he was a threat to Canadian security, and he was ultimately refused entry.

Most body modifiers are not as extreme as Andrew in their pursuit of body alteration, but many share his belief that "you can take control of what you otherwise could not" through body technologies. This sentiment is a major theme of the contemporary body modification movement. While various forms of body modification have become hugely popular among youth and others, a significant portion of the body modification movement could be characterized as outside the mainstream. Nonmainstream body modifiers create not only spectacle and controversy but also new forms of social rebellion through the body. For example, cyberpunk body modifiers like Andrew attempt to customize their bodies in ways previously imagined only in science fiction. In doing so, they raise the issue of who owns and controls medical and other high technologies. Other body modifiers address sexual

politics, gender inequality, and cultural identity. For example, gay men and leatherdykes have eroticized practices like scarring and branding and used them to reject the assimilationism of the more mainstream gay rights movement, to mark themselves as "queer among queers," as one gay body piercer put it to me. Some women have described their body art as a way to rebel against male dominance and to "reclaim" power over their own bodies. In creating scarred, branded, pierced, and heavily tattooed bodies, they aim to reject the pressures of beauty norms and roles of "proper" femininity. Another group of body modifiers, those who call themselves "modern primitives," romantically identify indigenous cultures as a repository of "authentic" and spiritual experiences, and see traditional forms of body art as a way to rescue the body and self from the problems of the modern world. In all of these instances, the body is revealed as a space of important social significance. Body practices such as these show how the body figures prominently in our notions of self and community, in our cultural politics, and in social control and power relations.

THE RISE OF A BODY ART MOVEMENT

In the early 1990s, journalists and sociologists began writing about what they called a "tattoo renaissance," which reflected not only a rise in the number of tattoo parlors, but also a rising interest in tattoos from among the middle class, including women. The shift was also aesthetic—for instance, tribal-style "blackwork" tattoos, which look radically different than the tattoos generally used in America and Europe, were becoming increasingly popular.[1] But what was happening was much more than an evolution of the Western tattoo. Body art was being employed by people who did not consider themselves part of tattooing communities, and in ways that would have caused great consternation at tattoo conventions. In addition to tattoos, body modifiers embraced the rituals and adornments of indigenous groups, and invented many of their own. Among their practices were scarification, a practice borrowed from Africa in

which the skin is cut with a sharp implement to produce keloiding—the production of scar tissue—in various shapes; branding, or burning the skin, usually with heated metal, to create carefully designed scarring; body piercing; subdermal implants, in which pieces of metal or other material are inserted through and placed under the skin, creating a 3-D image from the flesh; and earlobe stretching, reminiscent of some African tribes, in which an insertion is made and then stretched over time to produce a permanently large hole and hanging lobes. Not only were body modifiers undertaking practices like these that even established tattoo communities would find shocking, but in cities like New York, Seattle, London, Amsterdam, and especially San Francisco, body modifiers undertook public acts of body marking. In SM clubs, at alternative music festivals, at art events, and elsewhere, body modifiers would scar and brand themselves, drive nails into the skin, perform flesh hangings where bodies would hang from hooks inserted into the chest or back, enact "ball dances" with weights pinned to the flesh, and wear Kavadi frames that held spears poking into the body.[2] The rituals and aesthetics of African, Hindu, Native American, Polynesian, and many other cultures would be appropriated and celebrated, alongside other practices inspired by the techno/leather/latex aesthetic of SM and fetish subculture. In these instances, body art would be conceived as a "tribal" ritual, a personal or political statment, or an erotic performance. Later, body art would be celebrated as an act of technological invention. Cyberpunks would appropriate biomedical and information technology for body modification, using medical implements to create new body styles, such as the subdermal implant and laser-created brands. The explosion of styles and performances of body modification, the rise of studios catering to the interest in nonmainstream forms of body art, and the advent of a whole host of magazines, websites, exhibitions, and books celebrating and debating the practices culminated in what became known as the body modification movement.

The movement borrows from a number of recent and established traditions and subcultures, including performance art, punk, queer ac-

tivism, pro-sex feminism, SM/leather fetishism, New Age spiritualism, and Western tattooing. Tattooing is the most established form of non-mainstream body art in the West, having been practiced by modern Europeans and Americans for many centuries. Tattoo historians identify Captain Cook's voyage, which brought tattooing from the South Pacific to England in the late eighteenth century, as inaugurating the modern wave of Western tattooing, and the tattoo in the West has signified a whole host of meanings and associations since then.[3] Initially embraced not only by sailors but also by some European aristocrats, the tattoo eventually became associated with working-class identity and, eventually, deviance and marginality. Between the nineteenth and early twentieth centuries, as tattoo scholar Margo DeMello describes in her history of Western tattooing, *Bodies of Inscription* (2000), professional tattoos in America were largely consumed by sailors, servicemen, and other working-class men. Their tattoos primarily used Westernized, masculinist, and patriotic symbols such as eagles and flags and commemorations of war battles. These kinds of tattoos, which are now considered old-school, operated as signs of class-specific, masculine group status. As DeMello sees it, the "Golden Age" of tattooing in America was the early twentieth century, during which tattoos provided a marginal but nonetheless positive medium for (largely male) working-class feelings of community and belonging. Midway through the twentieth century, though, tattoos were becoming more closely associated with stigmatized groups like bikers, street gangs, and convicts. As sociologist Clinton Sanders writes, by this time tattooing "was firmly established as a definedly deviant practice in the public mind."[4]

The stigmatization of the tattoo allowed for it to become a mark of disaffection for groups who sought to stage symbolic rebellion and create a subcultural style, and, eventually, to create personal and political body art. In Sanders' terms, tattooed persons were perceived by the second half of the twentieth century to be "marginal, rootless, and dangerously unconventional," and so tattooing became appreciated as "a symbolic poke-in-the-eye" directed at mainstream society.[5] Other

forms of body alteration (also often borrowed from non-Western cultures) were also being deployed as rebellious practices in the mid to late twentieth century. British punks in the 1970s, for instance, appropriated the Native American "Mohawk" hairstyle and facial piercings along with tattoos. Punks combined body modifications with torn t-shirts and pants, military jackets and boots, hair painting, metal studs and spikes on belts and wristbands, and even the swastika. The effect of punk depended on the mismatch of pastiche as well as the embrace of the shocking and the vulgar, as Dick Hebdige pointed out in his *Subculture: The Meaning of Style* (1979). Hebdige's work, which comes out of British cultural studies and is anchored in semiotics and Gramscian theory, focused on how the medium of style—its street-level inventiveness, disconcerting mismatch, and offensive imagery—was part of the message of punk. That message, as both Hebdige and, more recently, punk scholar Daniel Wojcik see it, was focused on confrontation, anger, and resistance to authority.

Wojcik positions the current body modification movement as an outgrowth of punk in his *Punk and Neo-Tribal Body Art* (1995), but identifies it as a movement that privileges the transformative potential of modifying the body over its ability to shock and express anger. Wojcik may be underestimating how shock value is also sometimes privileged in new body art, but he is right to point to other significant themes raised by the movement. These include issues raised by the feminist, gay liberation, and New Age movements. These movements, taken together, have politicized the body as a primary site of social control and regulation, but also as a site upon which to imagine a new culture of the body that is more spiritual, healthful, empowered, and sexually liberated.[6] Feminism, for instance, has described how the female body living under patriarchy has been denigrated by numerous forms of social control and violence, but also how it can be reconceived as a space of pleasure and empowerment for women. What has been called "pro-sex" feminism in particular has explored feminist porn, female fetish practices, and other emerging expressions of

women's liberated sexuality. The New Age and alternative health movements have considered how the body has been repressed by Western patriarchal religious traditions, as well as turned into an object to be dominated and controlled within conventional Western medicine. Each of these movements has turned to non-Western cultures as resources for establishing new ways of thinking about and caring for the body. Gay liberation, which has been variously assimilative and radical since the late 1960s, has spurred a whole range of discussions, practices, and identifications related to sexuality. Some of these celebrate alternative sexual pleasures and encourage so-called deviant body styles, including the use of leather, tattooing, and piercing within fetish practices and SM, as well as transgendered dress, adornments, and permanent and semi-permanent modifications, including the use of "tight-lacing" corsetry, which over time can alter and "feminize" the shape of the waist in both men and women. Queer activists in particular, who make up the most radical segment of the movement, have argued against gay assimilation into the mainstream, instead championing more radical, in-your-face body styles and pleasures that can push at the boundaries of sex and gender norms.

Out of these interests in non-Western cultures, gender, and sexual politics came a focus on the body itself. Around the late 1980s, body modification began to emerge as a cultural movement that brought together a range of interests and traditions related to the body, culminating in a network of overlapping subcultural groups with diverse interests, who eventually began identifying themselves and each other as "marked persons" or as body modifiers. What they shared was that they all positioned the body as a site of exploration as well as a space needing to be reclaimed from culture. The affective aspects of the body—for instance, its experiences of pain and pleasure in sexual practice and in non-Western tribal rituals—and its political significance became a primary focus of body modifiers. Instead of an object of social control by patriarchy, medicine, or religion, the body should be seen, they argued, as a space for exploring identity, experiencing pleasure, and establishing

bonds to others. A "deviantly" altered body was, as it had been in the past, also framed as a way to express social disaffection and rebellion and to establish one's membership in an alternative community, as well as a way to establish one's own individual, unique identity.

One of the prominent architects of new body art discourse was Fakir Musafar, a white, urban Californian who took his name from a nineteenth-century Iranian Sufi. Musafar is often credited with founding "modern primitivism," having coined the term in 1978, which links body modifications to non-Western, spiritual, communal rituals. In the 1970s, he was part of an early tattooing and piercing group that met in Los Angeles. He later began promoting flesh hangings and other practices modeled after those of indigenous cultures. In 1985, he appeared in the documentary *Dances Sacred and Profane,* in which he enacted the rituals of a Native American Sun Dance. Modern primitivism also promotes scarification, tribal tattooing, ball dancing (dancing with items hung from the flesh), and many other practices used by indigenous cultures.

A pivotal moment in the rise of body modification as a subcultural movement was the publication of V. Vale and Andrea Juno's *Modern Primitives,* a highly popular book of interviews and photographs Musafar had inspired that focused on the tribal theme. In the words of writer Catherine Dunne, the book, which explored "ancient forms of body modification mingling the spectrum of spiritual quests and political statements," had an "enormous impact on the underground and avant-garde art world," [7] selling more than 60,000 copies in 6 reprints by 1996. (Its first printing was in 1985.) Here and elsewhere, Musafar and other modern primitives present indigenous practices as alternatives to Western culture, which is perceived as alienated from the body's spiritual, sexual, and communal potential. They also articulate disaffection with mainstream Western attitudes toward the body. Musafar writes of the earliest pioneers of modern primitivist body art,

Whether we were Native Americans returning to traditional ways or urban aboriginals responding to some inner universal archetype, one

thing is clear: we had all rejected the Western cultural biases about own-
ership and use of the body. We believed that our body belonged to
us . . . [not to] a father, mother, or spouse; or to the state or its monarch,
ruler or dictator; or to social institutions of the military, educational,
correctional, or medical establishment.[8]

Through the revival of non-Western, "primitive" body rituals, body
modifiers aim to demonstrate symbolic control over their bodies by ex-
periencing and adorning them in ways prohibited by Western culture.
 In addition, the practices are conceived as eroticized forms of "body
play," and Musafar's body modification magazine links primitivist prac-
tices to sexuality. His *Body Play and Modern Primitives Quarterly,* begun
in 1991, promotes a number of sadomasochistic and eroticized prac-
tices including corsetry, flagellation, branding, and genital piercing.[9]
Piercing had been used for decades by gay men, and both neotribal and
eroticized forms of body piercing, plus scarification, branding, and
corsetry, spread in popularity within gay and lesbian SM communities
in the late 1980s and 1990s. Queer body modification flourished in
urban centers such as San Francisco, a city that also hosted numerous
body art performance events, including Bob Flanagan's SM self-torture
and public scarifications by HIV-positive performance artist Ron
Athey. In 1990, London saw the establishment of Torture Garden, Eu-
rope's largest monthly fetish and body art club. In the United States,
queer, fetish, and SM gatherings organized performances of cuttings
and brandings, including Boston's Fetish Ball, Blood Fest in Texas,
Cleveland's Organ Grinder's Ball, and the Black Rose conference in
Washington, D.C. During the 1990s, SM and queer communities were
also rallied by a number of controversies surrounding gay body modi-
fication, including the arrests in Britain of the so-called Spanner men,
a group of consenting sadomasochists, and the body piercer Alan
Oversby. The Spanner men were prosecuted (and some were jailed) for
causing bodily harm to each other, and with that case as a precedent,
Oversby was prosecuted for piercing his (consenting) lover's penis. In

the United States, there was political turmoil in Congress surrounding the National Endowment for the Arts funding for the performance art of Ron Athey and others. These controversies galvanized queer body modifiers, who, as the queer writer Pat Califia describes, defended their practices as a form of sexual expression and free speech.[10]

The message of self-control over one's body through self-inscription resonated deeply in women's alternative communities, and also sparked much controversy among feminists. Women's body modification is situated in the larger context of feminism, the sex debates over sado-masochism, and feminist struggles over the political significance of the body and bodily roles. The body is extremely important in feminist theory and activism. Feminists have described how women regularly find that they are not in control of their own sexuality, health, and bodily safety. Many body modifications that women regularly undertake, such as plastic surgery and compulsive dieting, are seen by the feminist movement as harmful results of the enormous pressures women face to be youthful, thin, and beautiful. In addition, far too many women have found themselves victims of sexual harassment and assault, and all women face these as potential threats. There has been a range of feminist responses to victimizations of the female body. Some radical feminists, for instance, have deplored all forms of body modification as instances of patriarchal abuse. Other, so-called pro-sex feminists have embraced alternative body styles and expressions of sexuality. Many female performance artists, for instance, including the famous Annie Sprinkle, have links to fetish and SM cultures, and their work has been focused on celebrating perversity and on undermining traditional norms of female sexuality that require women to be passive and undesiring. Sprinkle, Hannah Wilke, Karen Finley, and other performance artists have also explored various kinds of bodily degradation to provoke attention to how women's bodies are violated in patriarchal culture. These efforts have not been uncontroversial. The feminist status of such art, as well as of sadomasochism and other displays of female desire that appear to violate the body, has been hotly debated since the 1980s.

The prominent role of the unconventional and adorned female body in pro-sex feminist SM culture expanded in the 1980s. In the face of political and social pressures, SM lesbians began rebelling by being public about their interest in sadomasochism and defending what they saw as sexual freedom. Late in the 1980s, some women in San Franciscan lesbian SM groups also began ritualizing bodily adornment, linking body marking to both SM and to neotribal spirituality. One jewelry maker and body piercer, Raelyn Gallina, is now well known for promoting piercing and scarification as a spiritually significant and empowering women's practice. In 1989, she argued in *Modern Primitives* that women who have been victimized by violence or oppression can "reclaim their sexuality in a way by having a nipple or labia piercing; this becomes a reclaiming ritual that helps undo a lot of shit from their past."[11] The 1991 underground film *Stigmata*, which included interviews with Gallina and the cyberpunk writer Kathy Acker, among others, articulated this message in graphic visual detail. Fakir Musafar reiterated the link between body modification and women's recovery from victimization in his epilogue to *Bodies Under Siege*, Armando Favazza's book on self-mutilation that situated body art in the psychiatric context. By the late 1990s, reclaiming rituals had spread beyond San Francisco, had been described to the straight world in *Vogue* and *Ms.*, had been adopted by girl punks and others, and had become a focus of disagreement for feminists already divided by the sex debates.

These practices have been received with both repugnance and fascination by mainstream culture. Mainstream journalists, therapists, psychiatrists, and radical feminist critics framed the practices as an emerging social problem, calling them instances of self-mutilation. At the same time, by the late 1990s some of the least offensive practices, such as neotribal tattoos and facial and body piercings, had become highly popular youth fashions. The fashionability of body modification and its spread to suburban youth was assisted in part by its promotion in the alternative music industry, including the alternative music tour Lollapalooza. Begun in 1990 by the tattooed-and-pierced singer Perry

Farrell, the tour mixed music, green politics, and alternative fashion. By 1992, the tour included an act called the Jim Rose Circus Sideshow, which presented body art in the manner of old-style circus sideshow performances, which had mostly died out by the 1950s. The sideshow was extreme and shocking, even by the standards of many body art enthusiasts, but following in the footsteps of punk, the tour and its sideshow effectively linked the new adornments to music, and less directly, to alternative politics. Eventually some of the practices, especially tattoos and body piercings, were appropriated by MTV and the catwalk, and by the late 1990s, these had become wholly acceptable, if alternative and hip, forms of fashion.

In one sense, the new fashionability of body modification represents a victory for body modifiers, since, as Musafar argues, "the kind of language used to describe our behavior ('self-mutilation'), was . . . a negative and prejudicial form of control."[12] As was the case for British punk, though, body modification's commercialization has been problematic for the movement, because many body modifiers see themselves as outsiders and innovators, not as followers of "alternative" fashion. (At the same time, some of the most dedicated body modifiers make a living as body piercers, one of the very rare employment opportunities where their modifications enhance, rather than eliminate, their prospects.) So, commercialization is an ambiguous process that forces body modification communities to define and reconsider the meanings of their practices. Within the magazines, web sites, and other texts of the movement, body modifiers have debated the "authenticity" of their practices, have defended them as personally and politically significant, and have negotiated the boundaries of who counts as one of them. "Hard core" membership in body modification, to use sociologist Paul Sweetman's term, is diffuse, diverse, and links individuals from multiple communities—for instance, gay men and lesbians, straight women, and male and female cyberpunks.[13] They share an interest in producing new modes of embodiment that push the limits of normative aesthetics and often link pain and pleasure.

Far beyond the limits of fashion, cyberpunk now takes body modification into cyberspace, biomedicine, and high technology. Cyberpunk, probably the smallest and most marginal segment of the movement, distinguishes itself in its relentless enthusiasm for technology and for framing the body as a limitless frontier for technological innovation. Cyberpunk often engages a mechanical, rather than a neotribal, aesthetic, and cyberpunk body artists have accomplished modifications previously imagined only in science fiction and high-tech medicine. The performance artist Stelarc, for instance, has wired up his body electrically and linked his neural responses to remote controls over the Internet. He has also used medical technologies to film his body's interior, rendering visible its internal structure and interior movements as well as recording its sounds.[14] Other cyberpunk body artists have also pursued the lay use of medical technologies, including anti-fashion cosmetic surgery, aimed at highly unconventional body alterations, and self-surgeries like subdermal implants. Cyberpunks often celebrate highly individual body customization, and sometimes talk about the how the "natural" body is becoming obsolete in the high-tech and virtual world. (In doing so, they directly challenge modern primitivism, which frames the body as a natural resource for individuals and cultures, as well as women's interests in "reclaiming" the body.) They raise a number of compelling issues about technology, including how technology might impact upon embodied relations of power, like race and sex; who should own and control expert-driven technologies of the body; and how technological access operates as a form of social stratification in the postmodern world.

In this book, I describe the world of body modification from the viewpoint of some of the groups that had major roles in shaping the movement in the 1980s and 1990s, including cyberpunks, radical queers, leatherdykes and other radical women, and modern primitives. One might call them the movement's "vanguard," as James Gardner does in his book *The Age of Extremism.*[15] Roughly speaking, this is a white, gay-friendly, middle-class, new-age, pro-sex, educated,

and politically articulate set of people that tend to find scarifications, brandings, implants, earlobe stretchings, and other nonmainstream practices as appealing as tattoos and body piercings.[16] These groups are diverse, but they do articulate recurrent themes, creating what Daniel Rosenblatt calls a subcultural "metacommentary" that frames the practices.[17] In their magazines, books, web pages, performances, interviews, and other spaces, radical body modifiers address a set of themes and goals. These are: (1) to celebrate the discoveries of "body play" (which mine the body for pleasures and other affective experiences); (2) to promote technical and anthropological knowledges of bodies; (3) to cultivate provocative bodily performance; and (4) to articulate the body's symbolic significance. The shared meanings of body modification emphasize bodily self-ownership; personal, cultural and political expression through the body; and new possibilities for gender, sexuality and even ethnic identity.

THE CULTURAL POLITICS OF THE NEW BODY TECHNOLOGIES

I explore in this book how radical body art practices reflect, consciously and otherwise, the social and political locations of individual bodies in the larger power relations of society. My approach is influenced by the social theories of cultural studies, poststructuralism, and feminism. I situate body modification in this theoretical context in chapter 1. Throughout the book, I consider a number of questions about body modification that are shaped by this theoretical framework. How do nonmainstream body practices reflect, and contest, contemporary norms and values about the body? What are the roles of the body in social, political, and economic relations, and how do individuals negotiate these? What is the subversive promise of radical forms of body alteration? What are the limits of radical body practices for cultural politics? To what extent are the meanings of bodies shaped by individual bodies and selves, and to what extent do collec-

tive histories, cultural values, and patterns of inequality and social stratification shape them?

Body modification by women—both straight women and lesbians—has generated a great deal of debate, both in the mainstream media and among feminists. Proponents stress how body modification has subversive potential, particularly for women, whose bodies are so often pressured by cultural norms of beauty or are the victims of sexual or physical abuse. In these cases, they argue, women can reclaim their bodies from physical or symbolic victimization by creatively and ritually modifying them. Piercing, branding, scarification, heavy tattooing, and the like challenge conventional beauty ideals, often resulting in shocked condemnation from the media. Some feminists have also expressed deep reservations about subcultural forms of body modification, seeing them as yet another denigration of the female body. The practices, especially when they are used by women, have also been read as pathological by some feminists, mental health workers, and journalists. In chapter 2, I explore the debates surrounding women's body modification. What contexts of oppression and constraint shape women's body modification? If body modification is understood by participants as a means to reclaim a sense of ownership and control of the body and the self, how does this actually work for particular women? What are we to make of the charge that such practices are pathological? How else might feminism respond to women's body modification practices?

Gay, lesbian, transgendered, and SM body modifiers have used body marking as a form of "queering" the body, rejecting mainstream culture, and creating sexually subversive ritual. In chapter 3, I describe painful, pleasurable body modification rituals undertaken in public subcultural spaces, such as gay SM clubs, as displays of radical sexual politics. These rituals, often simulating non-Western rites of passage, are often used to affirm queer sexual identities and to promote a subculture that welcomes what are elsewhere stigmatized bodily pleasures. I explore the subversive possibilities of gay, lesbian, and queer body modification.

How does the oppression of gays, lesbians, and the transgendered influence the ways they use radical body practices and how the broader culture responds to them? How are sexual mores challenged in queer body modification? How are radical body art practices linked to the issues of assimilation that are pressing for gay and lesbian communities? How is the marked body, which is sometimes exposed in one setting and hidden in another, linked to the "closet" issue of gay visibility and concealment? Also, how do queer body modifiers link themselves, through their modern primitivist aspects, to images of cultural Others?

Many body modification practices are informed by images of non-Western, indigenous cultures, whose body rituals and norms of embodiment are contrasted with those of the West. In chapter 4, I take up a more sustained analysis of modern primitivism, the embrace of body modification as an expression of solidarity with, and nostalgia for, indigenous cultures. In modern primitivism, tribal or indigenous cultures are often seen as more authentic, spiritual, and natural, while the contemporary West is seen as fraught with environmental, social, and spiritual problems. I explore, among other issues, the historical context for this nostalgic embrace of the "primitive." How does modern primitivism fit in with the West's historical treatment of indigenous groups and its representations of cultural Others? Also, how does modern primitivism work as a radical style of the body? While modern primitives often articulate radical political perspectives, they have been criticized for the ways they appropriate indigenous cultural rites and for their romantic ideas of so-called primitive ways of life. At the same time, they have also been celebrated and emulated in museum exhibits, high fashion, and youth culture. I explore here the cultural politics of modern primitivism as it is expressed in multiple sites of marginal, popular, and high culture. Through the critical perspectives of postcolonial and feminist theories, I explore the political problems of its representation of non-Western cultures and bodies.

Body modifiers often argue that the individual can author her identity through altering the body and symbolically changing its meanings

and significance. Of all the styles of body modification, cyberpunk body art pushes this idea to its limits. Cyberpunk appropriates tools and knowledges from doctors, surgeons, computer technicians, and other specialists of technology in order to explore the body as a limitless frontier of exploration and invention. What are we to make of the cyberpunk notion that body technologies are theoretically limitless, and that through them human identities are wholly malleable? In the world of postmodern consumer capitalism, how is cyberpunk ideology, which often champions individual freedom to customize the body, distinct from consumer ideologies? How do issues of social stratification and inequality impact upon technological promise? In chapter 5, I explore these issues and offer a critical perspective on the power relations of body technologies.

Body modifiers highlight how the body is a site of significant social contest. This is nowhere more evident than in the debates about "self-mutilation" that surround subcultural body modification. In chapter 1, I address how the media has framed body modification as an issue of mental illness and pathology, and in chapter 2, how radical feminists have done so. These views suggest that body modification is primarily a mental health matter, and that nonmainstream body modifications are a form of self-harm. In this interpretation, body modifications that are not socially acceptable, or that do not beautify the body according to social norms, or that are painful, are seen as self-mutilating. The prevalence of this perspective would be hard to ignore. Mainstream print and television journalists were framing "deviant" body modification as a social problem throughout the 1990s. Within the academy, throughout the period of my own research on body modification, I have been asked many times by readers of my journal articles, audiences at conference talks, and colleagues to draw a line between sick, pathological, and unacceptable forms of body modification and those that are morally and medically acceptable.

However, I have resisted such an approach. I critically interpret body modification practices throughout this book, but I do not rely

on a medical or psychiatric model of normalcy to do so. My refusal to adopt this position is not simply a postmodern relativism. Although I use postmodern theories in this book, I do not subscribe to the relativist view that all body modifications are homogenously significant. I also take issue with any suggestion that we are all equally free to choose our bodies and identities. Neither am I joining in the optimism of celebrating the "cyborg" that characterizes some segments of postmodern theory, although I consider the political promises of technology for progressive cultural politics as laid out by feminist scholars of technoscience like Donna Haraway. Rather, I am interested in exploring how body technologies are multiply significant, and how both the manner and the political context in which they are used impacts upon their social meanings. These meanings, I believe, are often erased or made invisible by assumptions that socially deviant bodies inherently suggest mentally ill selves. Claims of mental pathology have been an all-too-common way to discredit behaviors, bodies, and subjects that we may find disturbing or challenging. In my view, scholars must treat pathologization as a very serious matter, because as the symbolic interactionist Erving Goffman showed us, to assert that a subject is mentally ill is an extremely powerful way of undermining her social legitimacy, and thus, her very subjectivity. Moreover, because certain groups are more closely scrutinized under the medical gaze, and pathologized more readily than others (women, people of color, sexual minorities), pathologization is never politically neutral. Often, it is politically devastating for the people so labeled, as it was for gays and lesbians until "homosexuality" was removed from psychiatry's official list of disorders in 1973.[18] For these reasons, and because I think radical body modifications are socially and politically interesting and significant, I do not use the mental health perspective to frame my discussion. Instead, I employ a different, more political approach to body modification, which is informed by poststructuralism, feminism, and other cultural studies perspectives. In this approach, the mental health perspective appears not as an authoritative truth, but rather as one

party among many that contributes to constructing how the practices are socially meaningful.

NOTES ON RESEARCH AND METHODOLOGY

My study relies on qualitative, interpretive research methods of interviewing and textual analysis.[19] I explored the rise of the body modification movement in the 1990s by touring its sites and texts, and primarily by asking body modifiers to articulate the meanings of their practices. I informally interviewed dozens of body modifiers and observed body modification events and settings.[20] In addition, I conducted in-depth interviews and follow-up interviews with 20 body modifiers and professional body modification artists, from 1996 to 2000.[21] I used a snowball method.[22] From a social scientific perspective, a snowball sample is a non-probability sample that has a low external validity and makes generalizability difficult.[23] As ethnographer Maria Lowe puts it, such a sample is generally believed to yield "highly credible and reliable data about the group" despite these limitations.[24] From my own feminist poststructuralist perspective, which problematizes the social scientific language of proof, validity, or other terms that insist that there is a singularly valid way to understand social phenomena, I would put it in other terms. A snowball sample is useful because it helps a researcher observe shared cultural codes in the communities one is researching.

There is some diversity in the informants presented here, but my focus is on a particular subset of body modifiers. The interviewees in this study range from age 20 to 53, and half of them are female. They are all Americans, and disproportionately gay, lesbian, or transgendered relative to the general population, but possibly not so disproportionate relative to the makeup of the body modification movement.[25] While this group is diverse geographically and in regard to sex, gender, and age, there are some groups unrepresented. A few of these should be mentioned. First, the interviewees are white Westerners. Many researchers agree that the body modification movement in the West has

been an overwhelmingly white phenomenon. Even so, there are people of color and non-Westerners who consider themselves part of the body modification movement.[26] I have not written a book that examines their experiences and bodies from their own points of view, and I hope that further research in this area will do so. A primary focus in this book instead is on the ethnic and racial coding of body practices by white, largely middle-class Westerners, which I believe is an extremely important issue raised by the body modification movement. I place this issue in a postcolonial theoretical context, and I analyze some of the implications of fetishizing bodies of color and so-called primitive practices. Many of the interviewees in my study considered themselves symbolic allies of indigenous groups around the globe, and I examine the political underpinnings of such symbolic affiliations.[27]

In addition, my study focuses on people who define themselves as body modifiers and as members of a geographically broad community of "marked persons," to quote one of my interviewees, and my method brought me to those people. Therefore, I did not interview people who may use tattooing or piercing as a form of fashion but do not identify themselves as body modifiers. Finally, I did not interview teenagers, who constitute a primary market for body modification as a form of fashion, and also now comprise a good deal of body modification's anti-fashion enthusiasts.[28] Some of my informants are college-aged men and women, but many are older. These limitations are important. My interviews, with some exceptions, largely depict the world of body modification from the viewpoints of a particular "generation" and subset that had an influential hand in shaping the 1990s body art movement—again, a mostly white, adult, gay-friendly, middle-class, New Age, pro-sex, educated, and politically articulate group.[29] This perspective has clearly influenced my analysis.

While in-depth interviews offer opportunities for individual subjects to define themselves, textual analysis can attend to larger collective discourses and codes. While my interview subjects were keenly interested in discussing the personal meanings of their scars and

marks, they also used a shared language. Themes echoed throughout the interviews. Tribal references, for instance, were incessant, as were assertions of bodily self-ownership and references to "reclaiming the body." I took an interest, shaped by my readings in cultural studies, in the ways the movement has developed a collective set of "ethics," to use social theorist Michel Maffesoli's word, or shared discourses.[30] My study of subcultural texts—especially magazines and web sites— allowed me to consider the collective self-definitions of the body modification movement as they are expressed in the texts body modifiers write, read, and to which they subscribe.[31] Again, I focused on the repetition of themes and lexicon. Unsurprisingly, there is a convergence between the language and themes used by individual body modifiers and those employed in the magazines and web sites they use.[32] I also looked at a number of visual texts popular in the subculture. These include the underground films *Bizarre Rituals: Dances Sacred and Profane* and *Stigmata: The Transfigured Body.* (I describe these films in chapters 2 and 4.) I examined a number of published photo collections of body modifiers.[33] *Modern Primitives,* for instance, has been "wildly popular in the subculture" and has sold over 60,000 copies in the United States and Europe.[34] In addition, I examined the representation of body modification in cyberspace. The ezine *Body Modification Ezine,* a hugely popular web site dedicated to body modification, is highlighted in chapter 5.

Finally, I looked at how body modification is perceived in mainstream culture. I analyzed articles on body modification in 12 major newspapers over the years 1995–2000.[35] This research provides the basis for my claim in the next chapter that body modification has been framed in public discourse as a social problem. I found, for instance, that "mutilation" was discussed in about half of these accounts. I then looked at themes in "mutilation" discussions, such as the use of mental health experts, the comparison of body modification to forms of addiction and other social problems, and the use of gender in discussions of body modifiers as "sick."[36] In chapter 4, I also examined the presentation of body art in a

widely publicized exhibit at The American Museum of Natural History, which took quite a different view of the practices.

In this book I try to situate emerging discourses of the body in a political and cultural context, but I do not claim scientific objectivity in this effort. I follow both interactionist and poststructuralist research epistemologies that have discredited such claims.[37] I examine the discourses body modifiers have used to give meaning to their practices, but also try to understand them from the critical theoretical perspectives of cultural, feminist, and poststructural theories. These theoretical traditions have shaped my focus and interests. They initially pointed my curious gaze at these spectacular displays of bodies, and later guided my exploration of the struggles over beauty, sexual oppression, pleasure, cultural nostalgia, high technology, and body politics that are playing out in spectacular body practices.

CHAPTER 1

SUBVERSIVE BODIES, INVENTED SELVES

Theorizing Body Politics

THROUGHOUT THE 1990s, THE BODY ART MOVEMENT BECAME increasingly newsworthy as an emotionally provocative topic, inspiring a range of interpretations about its meanings. Because they have pushed the envelope of body aesthetics, body modifiers have been understood as perverse, criminal, and offensive, but also as artistic, expressive, and radical. Alternatively pathologized and celebrated, the practices have provoked debates that reveal the significant role of the body in supporting and reproducing the social order. On the one hand, the practices have been socially problematized, depicted as forms of "self-mutilation" engaged in by youth, women, and gays and lesbians, among others. On the other hand, from a "post-essentialist" perspective, which argues that human bodies are always shaped and transformed through cultural practices, new body modifications have been interpreted as challenges to the naturalized status of Western body norms, and as forms of self-fashioning and self-narration in postmodern culture.

Reminiscent of the treatment of punk in the 1970s, some mainstream journalists and therapists have framed body modification as a

new social problem of delinquency, sickness, and perversion. Such crit-
ics view the practices as attacks upon the body that reflect both self-
abuse and social disaffection. Because the practices are often painful,
and because they often create permanent inscriptions that work against
Western beauty norms that idealize smooth and pristine skin, they are
considered by some to be mutilative.[1] Body modifiers are depicted not
only as defiant, deviant, or shocking, but also as self-hating, ill, and out
of control. Permanent, painful and non-normative adornments are de-
scribed as forms of self-injury.

Youthful, gay, and female body modifications are especially likely
to be framed as socially problematic. Youths' body modifications raise
fears of social delinquency; sensationalized media accounts raise
moral panic, associating children's tattoos and body piercings with
drugs, homelessness, and other social problems.[2] The *Washington
Post,* for instance, lists body modification among the "methods of ru-
ining" one's life:

> There is alcohol, of course, but also marijuana and hashish and heroin
> and cocaine and LSD; amphetamines and methamphetamines, barbitu-
> ates and airplane glue, animal tranquilizers and Ecstasy. There are the
> aesthetic means of self-harm: tattooing, body piercing, scarification,
> anorexia, bulimia. There is the outlaw life: gangs, guns, crimes, prison.[3]

That the practices are perceived to reflect cultural disaffection is often
cited as one reason for concern. I would argue that another source of
contention is that the practices are associated with unconventional sex-
uality and gender. Gay and SM body modification has faced particu-
larly aggressive censorship and criminalization, and women's body
modifications have been pathologized as a particularly gendered form
of self-harm. Because the practices appear to them to violate the body,
some radical feminists have joined in the criticism of deviant body pro-
jects.[4] Arguing that the practices harm the body's integrity and consti-
tute self-attack, they have linked the Western appropriation of tattoos,
scars, and piercings to anti-feminist backlash.

In my study of the framing of body modification as a social problem for the journal *Body and Society* (2000 [1999]), I described how many newspaper articles that raise the issue of self-mutilation begin with some version of the question, "where does body modification end and self-mutilation begin?" From the Latin *mutilus,* the term has a negative connotation—to maim, cut off a limb, create dysfunction, or make imperfect through excision.[5] In the mental health use of the term, the "self-mutilated" body expresses a suffering self. The "mental health camp" in the mutilation debate suggests that body modifiers are driven by harmful impulses that they do not understand or cannot control.[6] Body modifiers are depicted as more psychopathological than other groups, and body modification practices themselves are compared to widely recognized forms of self-injury. Practices such as piercing, scarification, and branding are linked to anorexia, bulimia, and what has been called "delicate self-harm syndrome," which is an addictive, repetitive, non-decorative form of skin cutting, usually on the arms or legs.[7] These comparisons seem quite obvious to some critics of body modification. As *The Guardian* describes,

> Two psychologists who have worked with anorectics readily see the connections between all these forms of body modification. For Susie Orbach, "there is a projecting onto your body of an absolute hatred." . . . To psychologist Corinee Sweet, it's all just self-mutilation. "From my experience as a counselor, what we do on the surface nearly always has some deep structure behind it. The expression of anger may be impossible, so we turn it in on ourselves."[8]

In such a psychiatric model, as Nikki Sullivan points out, body marking is read ideographically as a message of harm that reveals the essence of the individual self, and in particular her mental health, which is often seen as characterized by personality disorder, depression, or other psychological problems.[9]

Among the problems of the self-mutilation argument is that it uncritically relies on a classical ideal of the skin as a pristine, smooth,

closed envelope for the self, and a notion of the body and self as fixed and unchanging. These notions were inherited from Enlightenment traditions that are undergoing major revision by contemporary theorists. In post-essentialist perspectives, any notion of an essential character to the body or the subject is replaced by a sense that both are culturally shaped and socially ordered.

The Enlightenment affirmed a mind/body binary in which the mind was seen as more significant, while the body was dismissed as a hindrance to *res cogitans,* Decartes' term for the intellect and selfhood.[10] Ann Cahill describes how the dichotomy between mind and body was essential to the Enlightenment interest in promoting a notion of the rational subject:

> Reason promised a host of good that the body could not hope to provide. Bodies lived, grew old, withered; reason worked according to universal laws of logic and produced timeless truths. Bodies distinguished individuals from one another; reason was the common denominator. Bodies were subject to desires, emotions, and drives that were appallingly outside the subject's control; rational thought was a careful, self-conscious process that the subject could undertake in a context of choice and autonomy. . . . Insofar as human beings remained susceptible to bodily dynamics, they were still mired in the realm of the animal, the instinctual, the unfree.[11]

In modern social thought, then, the body was often assumed to be a fixed, material fact of being to be transcended by reason. Bryan S. Turner, a sociologist whose work has focused on the body, has described, for instance, how classical sociology, which developed partly in tension with biological explanations for social action, emphasized rational social structures and laws. To the extent that it approached the body, Turner writes, classical theory assumed rationality on the part of social actors and perceived the body as a constraint to rationality and Reason. On the other hand, the body was not only seen as a constraint, but also as a "potential which can be elaborated by sociocultural devel-

opment," and it is partly this view that is revived and revised in much contemporary body theory.[12] It was largely anthropologists, however, rather than sociologists, that gave their attention to the body, which Turner attributes to the prominent and visible role of body marking in the tribal societies that occupied them. Sociologists in the nineteenth century were instead pursuing themes of urban and industrial capitalism, secularization, and rationalization. The "question of the ontological status of social actors remained submerged," Turner writes, and classical sociologists largely presumed the rationality of actors.[13] In the modern sociology of the twentieth century, the body for the most part became "an organic system [that] was either allocated to other disciplines (such as biochemistry or physiology), or it became part of the conditions of action, that is, an environmental constraint."[14] Functionalism, for instance, presumed an economic model of the rational actor, and the "body thus became external to the actor, who appeared . . . as a decision-making agent."[15]

There have been threads of body theory, though—what Turner calls a "secret history of the body in social theory"—from the nineteenth century to the current period, from Friedrich Nietzsche through Max Weber, Erving Goffman, and Michel Foucault—that are influential in the current explosion of post-essentialist theoretical interest in the body. Among other contributions, these theorists challenged rational and fixed notions of the self, and thus disrupted established views of the self's relation to the body. Turner points out a number of examples. For instance, Nietzsche's project included an exploration of modern and ancient cultures' Dionysian/Apollonian tensions, which opposed embodied passions and disembodied, rationalized worldviews. Nietzsche inverted the conventional hierarchy between the two, thus valuing the contributory cultural significance of the Dionysian, of the body and embodiedness. Weber analyzed the irrational roots of modern capitalism in early Protestant faith and explored the ironic, ill effects of the hyper-rationality of the Protestant ethic as it was realized in modern bureaucracy, such as the production of over-rationalized

subjects, including the bureaucratic "specialists." Goffman saw the body as a site for performing a self that has no essential ontology or core. Although he did not develop the radical implications of this view in regard to the body, his notion of the body as a dramaturgical tool suggests both its malleability and its communicative function. Most notably, Foucault described the self's production in modern regimes of discipline, and the role of the body in producing and ordering the self. His work, to which I will return later in this chapter, has probably had the most impact of any single contemporary theorist on current, post-essentialist body theory.

Many contemporary theorists, inspired both by a revived interest in earlier writers like Nietzsche and by the project of developing a new sociology of the body, reject such notions as the body's universality, naturalness, and subordinate relationship to a rational actor as deeply logocentric. Post-essentialist theories of the body, expressed in cultural studies, feminism, postmodernism, poststructuralism, and other areas of thought, reject the notion that there is an "essential," proper, ideal body. Instead, the body, along with social laws, nature, and the self, is seen as always open to history and culture, and always negotiable and changing. Instead of one truth of the body or of ontology, there are competing truths that are productions of time, place, space, geography, and culture.

In addition to overturning universal conceptions of the body, an important focus of new body theory has also been on the relationship between the body and the self. The notion of the rational actor, the willful, fixed subject who behaves according to calculated choices based on utilitarian concerns or cultural and moral values (to paraphrase Turner), has been undermined by the theoretical developments described above, and also by the work of psychoanalysis and structuralism as well as feminism, postmodernism, and poststructuralism.[16] For instance, psychoanalysis and structuralism stressed how the self and the social order are guided and shaped by invisible forces such as unconscious desire, in the case of Freudian theory, and the "laws" of language, in the case of structuralism, while feminism has focused on the role of gender in shaping

desires and bodily practices. Poststructuralism emphasizes the historicity of such forces, their contingency on history, sociality, and politics, and explores the ongoing politics of the shaping of selves, bodies, desires, and pleasures though language, representation, and "discourse," to use Foucault's term. The body, then, is positioned in multiple ways, including as a site for establishing identity that is read by the self and others; as a space of social control and social investment; and as an ever-emerging, unfinished materiality that gains meaning through various forms of symbolic representation and material practice.

SITUATING BODY ART IN POST-ESSENTIALIST THEORY

From post-essentialist perspectives, the historic and geographic diversity of bodies and body practices point not only to the body's shaping by and through cultural practices, but also to *the impossibility of a natural model of the body.* Thus, non-Western and subcultural body rituals, which can be painful and can dramatically alter the body's skin and its shape, are no more or less natural than accepted Western practices, and marked bodies would be no more ontologically improper, theoretically, than unmarked ones. Moreover, *all* bodies are marked, and no less so in contemporary Western cultures.

In fact, the heightened visibility of body practices has played a role in the increasing theorization of the body. The body is no longer seen in popular and mass culture as fixed and pristine or as subordinate to the self. Instead, it is increasingly apparent that Western cultures are fascinated with manipulating the aesthetics, norms, and possibilities of the body. Writers like Bryan S. Turner, Mike Featherstone, and Alberto Melucci collectively attribute this to a number of factors. These include: the increasing role of leisure in late modern capitalist economies; the shift of social movement activity from class struggle into identity politics and sexuality; the erosion of traditional authority over bodies and sexuality (such as that of the church); medical advances that have

resulted in increased technological intervention and longevity; and public controversies over bodily issues such as AIDS, pollution, health care access, and alternative medicine.[17] Such social, economic, and cultural shifts are often identified with postmodern society.

In postmodern culture, the breakdown of modern power's traditional authority over the body and identity appears to render possible new symbols, meanings, and options for the body. Thus, in the contemporary West, body modifications are undertaken in diverse realms and engender a differentiated "universe" of bodies, as Mike Featherstone puts it.[18] For example, regimes of diet, exercise, cosmetic surgery, spa practices, bodybuilding, and subcultural styles have involved temporary, permanent, and semi-permanent body modifications of the figure, skin, and hair. The body shrinks in size through some of these practices, is built and sculpted in other practices. It is painted, wrapped, oiled, stretched, cut, implanted, excavated, sectioned, measured, and otherwise transformed. In medical practice, body modifications include transplants and prosthetics for an increasing number of organs and body parts. Here the body ingests and absorbs synthetic and organic materials, and is reshaped by lasers, plastics, and sutures. The cyborg, the organic-synthetic hybrid envisioned in science fiction, has at some level already been achieved. Technicians have mapped human DNA and technology has rendered the inside of the body visible, as in video surgery and the Visible Human Project (a digital simulation of the inside of the body produced by using computer modeling technology and digital images of a corpse, as Neal Curtis described in his work).[19]

New body projects can be distinguished from more traditional ones not in utility, severity, or pain, but in their social significance, as the philosopher Alphonso Lingus has suggested.[20] In indigenous cultures, the body, especially the skin, often appears as a surface upon which social hierarchies, such as age, status, and clan, are inscribed or codified. In Lingus's view, such bodies are *not, as for us Westerners,* "the very expression, moment by moment, of an inward spirit, or a person belonging to himself."[21] Instead, indigenous body rituals that create scars,

cuts, tattoos, welts, hollows, rims, and stretched, reshaped, and inlaid surfaces can mark the body to indicate social position. In contrast, the modern Western body is understood not as a collective product of inscription, but as a personal projection of the self. Bodies then become understood as exteriorizing an "inward depth." As Lingus has it, such an exteriorization of the self is, for Westerners, largely understood to involve volition, thoughts, processes, and sensations that use the body to "signify something, to aim at something, to tend toward something."[22]

Given the widening perception in postmodernity of both bodies and selves as open to transformation and self-narration, writers like Anthony Giddens and Chris Shilling have described how the body has become a space of self-expression. Shilling's concept of the "body project," for instance, identifies a recent Western tendency to view the body as "a project which should be worked out and accomplished as part of an individual's self-identity."[23] Not only is the postmodern body seen as an expression of an individual personality, but body projects are also seen in late/postmodernity as *integral* to the construction of a self, as Giddens argues.[24] The transformation of the body, in this view, often reflects such a narrative project of the self, and bodies are read as surfaces that display one's identity to others. Following Giddens and Shilling, then, instead of revealing "personality disorder and a propensity to crime," as the psychopathological and criminological theories would read them, body marking might be understood as a "process of expression and reception" of meaning or a "form of self-determination" within a postmodern cultural context.[25]

Body art has been seen as such a body project by a number of sociologists and ethnographers.[26] Paul Sweetman, for instance, describes how body modifiers welcome the painful aspects of new body art practices as a way of exploring subjectivity. Sweetman points out that the new body marks make the body bleed, scar, and heal and create a need for self-attention. He describes how tattooees and piercees enjoy how such self-care lends them a heightened sense of reflexivity. They gain, he suggests, a sense of accomplishment by enduring pain and healing

the body. By expanding their sense of embodiedness, they understand themselves as experiencing subjectivity "to the full."[27] In this body–self relationship, body marking is used to create a "coherent and viable sense of self-identity through attention to the body . . . to anchor or stabilize one's sense of self-identity, in part through the establishment of a coherent personal narrative."[28]

Margo DeMello argues in *Bodies of Inscription* that such notions of individual self-awareness informing new body art projects (especially tattoos) are middle-class ideas that originated in the self-help and pop psychology movements of the 1960s and 1970s. Once the inscription tool of rebellious working-class subcultures, the tattoo is now used as a tool of individual self-actualization.[29] In her account, the tattoo's revival by the body art movement emphasizes the transformative effects of self-marking, in which individuals express their identities, social and personal commitments, and efforts at personal and spiritual growth. This personal growth is linked to consumerism, and tattoos are now a "sign of status."[30] DeMello prefers old-school tattoos popular in the early and mid-twentieth century, which she sees as expressing less superficial meanings, including working-class rebellion and community belonging. The "commodification and superficiality" of much contemporary tattooing, as DeMello sees it, is reflected in the middle-class desire to make tattoos more meaningful, highbrow, and exotic through the miming of tribal rituals.[31]

That self-expression can now include adopting so-called primitive forms of body art also suggests for many the globalization of postmodern culture. The postmodern conditions of social life, which include insecurity about the truth of human subjectivity, the erosion of tradition, nostalgia, and an expanding array of cultural possibilities with which to identify, create opportunities for new forms of body work. Bryan Turner, for instance, describes how contemporary body marks are created in a postmodern, globalized culture that resembles an "airport departure lounge." In this context, body marks, including not only "tribal" tattoos but also scars, brands, and piercings, are seen

as fun and pleasurable means of establishing one's personal aesthetics and lifestyle in a culture characterized by movement, exposure, and fleeting temporality:

> Postmodern society resembles an airport departure lounge where membership is optional as passengers wait patiently for the next action to unfold through the exit doorway . . . we survey other bodies for playful marks as we consume the surface of other bodies. Gazing at the lifestyles of other passengers becomes a pleasurable pastime, suitable to fill the time prior to departure. Reading body marks is, however, an uncertain form of textual practice because there are no necessary linkages between marks and roles. Body marks are typically narcissistic . . . playful signs to the self.[32]

In contrast to traditional body marks, which symbolically locate and anchor an individual in the tribe or community, Turner points out that contemporary body marks are more superficial, consumerist, playful, and Dionysian. They do not reflect a traditional cosmology and are not socially "functional," and so they have no socially stable meanings. Rather, they (parasitically) simulate the images of non-Western cultures, and are often narcissistic attempts to address the "time-out, alienation, and pointless leisure" characteristic of postmodern society, in which social attachments are temporary and fleeting and meanings are often ironic.[33]

> [T]he postemotional actor [of postmodern society] is a member of the airport departure lounge, in the sense that she is blasé, indifferent to traditional signs of commitment and remote from the conventional signs of caring. Her tattoos are surface indicators of identity and attachment.[34]

From these perspectives, the postmodern body art project can be seen to facilitate individual self-expression and fulfill identity needs within a widening set of cultural and technological options. These accounts, to my mind, helpfully correct what has been shown to be a problematic idealization of the natural body in self-mutilation discourse, and have shown us the relativity of contemporary body projects, such that tattoos,

piercings, and scars can be shown to have a lot in common with more conventional body practices. However, I worry about overemphasizing the self-narration and self-construction of postmodern bodies as the alternative to an ontologically given bodily essence.[35] My worries include that postmodern bodies are often taken to be ontologically freer to be transformed, and thus unmarked and unlimited by, powerful categories like gender, class, and race. In the absence of attention to power relations like these, such theories may encourage a liberal reading of the subject as the free-acting manager of the body's meanings, presenting "identity construction as an option within the reach of all subjects," as Mike Featherstone puts the problem.[36] Following this warning, it is important to stress that self-invention is an *ideology* that informs body projects as much as it is a practice that constitutes them. No body projects limitlessly expand the range of possibilities for human subjectivity, nor do they "invent" the self as a matter of personal choice. Body projects may appear to be productions of the self, but they are historically located in time and place, and provide messages that "can be 'read' only within a social system of organization and meaning," to put it in Elizabeth Grosz's words.[37]

As Featherstone describes, capitalism provides one such system. The ways in which bodies are encouraged to be self-transforming, and the rate at which they are expected to do so, are deeply influenced by consumer capitalism.

> An ideology of personal consumption presents individuals as free to do their own thing, to construct their own little worlds in the private sphere . . . The basic freedom within the culture is freedom to consume, yet the hedonistic lifestyle and ever-expanding needs ultimately depend upon permanent economic expansion.[38]

Body projects are differentiated by economic privilege and constraint, as Featherstone suggests, and by how they negotiate the normalizing pressures surrounding the body. Western, postmodern body projects have multiple symbolic origins, are differently received and so have dif-

ferent social implications—many body projects are culturally celebrated, while others provoke stigma. In our culture, cosmetic surgery that removes wrinkles is not only acceptable, but it is almost expected of people of a certain gender and class status. Conversely, scarifications and brandings can create horror and revulsion. Even though at some level subcultural body art practices are commodified and fashionalized, they still have a "more than just a little problematic" relationship to fashion, as Anthony Shelton puts it in his essay "Fetishism's Culture."[39] Some body modifications, such as cosmetic surgery, spa practices, and keep-fit practices, are linked to the economy in ways subcultural body modifications are not, and so the social consequences of each are different. Moreover, whatever body projects they practice, individual body-subjects are situated differently in power categories like gender, sexuality, and race. The postmodernization and globalization of Western cultures has not freed individuals from the imposition of norms of gender, ethnicity, and sexuality, and bodies continue to be marked by them. Because body-subjects are symbolically differentiated, then, body projects, to put it in Stuart Hall's terms, are "constructed within the play of power and exclusion."[40] Thus, the flexible self-invention of contemporary body projects is complicated by the many ways in which the identities and meanings of bodies are constituted by and within social forces.

When bodies are understood as social and political—as inscribed by and lived within power relations—anomalous body modifications do not appear as inherently unnatural or pathological, but they also don't illustrate that individuals can freely or limitlessly shape their own bodies and identities. Rather, body projects suggest how individuals and groups negotiate the relationships between identity, culture, and their own bodies.[41] While the body is material, embodiment is a social process shaped by the range of the "social power of existing discourses, access to those discourses and the political strength of those discourses," as feminist theorist Chris Weedon puts it.[42] The sociality of the body is what positions it beyond essentialism's notion of fixity, but

it also provides the hierarchies of power, and the powerful imaginaries of representation, that position the body beyond individual control. As postmodern body-subjects, then, we may engage in a whole range of body projects, but we do not do so, to quote symbolic interactionist Arthur Frank, "in conditions of [our] own choosing."[43]

POST-ESSENTIALISM IN FOUCAULT AND FEMINISM

Although it owes a major debt to early writers (including Nietzsche and Kafka), the theoretical link between the body and power has been most profoundly established by Michel Foucault and by feminists. Rather than viewing the "natural" body as inherently pristine and unmarked, or primarily as a site for the expression of personal, individual identity, they have described the body as a primary site where social relations operate. Poststructuralists and feminists have insisted that the social history of the body in the West has been marked by its policing and moral regulation. Moreover, they have explored how the body is linked to ideologies of power, especially the social hierarchies of race, gender, and sexuality.

Foucault's concept of "biopower" provided a major conceptual tool for body theory. His argument was that modern power from around the late seventeenth and eighteenth centuries to late modernity has operated through the body, especially through establishing the body's individual subjectivity. Through new technologies of bodily control, such as spatial separation, time management, confinement, surveillance, and examination, the individual body became a primary space to identify, label, and manage the psyche. Modern institutions initially employed disciplinary methods to inculcate subjects with aptitudes, skills, and behaviors that fulfilled industrial needs. Nothing in the disciplined body was left to its own. In becoming the target for new mechanisms of power, the body was also, as Foucault writes in *Discipline and Punish* (1978), "offered up" to new forms of knowledge. In addition to the

scientific management of all forms of labor in military institutions, prisons, factories, schools, and hospitals, the sciences deployed new truths of sexuality and the self that influenced the movement of bodies, desires, and identities.

The development of new disciplines of the sexual body from the eighteenth to the start of the twentieth century, including psychiatry, sexology, psychoanalysis, and eugenics, provided norms of sexuality geared toward regulated procreation. Foucault described in *The History of Sexuality* (1978) how scientific discourses influenced the educational response to sexuality, the socialization of procreative behavior, and the pathologization of new categories of "perverse" behavior. Foucault argues that sexuality was an efficient vehicle for normalizing the self. The practices of the clinic, hospital, and psychiatrist circulated discourses that became foundations for experience, pleasure, self-understanding and self-policing. The professional gaze induced self-reflection, and new scientific categories were internalized as identities to be embraced or avoided.

Medical-scientific discourses were not politically neutral but rather shaped by relations of power, including colonialism and patriarchy. For instance, the new sciences linked female sexuality to the perceived lower evolutionary status of colonized subjects. A famous display of this logic was the exhibition of the so-called Hottentot, a South African woman, on the streets of London in the early nineteenth century. She (and her genitalia) were exhibited as evidence of the heightened, excessive sexuality of racial Others. As Anthony Shelton points out, both European and colonized women in the Victorian era faced many sexual constrictions informed by racist and misogynist logic about the uncivilized, savage nature of uncontrolled female sexuality.[44] Deviant European women and colonized subjects were regulated, to different degrees, through discourses that linked both the non-conforming and the non-Western body to dangerous sexuality and primitiveness. The Hottentot example shows not only an egregious racism on the part of colonialist men, but also a more general degradation of all female bodies and female sexuality. The linking of women, and all degraded

groups, to nature and sexuality situated them against and outside reason, government, and the social order. It pitted the body (especially the female body, which was seen somehow as more bodily and less self-contained) against culture and imbued it with danger. After diagnosing sexual excesses in the bodies of colonized women of Africa, scientists found them in the bodies of prostitutes and promiscuous women and in fetishism, female eroticism, and sadomasochism.

Non-mainstream bodily practices related to sexuality and gender roles were characterized variously as criminal and sick throughout the twentieth century.[45] Homosexuality, sodomy, female promiscuity, sex work, cross dressing, sadomasochism, and many other aspects of the body and sexuality have faced modern forms of social control. The policing of bodies has included physical control through incarceration, hospitalization, shock therapy, and drugs, but in late modernity less openly coercive strategies are the primary means of producing and maintaining the social order, regulating behavior, and creating "docile bodies." By imposing standards of sexual normality, health, intelligence, and fitness, medical-scientific discourses circulate ideologies through which bodies, identities, and desires are shaped.

How bodies and identities are not only shaped by powerful discourses, but also how they come to be marked with inequality, has been a major topic for feminist body theory. Post-essentialist feminism in particular has argued that the body-self is produced by culture.[46] Feminists have long understood, even before the influence of poststructuralism, that the body's gendering disadvantages women, and feminist poststructuralists have taken up the problem of how gender comes to be inscribed onto the body. Judith Butler's argument that gender is not simply a fixed category or set of roles, but rather is an ongoing, embodied process, has been among the most powerful arguments in feminist body theory. She argues that the creation and sustaining of gender roles and identities happens through bodies in space and time—in her formulation, gender is "performed" as the body is "stylized."[47] Most often, our everyday body practices buttress normative, dichotomous gender roles and sexualities. For instance, the practices of fashion consumption, food consumption, ath-

leticism, and spa culture are coded with dominant models of gender identity. Gym workouts not only promote healthy bodies, but also often follow beauty ideals. Even while they reflect personal accomplishment and self-satisfaction, popular body projects—not only for women but for men, too—are often informed by dominant discourses of gender and sexuality. They groom the body in heteronormative fashion and promote heterosexual gender roles.

Of course, feminist interest in the body has focused in large part on the disciplining and normalization of women's bodies. The female body is the subject of enormous cultural efforts to feminize it, and these efforts have both symbolic and material consequences for women. The slimming, shaping, and literal reconstructing of the female body in beauty regimens, for example, train women and produce the category of the "feminine." Feminists have critiqued such body projects because of the hierarchies and power relations they affirm. These are not limited to gender—the female rendered more "normal" or more beautiful by cosmetic surgery, for instance, often reproduces an ideal that invokes hierarchies of ethnicity, race, and economic status as well, as Anne Balsamo has written.[48] Through countless body projects and ongoing performances, the body continually displays its status. It bears messages and marks of differentiation, expressing the hierarchies of gender, race, class, ethnicity, age, health, and sexuality.

Normative inscriptions of the body are not so much openly forced on subjects, as feminist body theorist Elizabeth Grosz writes, as they are written into the psyche through what appear to be the "voluntary" projects of adornment, ritual, habits, and lifestyle, which are encouraged by cultural values. Through clothing, makeup, undergarments, athleticism, bodybuilding, and so on, men and women mark themselves. These practices render bodies appropriate for their gender, class, time, place, and of course their culture, which provides them with the "writing instruments" for their tasks (razors, bleaching cremes, push-up bras). The instruments and practices of body projects contribute to the grammar of "body language," which Grosz sees as the "the ways in which culturally specific grids of power, regulation and force condition

and provide techniques for the formation of particular bodies."[49] Individuals do not independently invent this language, but use it both consciously and unconsciously. (Along these lines, feminist theorist Patricia Clough has described the "impossibility of a fully intended writing" of the self.)[50]

In these poststructural accounts, the selves and bodies we construct in body projects are not "outside of power," as Foucault famously puts it, but saturated with it. Given this understanding of the link between bodies and power, body projects that are narcissistic and pleasurable appear also as historically situated within power relations. Yet, this perspective need not assume that all practices similarly express norms and reflect social control. Because the body, gender, and other categories are seen as continually created in ongoing practices of embodiment, they are de-essentialized, stripped of any "naturalness" or inevitability. Read optimistically, this view affords the possibility of radicalism in body practice. Because the body-subject is socially constructed, it may be open to deconstruction and rewriting. Even though the body may be considered always already inscribed, it is never fully inscribed. As Grosz writes,

> [I]f the body is the strategic target of systems of codification, supervision and constraint, it is also because the body and its energies and capacities exert an uncontrollable, unpredictable threat to a regular, systematic mode of social organization. As well as being the site of knowledge-power, the body is thus also a site of resistance, for it exerts a recalcitrance, and always entails the possibility of a counterstrategic reinscription, for it is capable of being self-marked, self-represented in alternative ways.[51]

THE SUBVERSIVE BODY AND ITS LIMITS

The political sense of hopefulness surrounding the body hedges on the failure of social control to ever achieve completion. As Dick Hebdige has pointed out, when Michel Foucault chronicled the development of pow-

erful discourses and technologies of discipline, he also uncovered the marginal bodies, confessions, and discourses of those targeted, labeled, or marginalized—the criminal, the pervert, the lunatic.[52] These subjugated knowledges and experiences served power by becoming points of exclusion, but they also persisted in tension with it. Even though he was famously pessimistic, Foucault saw power as always incomplete, and he left open the possibility of resistance. ("Where there is power," he wrote, "there is resistance."[53]) One Foucauldian reading of the anomalous body, then, can see it as subversive to the extent that it resists discipline. Such a body defies normativity in its appearance, practice, or stylization, and fails to situate itself easily in dominant categories and roles.

Because the body is a site of investment, control, and cultural production, anomalous bodies can be understood as threatening to the social order. The Russian formalist Mikhail Bakhtin traced this threat as far back as the medieval carnival.[54] Bakhtin's historical analysis of the grotesque in medieval carnival, which lingers in modern curses and vulgarities, points to the symbolic disorder made possible in anomalous bodies. The grotesque body may be opened or oozing where it ought not to be, or may contain contradictory bodily images, or it may display bodily property—orifices, fluids—which ought, normatively speaking, to remain hidden. For instance, the comical, horrible figure of the pregnant hag, popular in the carnival, could raise unease about the female body. The grotesque operates through juxtaposition and irony. Its primary feature is that its borders are ambiguous, and this ambiguity is not avoided, but celebrated, in the carnival. From the vantage point of people in the margins of society, a grotesque body can represent a refusal of orderliness and social control.

For Bakhtin, the grotesque was a code of (limited) agency for medieval subjects who were politically oppressed. Subversive spectacle also exists in late modern subcultures of the twentieth century. In the 1970s and 1980s, even before the recent explosion of interest in bodies in cultural and feminist theory, writers of the Centre for Contemporary Cultural Studies (CCCS) in Birmingham, England, argued that spectacular

"style" is created in subcultures to express rebellion against dominant values and institutions. Through their analysis of subcultural style, which includes image, demeanor, expression, and costume, CCCS writers portrayed the body as a space for manipulating cultural codes. Flagrant bodily spectacle transformed, for marginalized youth, the situation of being-looked-at into one of agency. Dick Hebdige, for instance, argued that the style of British working-class punks could be understood as a kind of "resistance narcissism" that inverted the youths' experience of being surveilled by authorities into a pleasure in display.[55] He understood punks, who saw themselves as rebellious but not political, as transforming their position as passive objects of authoritarian surveillance into one of creative, rebellious expression.

> Spectacular subcultures of the young . . . can be seen as attempts to win some kind of breathing space outside the existing cultural parameters, outside the zone of the given. They can be seen as collective responses from the part of certain youth fractions and factions to dominant value systems, as forms through which certain sections of youth oppose or negotiate, play with and transform the dominant definitions of what it means to be powerless, on the receiving end.[56]

Display might employ tactics such as symbolic inversions, or performative practices that invert, contradict, or present alternatives to dominant cultural codes.[57] They manipulate culturally understood meanings. Hebdige's examples included the punk use of garbage bags and safety pins as adornments. Such tactics can be ironic, playful, contentious and "in your face," and can constitute a form of micropolitics, or street-level, image-focused cultural critique, as Ken Gelder puts it: "Display is not a politically neutral activity; indeed, it may draw together a range of issues (to do with sexuality, gender, ethnicity, class and so on) which are then focused, and given expression through such an activity."[58]

While much of the CCCS writings were ultimately wedded to a Gramscian analysis of how display reflected (heterosexual) male work-

ing-class rebellion against class hegemony, the notion of display is also relevant in a feminist and poststructuralist analysis interested in how power operates through the body. To the extent that bodies are spaces where identities are both continually enacted as well as socially patrolled, spectacular bodies can be socially disruptive. Performative display can be constituted by "bodily acts and images that, bringing into play parody, multiplicity, and slipperiness, resist a resolution into the fixity of a dichotomous system."[59] Such practices may highlight normative femininity, masculinity, heterosexuality, or other categories of identity. What a feminist analysis may emphasize is how these strategies might subvert such categories. Theoretically, they can problematize gender norms, sexual identities, and other bodily conventions.[60]

Many body theories in feminism and queer studies have linked the anomalous body to such struggle. Judith Butler, for instance, describes the "abject" body as the material body that has smeared or blurred symbolic borders. The abject is the realm, for Butler, of "I don't want to do or be that!"[61] She suggests that abject display might be for body-subjects a "critical resource in the struggle to rearticulate the . . . terms of symbolic legitimacy and intelligilibility."[62] The abject body may evade binary gender categories by residing in both genders or by positing a third gender. Seen most radically, the abject or grotesque bodily performance may be gender disruptive, refusing the body's sex-gender script. Drag, for instance, might refuse the equation of gender with biological sex, as Butler argued in *Gender Trouble*. The biologically male body outwardly adorned as female may denaturalize sex and gender by highlighting the distinctions between them. Butler writes: "Drag fully subverts the distinction between inner and other psychic space and effectively mocks both the expressive model of gender and the notion of a true gender identity."[63]

Female subcultures, too, have been interpreted as potentially radical. A number of feminist writers, including Anne Balsamo and Leslie Heywood, have described how femininity is highlighted and problematized in women's bodybuilding. Even though women bodybuilders do not always

identify *themselves* as rebellious, the development of female strength and muscularity can be seen as subversive in that it challenges ideals of heteronormative femininity. Even more overtly oppositional is female punk. Melissa Klein describes in an article on young women's practices of resistance how "feminist punk," inaugurated in the early 1990s with the rise of Riot Grrrl, all-female punk bands, female invasions of the mosh pit, girl fanzines, and school chapters and networks, appropriated "toughness, anger, and acts of rebellion" for girls and young women while encouraging punk-style body modifications:[64]

> Punk female fashion trends have paired 1950s dresses with combat boots, shaved hair with lipstick, studded belts with platform heels. We dye our hair crazy colors or proudly expose chubby tummies in a mockery of the masculine ideal of beauty. . . . We are interested in creating not models of androgyny so much as models of contradiction. We want not to get rid of the trappings of traditional femininity or sexuality so much as to pair them with demonstrations of our strength or power.[65]

Girl punk, according to Klein, presents the female body as inscribed by power relations while also refusing to view such relations as inevitable.

To the extent that they challenge what is "permitted" in regard to gender and sexuality, girl punk and women's bodybuilding can both be seen as subversive. At the same time, since they show that body practices are infused with power relations, neither punk nor bodybuilding are evidence of women's total freedom to choose and self-author new bodies, nor are they politically unrisky. Rather, new practices for the body respond to, are shaped by, and are limited by the larger social and historical pressures that regulate bodies. No bodily performance, even an overtly rebellious one, operates outside of the "accumulating and dissimulating historicity of force," over which individuals have little control, as Butler writes in *Bodies That Matter*.[66] From a "resistance" perspective, then, rebellious body practices can disappoint. This is borne out in research on body practices. The work on subcultural display, for instance, began with an unbridled optimism concerning its

radical effects, but some CCCS writers eventually modified their initial celebrations of subcultural style. As Hebdige described in his work on punk, the commercialization of 1970s male punk was rapid, a fact that was disappointing to scholars championing it for its cultural authenticity.[67] Also, punks did not eschew symbolic stratification themselves. Punks' use of the swastika, for instance, was difficult to accommodate in an analysis focused wholly on punk subversion of official authority. Whether or not any such problems will be found in female punk remains to be seen, but they remind us that performances that are subversive in some ways may be unsubversive or even reactionary in other ways, and that spectacular displays can invoke historic systems of representation over which subcultures have very limited authorship.

Feminist writers have also found reason to be wary, finding that street-level body technologies, even those that test social tolerance, cannot be considered inherently transgressive in their effects. Rather, they can be underwritten with ideologies that support *and* subvert normative categories of identity, and can have both subversive and unsubversive effects. For example, Balsamo argues that "feminist bodybuilding" may continue patterns of stratifying women according to conventional standards. She finds exciting transgressions in women's bodybuilding, but also a set of oppressive notions of beauty and femininity. Women body builders do transgress gendered conventions of appearance, but they also rely on them to negotiate their practices within the context of social pressures for them to be more normal. Women's bodybuilding

> reveals the artificiality of attributes of "natural" gender identity and the malleability of cultural ideals of gender identity, yet it also announces quite loudly the persistence with which gender and race hierarchies structure technological practices, thereby limiting the disruptive possibilities of technological transgressions.[68]

Theorists have also worried about the possibility of producing new identity categories that can become essentialized or inadvertently serve disciplinary regimes.[69] Butler, for example, points out that drag may

buttress the very categories it seeks to displace. While the drag queen violates standards of masculinity, s/he may also affirm traditional notions of womanliness through her comic hyperfeminization. Peggy Phelan warns about the dangers in "visibility politics" of producing body-subjects that may not only fail to disrupt binary categories, but may also increase surveillance and encourage voyeurism and Othering, which positions them outside the norm. She reminds us that the meanings of visible representations of identity depend as much on the seer as the person or body seen: she worries about how much the "silent spectator dominates and controls the exchange."[70]

When, then, can body practices be seen as critical, and when can they be seen as unreflective inscriptions of power? To what extent do the subject's *intentions* "successfully govern the action of speech," as Butler puts it?[71] Are girl punks more subversive than women bodybuilders (or for that matter, than working-class boy punks) because they articulate themselves to be? No, says Butler, who calls for decentering the "presentist view of the subject as the exclusive origin of what is said,"[72] and argues instead for reformulating the question of agency into one of "how signification and resignification work."[73] I agree to the extent that anomalous bodies can be threatening to the social order without subversive intentions, and rebellious body projects may involve subversive intentions and still have ambiguous, contradictory, and even reactionary effects. They may be informed by the unconscious grammar of body language, or that grammar can rise to the conscious surface and come under scrutiny, or both.

In contrast to a liberal postmodernism, which depicts body projects as willful acts of self-narration, in poststructural feminism embodied identity is historicized and politicized such that self-narration becomes improbable, incomplete, or otherwise problematic. (A whole range of feminist perspectives, in fact, have shown us that our self-identity, our sexualities, and other aspects of our embodied subjectivity are shaped by powerfully gendered discourses.) Butler's interest is to stress how body projects or "speech acts" are not necessarily willful, conscious, or chosen,

but are rather practiced as *imperatives* influenced by powerful norms. Thus, how we assess body projects within feminist theory cannot be limited to an evaluation of subjects' intentions. The sense of willful self-assertion claimed by girl punks, for example, cannot be taken as the sole word on female punk's social and political meanings.

Yet, given the ways in which dominant discourses have so often colonized our voices, feminism has *also* encouraged us to think about the ways in which subjectivity is experienced in the embodied lives of women and other groups whose bodies have been coded as "Other." To my mind, understanding embodied experience is not peripheral to a feminist project of theorizing body politics, nor should it be seen as peripheral to a critical theory of body projects in postmodern culture. I see individual narrations of experiences of the body as a party to the constitution of bodies as socially meaningful, along with other discourses such as those of global capitalism, consumerism, psychiatry, medicine, feminism, postcolonialism, queer politics, and social movements.

Unlike Butler, I still think we need to give some attention to personal understandings of individual bodies, not because they are authoritative in determining the body's meanings, but because even as they are socially constituted, bodies *are* still persons. While I worry about interpreting body projects as unimpeded autobiographies of the self, and I am keen to trace the workings of power in and through body projects and identities, at the same time I want to avoid theorizing the person wholly out of the body. This is because how signifying practices work, in my estimation, includes not only how they work for the spectator *but also* how they work for the performer herself, how they identify bodies *and* how they become identifications for body-subjects.

At the same time, Butler points, as Patricia Clough puts it, "beyond the representation of the subject . . ." to "the aesthetic of exposure, over- and under-exposure . . ." that is part of how technologies of the body and embodiment operate.[74] Technoscience feminism, to which I turn in later chapters, stresses how the deployment of technologies by individuals, groups, and nations both reflects and creates privileges and

constraints, and how access to and control of social and material technologies are highly political matters. In postmodern capitalism, technologies are characterized by speed, capital, exposure, and processes of territorialization and reterritorialization that impact the abilities of individuals and groups to define themselves and their bodies. The ability to self-define is not only, then, about the flexibility of bodily identity in postmodernism, but about self-definition as a *technology of naming* that is itself saturated with power relations.

What a critical perspective on body technologies calls for, then, is an approach that positions the meanings of body projects as part of, but also beyond, the intelligibility of individual selves. Read together, the body theories I have described in this chapter suggest the need to acknowledge power *and* resistance, the personal and the social, the intentional and the unintentional, the visible and the not visible, in theorizing bodies—and moreover, to create accounts of the embodied self and the socially embodied that complicate these distinctions. Therefore, in this book, I attend to questions of self-definition, to the powerful forces that may territorialize and reterritorialize the body, and also to the historicity of the social and material technologies used in body projects.[75]

CHAPTER 2

RECLAIMING THE FEMALE BODY

Women Body Modifiers and Feminist Debates

WOMEN'S SUBCULTURAL BODY ART VIOLATES BEAUTY NORMS IN A number of ways, and according to the rhetoric of body modification communities, subverts the social control and victimization of the female body. Women body modifiers have argued that modifying the body promotes symbolic rebellion, resistance, and self-transformation—that marking and transforming the body can symbolically "reclaim" the body from its victimization and objectification in patriarchal culture. Not in small part due to the importance of the body in feminist understandings of gendered inequality, women's nonmainstream body modifications have also raised controversy among feminists. On the one hand, the practices have been criticized as self-harming, "mutilative," and self-objectifying. On the other hand, they are celebrated as forms of resistance because they pursue difference and violate gender norms. As postmodern feminists have argued, the deconstruction of bodily norms, which are part of the ideological arsenal used to subjugate women, can have radical effects. The subcultural discourse of body art provides support for this view, positioning women's body modifications as rebellious acts of "reclaiming" the female body.

Women's subcultural stories, their own ways of representing and narrating their body practices, constitute an important discourse that contributes to the meaning and effects of women's body modification practices. These also need to be situated in critical and theoretical perspective. After introducing the feminist debate surrounding women's body modification, I present in detail the narratives of Jane, Karen, Elaine, Lisa, Mandy, and Becky, all women body modifiers. I situate them in feminist understandings of women's agency in relation to the body—some of which rely on medicalized, psychiatric notions of female embodiment—and finally, offer my own critical view. My approach entertains the radical potential of the practices while considering their possible limits: I address these body projects as expressions of agency that potentially work against relations of power that oppress women, but I also try to trace ways in which they may fail to reclaim the female body. At the end of this chapter, I raise again the issue of pathology and self-mutilation, and I suggest how feminism might be helpful in, and benefit from, reconsidering medicalized and pathologizing approaches to both body modification and vulnerable bodies.

SITUATING FEMALE BODY MODIFICATION

The debates surrounding women's body modifications between radical feminists, postmodern feminists, and women body modifiers themselves begin from a shared critical awareness of the gendering of women's bodies. In late modernity, the body is presented as a plastic, malleable space for the creation and establishment of identity, as well as a site for representing one's depth personality to others. Body projects are now seen as integral to the development of self-identity, and the ideology of consumer culture suggests that through them, a person can achieve self-actualization as well as beauty, fitness, and success. Yet, feminists have powerfully argued that not all bodies "are subject to the same degree of scrutiny or the same repercussions if they fail," to put it in anthropologists Jacqueline Urla and Alan Swedlund's

terms.[1] Women are expected to undertake a wider array of body projects, be more disciplined in them, spend more time and money on them, and achieve more with them in terms of shaping the body, combating signs of ageing, and conforming to the dominant beauty ideal, which for American women is to be thin, young, and white, among other things. And, as many women have discovered, the beauty ideal is really about everyday bodily behavior, and so body projects for women are often never-ending quests without any final sense of achievement, as Naomi Wolf has pointed out.[2] Beauty quests have become a significant part of the late modern woman's lifestyle, reflected in the approximately $50 billion Americans spend per year on cosmetics, beauty treatments, fitness clubs, and, of course, cosmetic surgery. Every year, for example, at least 150,000 women undergo breast implant surgery to meet body ideals.[3] Other surgeries homogenize ethnic differences, such as plastic surgeries that change the shape of noses and eyes.[4]

Rather than expressing a new cultural logic of bodily freedom and personal choice, women's body projects must be seen as linked to the enormous economic, social, and political pressures surrounding women's appearance. For women and girls, beauty is significantly associated with their perceived chances for upward mobility, happiness, and self-esteem, so much so that up to 80 percent of nine-year-old girls in the suburbs are concerned with dieting and weight control.[5] Appearance-related worries for women include harassment, mistreatment, and discrimination. Disabled women and girls, middle-aged and older women, women and girls of color, obese women, women with small breasts or breasts that are "too large," post-mastectomy women, and androgynous women are among those who face such threats, as Urla and Swedlund argue.[6] Even many women who manage to (at least temporarily) succeed according to normative ideals lose in other ways, such as experiencing self-esteem problems and eating disorders.

As Susan Bordo reminds us in *Unbearable Weight*, feminists have long understood the connection between the gendered body, ideals of

femininity and beauty, and social control. As early as 1792, Mary Woll-stonecraft described the disciplining of genteel women's bodies through standards of beauty and femininity. Wollstonecraft suggested that the sedentary life of such women, prohibited from exercise and free movement of their limbs and literally bound in clothing and adornments to "preserve" their beauty, promoted the frailty not only of their bodies but of their minds—as clear an example, writes Bordo, "of the production of the socially trained, 'docile body' as Foucault ever articulated."[7] In 1914, the "right to ignore fashion" was among the list of political rights demanded by women at the first Feminist Mass Meeting in America.[8] By the second wave of the feminist movement in the 1970s, the objectification of the female body, now fueled by the staggeringly profitable beauty and culture industries, was seen as fundamental to women's oppression, and the call for self-governance over the body came to be understood as "the most radical demand feminists can make."[9] For many, this meant a rejection of bodily practices that constituted most women's self-beautification regimes. Andrea Dworkin's 1974 depiction of the problem, for instance, argues that:

> Standards of beauty describe in precise terms the relationship that an individual will have to her own body. . . . *They define precisely the dimensions of her physical freedom.* . . . In our culture, not one part of a woman's body is left untouched, unaltered. No feature or extremity is spared the art, or pain, of improvement. . . . From head to toe, every feature of a woman's face, every section of her body, is subject to modification, alteration.[10]

During feminism's second wave beginning in the 1970s, radical feminists argued that the modification of the female body is linked to its victimization. Unsafe weight loss regimes and painful and dangerous cosmetic interventions are among the many direct risks of beauty projects for women and girls. Radical feminists also linked the objectification of the female body in advertising and pornography to sexual violence, including harassment, assault, and rape. While social scien-

tists had understood rape largely as psychopathological, feminists con-
nected rape to cultural values and sex roles constructed by a patriarchal
culture, including its media. They argued that through its demeaning,
Barbie-esque representations of women's bodies and its incessant de-
pictions of sexual violence, the media "prepares girls to become victims,
just as surely as it teaches men to be comfortable perpetrators of vio-
lence," as Emilie Buchwald puts it in *Transforming a Rape Culture*.[11]

Although feminists have largely agreed that the disciplining and nor-
malization of the female body through sexualized, normalized beauty
ideals has been damaging to women, we have famously disagreed over
how women can assert control over their own bodies. Radical feminists
like Dworkin, Catherine MacKinnon, and others have depicted body al-
terations, even deviant ones, as instances of the patriarchal mistreatment
of women's bodies. For MacKinnon, the sexualization of the female
body, often achieved through adornments and body modifications, is
the height of gender inequality. As she puts it,

> So many distinctive features of women's status as second class—the re-
> striction and constraint and contortion, the servility and the display, the
> self-mutilation and requisite presentation of self as a beautiful thing, the
> enforced passivity, the humiliation—are made into the content of sex
> for women.[12]

In this view, body modifications represent both patriarchy's willing-
ness to make literal use of the female body as well as women's psychic
internalization of its aims. Women's willingness to happily endure
pain to shape the body, she and Dworkin argue, reflects women's self-
abnegation in patriarchal cultures.[13] Along with cosmetic surgery,
Chinese foot binding, diet regimes, sadomasochism, and other painful
or difficult practices, women's tattoos, piercings, scars, and brands
have been described by radical feminists as representing women's
"[self-] hatred of the flesh."[14] Even though the most provocative of
new subcultural body mod practices usually have the effect of distanc-
ing women from Western beauty norms rather than bringing them

closer, critics have likened the practices to mutilation. Informing this depiction of women's body modifications as self-objectifying or mutilative is a view that the female body should be "spared," to use Dworkin's term, interference, alteration, and, most certainly, pain.

The "sex wars" of the 1980s foreshadowed the disagreements over body art a decade later. Debates over SM focused on women's agency in relation to sexuality. Radical feminists objected to women's SM and women-made pornography (including women's obscene art). According to Dworkin and MacKinnon, these represented the worst consequences of misogyny—women's internalization and reenactment of patriarchal abuse of the female body. Their rejection of a sexualized, modified female body depended partly on the notion that a pristine, natural, organic body—a body unmolested by culture—would be a primary resource for resisting patriarchy and its use and abuse of female embodiment. Pro-sex and postmodern feminists, on the other hand, celebrated women's sexual deviance, including SM and porn, and argued in essence that women were reclaiming sexuality and desire and rebelling against oppressive prohibitions on female pleasure. Freedom of sexual expression was positioned as the primary cause, in contrast to the radical feminists' demand for freedom from harm. In retrospect, the debate seems to have been limited by its narrow focus on speech freedom, censorship, and the role of the state in "protecting" women from harm.[15] But also at stake were some of the broader meanings of agency and freedom in relation to the body. The postmodern possibilities of irony and contradiction, for instance, were raised as possible resources for cultural battle.

Rather than viewing all forms of body modification as the same, postmodern feminists have viewed women's subcultural body modifications as part of a "focus on contradiction" and resistance, as Melissa Klein puts it.[16] While body practices that conform to normative ideals of beauty are deeply problematic, those that seem to reject such ideals can be perceived as instances of women's assertion of agency in relation to their bodies. In SM, punk, "feminist" porn, performance art, and

body art, the deviant female body is seen as a thing to be "re-examined and reclaimed."[17] Since the 1960s and 1970s, for instance, when they began a tradition of graphic, vulgar performances to express feminist themes of sexuality, power, and violence, women performance artists have explored the symbolic power of body alteration. They sensationalized the body through smearing, opening, burning, and slicing body parts to rebel against "normative feminine behavior," as Lenora Champagne puts it in *Out from Under: Writings by Women Performance Artists.*[18] Artist Karen Finley, for example, has used a variety of symbols of defilement, including covering herself with substances that look like "shit" and "sperm."[19] Other artists, including Hannah Wilke and the infamous Annie Sprinkle, presented their bodies obscenely, "flaunting the female sex" in ways that expose and therefore upset or circumvent "the politics of the male gaze," as Amelia Jones describes in *Body Art.*[20] As well as drawing attention to bodily oppression, these performances politicized the status of women's sexuality in patriarchal culture.

By the 1990s, tattoos on the bodies of young feminists, Riot Grrrls, and others were beginning to be embraced by some postmodern feminists as subversions of "traditional notions of feminine beauty."[21] Other, even less legitimate forms of body modification have also been claimed as practices of female rebellion. Because they violate gender norms, explore taboo aspects of embodiment, and provoke attention, they can be seen as ironic examples of women's "strength and independence," to use Klein's term.[22] Karmen MacKendrick describes the new body art practices as promoting "mischievous" pleasures that appropriate the body from culture. Tattoos, scars, and piercings violate Western body norms. Women who undertake such body modifications are not ignorant of the abjection that they can provoke. Neither, according to MacKendrick, are they unaware of the multiple ways body alteration has usually served patriarchy. Rather, she argues, "the postmodern response on display in modified bodies is fully contextualized, ironically playful, and willfully constructed."[23]

The subcultural discourse also celebrates the practices as empowering. In magazines, ezines, underground films, and in body art studios,

the subculture depicts women's body modification as having the potential to signify body reclamation for women, including those who have experienced victimization. In reclaiming discourse, women (and sometimes men) assert that scarification, tattooing, and genital piercing can achieve a transformation of the relationship between self, body, and culture. In contrast to radical feminist criticisms of women's body modification as mutilation, they claim that women's anomalous body projects can provide ritualized opportunities for women's self-transformation and for symbolically recovering the female body. Far from revealing women's self-hatred and lack of self-control, they argue, the practices demonstrate women's assertion of control over their bodies.

RECLAIMING THE BODY

Reclaiming discourse was first articulated in print in the highly popular book *Modern Primitives* in the late 1980s, where women's body piercer Raelyn Gallina suggested that women can alter non-Western, indigenous body modification practices to create meaningful rituals, in particular to symbolically reclaim their bodies from rape, harassment, or abuse. The 1991 women's underground film *Stigmata: The Transfigured Body,* is another early example of this view.[24] *Stigmata* presents women body modifiers in San Francisco, arguing that their nonmainstream body markings are significant forms of gender resistance. The cyberpunk writer Kathy Acker, for example, equates the normative female body with constraint and oppression: "I dislike," she says in the film, "that because you're a woman you can't do things, that the word 'no' is the first word you learn and it's burnt on your flesh." Angel, a woman whose back is nearly covered with tattoos and who also wears nipple and clitoral piercings, describes her body markings as "upsetting" to many men because "men impose their wills and their ideas about how women should look." The women agree that the female body is socially controlled, and that permanently marking the body is an expression of female power.[25] Reclaiming the body is presented as a

process of highlighting the power relations that surround the body, and undergoing painful, often emotional ritual to transform the self–body relationship.

By the mid 1990s, this discourse of reclaiming the body from victimization was being widely reported in accounts of women's body modification, including in more mainstream media such as *Ms.* magazine and *Vogue*.[26]

Many of the women I interviewed made use of and contributed to the reclaiming discourse surrounding women's body modification. I describe in detail the interview-gathered stories of Jane, Karen, Mandy, Elaine, and Lisa, plus the autobiographical narrative of Becky, each of whom makes a case for reclaiming the body that echoes the subcultural discourse articulated in *Stigmata* and other subcultural texts. The women's stories situate reclaiming projects in their larger body-biographies, which often reflect on the impact of sexual violence, beauty norms, and gender relations on their body images and sense of self. I make sense of their reclaiming narratives partly by drawing attention to the ritualized, liminal aspects of the practices they describe. Modifications of the body that open the body's envelope are, from the Western perspective, abject and grotesque, but as the women describe, they also place the body in a physical and symbolic state of liminality and transformation. Later, I interpret these stories through the lens of poststructuralist feminism, which can help highlight their political significance while contextualizing them in larger relations of power.

KAREN

Karen was raised in a working-class family, one in which she unfortunately suffered abuse as a young child, and became a single mother in her early 20s. Once on welfare and surviving on various low-wage jobs, including reading meters for the water company and driving trucks, she put herself through night school, and, later, through law school. During this time, she used psychotherapy to address her early victimization.

At 24, she had also come out as a lesbian, and in her 30s joined a women's SM organization, where she learned about new forms of body modification. Now in her 40s and a breast cancer survivor, she has worn nipple piercings and sports permanent tattoos and scarifications, and uses reclaiming language to describe their meanings: "they were ways," she argues, "of claiming my body for me."

Karen's breast has been marked with a tattoo in the symbol of a dragon. She explains the dragon tattoo as part of a process of recovering from early victimization and gaining a sense of independence.

> I came out of an abusive childhood. I was sexually abused by an uncle. My family sort of disintegrated when I was five years old . . . my family moved back to Chicago because that's where my mother's family was and we moved in with her parents and I grew up in this extended Italian family. One of my uncles was a child molester. The dragon was really about finding my way to stand on my own two feet. Finding a way of separating from that extended family and being in the world on my own as a real person.

Karen's experience of abuse is presented as an important aspect of her biography. During her interviews, she also repeatedly describes separating from her parents and extended family as a difficult and important event. Karen presents her separation from the family, which had failed to protect her and later resisted her lesbianism, as an assertion of her own authority over her body. The image of the dragon arrived when one of Karen's girlfriends suggested she visualize a dragon guarding a cave as a process of overcoming fear.

> *KAREN:* The purpose of that visualization was to give one an awareness of what they do with fear and how they deal with fear and where their courage comes from. The way I dealt with getting into the dragon's cave was I sat in the dragon's mouth very peacefully and made myself one with the dragon. Some people actually pick up swords and swipe the dragon mightily and others figure ways of getting around it. My way of dealing with it was to make myself one with the dragon and make the dragon become me.

VP: What was the dragon for you?

KAREN: I came out of an abusive childhood. I was sexually abused by an uncle.

This plan to "make the dragon become me," a strategy of confronting fear imposed on her body by an abusive adult male, was made literal in Karen's decision, a year after graduating from law school, to have the image of the dragon tattooed on her breast. The inscription, she asserts, claims her ownership of her breast, and symbolically dissolves the fear by incorporating it. She also describes her breasts as a focus of unwanted attention and harassment by men:

> So, the dragon was my way of claiming my body, claiming my breasts. Because I [also] grew up having very large breasts and having men ogle me. Being 14 or 15 years old to be walking down the street and have guys drive by and yell, "hey baby." Really ugly things that guys who are out of control do. And it made it really difficult for me to feel comfortable in my body. So having a dragon put on my breast was a way of saying, "this is mine." It was an evolution of that whole process of keeping myself safe and keeping myself whole.

Reclamation of the body, suggests Karen, is effected by self-writing it. Her ogled and uncomfortable breast, once a site of sexual abuse and later of anonymous harassment, becomes less alienating, she seems to suggest, through inscription. Years later, when she is diagnosed with breast cancer, she is upset by the idea of losing the mark: "my one request to the doctor," she says, "was to save the tattoo." Karen perceives her body as recovered through her marking of it. Through the tattoo, the breasts—and by implication the whole body—have been rewritten with new meanings.

Opening the body transgresses Western bodily boundaries. The boundary transgression of body marking is explicit in Karen's description of her scarifications, one of which created a scar in the shape of an orchid. This mark was created by a body mod artist in an event attended

by members of her women's SM community, which was sponsoring workshops on body modification. She describes her scarification as modeled after a "Maui form of tattooing . . . using a sharpened shell to do the cut and rub ash into the open cut to make the scarring." The practice was ritualized and, as she describes it, "spiritual."

> What was going on here . . . was about the spirituality of claiming myself. Accepting myself. And that state of concentration, that is about spirit. I think it is the same or similar state that Buddhists, when they spend hours and hours and hours of the state of prayer. It's that place of acceptance and floating and honor. It's very, it's absolutely connected to the spiritual center of myself. . . . I think that people are really afraid of that state of being. It's terrifying to let go of the control that much. It is really about your control over the moment, and simply being in the moment, being one with the moment. Being completely open.

The openness in scarification ritual creates the liminal stage in what Karen, in modern primitivist fashion, considers a rite of passage. In anthropologist Victor Turner's description of indigenous rituals, liminality is the point of transition in ritual, the middle stage between young and old, unsocialized and socialized, pristine and marked. For example, the male undergoing puberty rites is no longer boy, yet neither a man; he is a liminal persona, a transitional person who resides in the margins.[27] Liminality is the temporal and physical space of ambiguity, in which cultural performance or rite is enacted with initiate and audience. The ritual of scarification invites liminality through its opening of the borders of the body.[28] In Karen's marginal, subcultural view of her rite of passage, the female body can be reappropriated through transgressive, self-marking ritual. The opening of the body violates its surface and also, as Karen describes, its former representations. For Karen, ritualized marking symbolically revokes former claims on the body—those of victimization, patriarchy, and control—and so is deeply meaningful.

Nonetheless, Karen's narrative hints at how such meanings cannot be fixed in the culture. In particular, she worries that the recent popu-

larization of body modifications in her West Coast area, especially tattoos and body piercings, dilutes their significance. In her words, "I think it has become a fad and . . . that's not what it is to me. . . . I have managed to keep myself apart from that." Yet conversely, people in mainstream culture can also react with horror: Karen imagines that some would "scream obscenities at us for doing what we're doing."

ELAINE

Symbolically distancing oneself from abuse is the focus in body marking projects for other women as well, including Elaine, a middle-aged woman who is part of an urban lesbian SM community on the West Coast. Long perceived as a tomboy, and, later, as unfeminine or butch, Elaine worked for years as the only woman on a construction team, eventually making it to forewoman. Over the years, she has transgressed gender norms in other traditionally male jobs as well. She is now self-employed, making a living creating fetish gear and other leather products in her own studio, and is scarred, pierced, and tattooed. Her narrative, like Karen's, describes body modification as a mode of symbolically reclaiming the body. In her words,

> [The first scarification] happened very soon after I was basically essential in getting my father put in prison. And he was put in prison for molesting one of my nieces. And it was because of the support that I gave my sister and one of my other sisters that he wound up in prison and that charges were ever put up against him . . . and it was around that, because of my own incest I survived as a child, that it was a marker in my life. And it was also in a way a growing up point for me. And you probably know that there's different growing up points. When you're fifteen you feel a little grown up, and at seventeen that seems like I'm really grown up. And there's these different points in your life where you feel like something happens where you grow up a little bit more. And at that point in my life I grew up a little bit more. That was standing up to a type of authority that was kind of omnipresent in my life up to that point.

The event of sending her father to prison is not only a point of growing up "a little bit more" and helping her sisters and niece, but also an action regarding her own sense of embodiment and abuse. The importance of this act for her own sense of embodiment is significant, according to her description:

> And of course coming from a very physically abusive background, and sexually abusive, the thing I really discovered is that the only thing I have true control over in this lifetime—everything else can fall apart— the only thing I have even the semblance of control over is my body. And how it looks. So I can make it bigger, I can make it smaller. I can scar it. I can pierce it. And some of those things I can make go away.

Of course, bodies are sites of representation, are not only physical but also communicative.[29] Elaine learned through early experience that modifying her body modified social relationships: she was kicked out of her home for piercing her nose at age 16. "I started seeing that as a way to control my own destiny," she says, "through my body. And making my own choices." This moment, when her material situation was radically altered as a result of the altering of her body, taught her that representation matters. Later in life, she has manipulated it through scarring and tattooing it, in order, she says, to ameliorate her sense of bodily estrangement.

This estrangement—echoing Karen's feeling uncomfortable in her body and alienated from her "ogled" breasts—is exemplified in Elaine's early attempts to manage her embodiment as a teenage athlete:

> When you're an abused child, whether it's sexual or physical abuse, or even emotional, you don't have a really good awareness of your body. To a very large extent, you don't have a really high respect for your body or understanding of what a gift your body is. The body is something that causes you discomfort and pain. . . . I became an extremely good athlete as a child. I was willing to injure my body as an athlete . . . I used to bicycle as a teenager 10 to 20 miles a day. I was very, very athletic. And I

had a broken bone in my foot, different sports-related injuries. I dislocated my shoulder, broke my clavicle . . . I had a disregard for my body.

Athleticism here is linked to the objectification of the body, and becomes mutilation that has serious repercussions—for Elaine, a collapsing body and painful mobility due to arthritis.

Years later (she is currently 42), Elaine describes scarification as a process through which she is "brought back" to her body. Elaine interprets scarification as a form of respecting her body, as reconciling her self and body. In contrast to her teenage attitude, her approach now is "realizing what a gift the body is." This rewriting of the body's meanings and of bodily identity is symbolized through the new sensation created within her body by scarring it. When I asked her about the scars she had cut into her back, she argued that they represent a new psychic relation to the body.

> VP: And you put them in places that you can't really see yourself.
> ELAINE: But when I want to be aware of them, I'm acutely aware of them.
> VP: And how's that?
> ELAINE: I can feel them. It's just a presence there. Not only just a physical presence, there's a presence in my psyche. That knows they're there. That knows about those times and knows that they're markers of those times. And if I feel like I need strength around those issues, they're actually very, very present on my body.

BECKY

A younger woman than either Elaine or Karen, Becky's scarification is described in autobiographical narratives she published in two body modification magazines. In *Body Play and Modern Primitives Quarterly,* her description is accompanied by photos that display long, highly keloided scars in the shape of half-moons. The half-moons encircle the lower end of each breast, echoing their contours. She writes:

In 1994, I made the decision to reclaim my body for myself. For a long time I had felt as though my sexuality were not my own. . . . I had had many bad sexual experiences as a child. Now as an adult, having been so used to protecting myself, becoming emotionally and physically withdrawn, I found that I was unable to physically and spiritually connect myself to my adult sexuality. I began with the relatively small step of having my clit-hood pierced. It was the most direct way I could think of to say to myself, this space is mine.[30]

Like Elaine, Becky began modifying her body with piercing, and she presents her genital piercing as a claim of jurisdiction and authority over this part of herself. The notion of reclamation suggests that even though the female body is marked by objectification, its identifications are not fixed. Raelyn Gallina, a woman who has been piercing, branding, and scarring women's bodies on the West Coast for over 13 years, argues that the clitoris piercing has signified (re)appropriation for many of her clients.[31] Gallina reiterated this message to me a decade after she first articulated it in *Modern Primitives:*

I've pierced a lot of women who are getting that piercing specifically because they're incest survivors, or they've been raped, or abused in some way, and they are wanting to reclaim their sexuality that's been damaged. They want to reclaim something that's been stolen from them in a really nasty way. They want to reempower themselves and their sexuality and take that back. And turn it into something that's for themselves, something that was so degraded that changing it into something beautiful, where every time they look at themselves or their lover looks at them there's [a sense that] "That's beautiful."

Symbolically, piercing the clitoris addresses Becky's sexuality. Becky's survival of sexual abuse included, like Karen's and Elaine's, a process of separating self from body, an alienation from the violated body and especially its sexualized parts. Following the clitoris piercing, she had her lower abdomen branded and her breasts scarred:

I knew that . . . my body modification journey was the path to take. In order to act out my release [of "pent-up bad feelings"], I went to Raelyn

Gallina and had a brand placed right on my lower abdomen. I again had a completely euphoric experience. I was sure I had taken the right step. . . . I decided that I would have cuttings done on my breasts. It was important to me that the cuttings scar and keloid. I felt that the physical manifestation of my experience would be a mental and spiritual release. I spent a great deal of time deciding on and revising the design I would use. A close friend offered to do them for me, and I accepted.[32]

Becky's rewriting of her body is radically literal. Upward and beyond her clitoris, the branding of the lower abdomen—the area encasing her internal reproductive organs—and the cutting of the breasts cover much of this space that she likely associates with her own sexuality.

Becky scarred her breasts several times to achieve a higher, more protruding mark. Becky suggests that the repetition of this act did not take on an uncontrolled quality, nor was it a simple masochism associated with pain. When, after several cuttings, the pain was "overwhelming the experience," she decided to stop. Meanwhile, she "enjoyed" the visibility of her own blood, and her breasts becoming "larger," and her nipples more "sensitive."[33] She describes a state of liminality, of dissolving former identifications and immersing oneself in embodiment. According to her description, it is the proliferation of the body, the flowing of blood and the growth of new tissue that is appealing for Becky. Her final modification was a brand on her stomach, designed, she writes, to connect her genitals and her heart.

As we see with Becky, the grotesque, opened body is the body of parts. The body is exposed. Becky's linking her genitals to her heart along the skin's surface is a reworking of the body's envelope. Reclaiming discourse characterizes reworking the lines of the body as an organic, messy ritual of making whole the self and body and rewriting identity. Taboo is violated and so are the body's former, alienating representations. Its new representations are preferable; its new openness is viewed as improvement. "Each modification has helped me feel more alive and sensitive," Becky writes. "My ghosts have been banished, and I have reclaimed my sexuality for myself."[34]

JANE

Jane describes her body modifications as acts of reclaiming, although unlike Elaine, Karen, and Becky, the reclamation is not a response to sexual victimization. But like them, Jane presents her visual modification as an attempt to claim authority over her body and rewrite its identifications. A 39-year-old student of social work who lives alone in a city on the East Coast, Jane has had a large dreamcatcher symbol cut across her chest.[35] It reaches up to her neck and down between her breasts. It is about six inches across and about six inches tall. The scar is highly keloided, and it has been injected with blue and purple tattoo ink. The image is startling, and it visually redefines her. Jane describes getting such a radical scar as a way of acknowledging, and rejecting, the pressure of cultural standards of beauty.

> As a child, I was what might be referred to as an ugly ducking. I was freckly, skinny, gawky, flat-chested, you know, all of the things that are not valued in society. I never thought of myself as cute or good-looking and never of course got told I was. . . . I didn't get positive reinforcement for my looks as a youngster, and I've grown up to become relatively attractive. But that's not how I feel about myself, because I have this lifetime of messages that I received from other people that said that I was not attractive. I don't necessarily hold onto it with a vengeance, but it's real hard to combat those messages. And . . . when I look in the mirror I don't look half bad unless I'm really tired. I don't have low self-esteem. I realize logically that I'm pretty good-looking, but those were not the messages that I got.

Jane presents her scar as a resistance against the normative "lifetime of messages" that pressure her to reach the beauty ideal. As well as self-ownership and renegotiated sexuality, beauty is thus a target for reclamation. In similar fashion, Karen had identified beauty as a target for reclaiming. She had picked an orchid as a scar symbol to represent inner beauty:

> The orchid was about beauty. The orchid was about my having felt that I wasn't particularly beautiful . . . the orchid was about claiming my

beauty and about saying, I'm not a spectacular looking person but I am beautiful and beauty comes from inside. So, that's how I came to have the orchid.

Like the body modifications of the other women, Jane's was undertaken in the presence of supportive friends and ritualized. After seeing cuttings and brandings at demonstrations sponsored by the local pro-sex feminist bookstore and later on a trip to the West Coast, Jane decided to organize her cutting event with the things and people that, in her words, "meant something to me." She set up her home as a ritual space:

> I personally went around and smudged my house with sage. For Native Americans, sage is an herb that purifies spiritual energy. . . . I had my own candles and oils that have to do with power and protection. I set up the living room; I set up the atmosphere, to be clear and clean.

In a sense, the ritual was also for her about representing bravery.

> I got a [Native American] dreamcatcher. . . . I can say that it would be a real good thing to have dreams. I haven't been able to allow myself to have dreams and wants or whatever for anything, anybody. I've been sort of plodding along in a very protective shell in my life . . . before I got this cutting. . . . I was acknowledging that I was going to open myself up more and did it.

The cutting as she describes it was extremely painful, more so than she had expected, and she decided to forego any other painful modifications in the future. However, she claims not to regret the experience, and explains by comparing her cutting to another painful body project women undertake or endure:

> VP: Do you wish it had hurt less?
> JANE: That's a real hard one, because it's sort of like having a baby. After the baby's born, you don't remember the pain, and you're just euphoric and you've got this new life here, and it was the same kind of experience.

As a physical body, Jane has dis- and re-figured herself. The surface of her upper torso is radically altered. She can feel the new growth: the scar tissue is sensitive, felt from within the body (a slight itching feel), and tactile. The highly prominent modification of her appearance also removes a normative ideal of beauty from possibility. In this way, Jane's transformation of her physical surface body also transforms her communicative body. Even though most of her descriptions of the experience are positive, she describes a shocked feeling at seeing the final result:

> I realized I've got this thing on my body for the rest of my life and said, what the fuck did I do? It's like not only do I have this thing on my body, but I'm going to be a counselor . . . and I have to wear button down shirts. It's really right there and I'm going to have to cover it up.

In subcultural settings, such as at the fetish flea market which attracts other body modifiers, she can "show it off and get all kinds of compliments and attention." In other settings, such as at her field-service placement for her social work training, she perceives showing the mark as inappropriate. She also has no plans to let her mother see it: "My mother has seen my eyebrow piercing, but no, I'm not going to tell her that I've got a cut. . . . It's where I draw the line."

MANDY

Mandy is a 53 year-old therapist, poet, and performance artist on the West Coast who is also a member of a lesbian SM community. Mandy's use of body modification both to celebrate nonnormative pleasures and to buttress community solidarity in the sexual underground will be addressed in the next chapter. Among her friends, though, reclaimative rituals are considered distinct from playful sexual scenes—they are not primarily "about sex," in Mandy's words. Women's SM communities can provide a safe space for the reclaiming ritual, because, she says, "they handle blood better, and they understand our reasons why bet-

ter." Mandy's description of scarification as a ritual to overcome bodily fear imposed by domestic violence echoes the reclaimative discourse of the women above. Like sexual assault, domestic violence is a process of intimidation that commands authority over the female body.

> I was afraid of knives. I [once] had a partner, my daughter's father, who became violent . . . and used to threaten me with knives a lot. And I had to leave and run away and hide and have my baby elsewhere. And he found me and threatened my roommates and tried to burn the place down. . . . Friends knew, and if somebody brought a knife . . . I'd go off to make coffee in the kitchen and somebody would say, "Mandy is really uncomfortable around knives."

Mandy argues that she had lost a sense of command over her body when she associated it with potential danger. The body's pain and bleeding had been usurped; she argues that by commanding these elements of the body, she took hold of them. Mandy describes her decision years later to turn her fear inside-out as a transgression, a direct provoking of fear in order to transcend it. As women's reclaiming rituals became popular in her lesbian SM community, she invited several women to participate in a scarification ritual. They provided an audience as well as a group of people to hold her hands, discuss her fears, and support her.

> [I was] saying okay, I'm ready to confront this fear . . . it was planned. It was a more deliberate confronting of the fear . . . but I was with people and I was safe. But I also knew really well that if I broke into tears and want to cry all over my friends, they would have helped me.

Mandy describes body marking as a ritual in which women tend to each other's bodies. Liminal activity is potentially community-building; it can be a "socially unifying experience."[36] As Victor Turner argues, it is also an occasion for the enactment of "alternative" social arrangements because it promotes "society experienced or seen as unstructured or rudimentarily structured."[37]

LISA

Unlike the other women, Lisa does not use the word "reclaiming" to describe her body modification rituals. I include her here, though, because in some respects her narrative contributes to and reflects the notion that body marking is empowering for women. Like the others, she also describes the ritualization of body art and the attempt to use it to build feelings of support among women. Lisa is a college student in her early 20s majoring in anthropology. As a high school student at a parochial school, she had pierced her nose and embraced punk as a way, as she describes it, to rebel against the strict rules and enforced femininity of her Catholic upbringing.

> I pierced my lip my junior year of high school myself. It's a weird thing. I've never even known other people did that kind of stuff. . . . I was like "wow, it looks so good," and it freaked everyone out which was kind of cool. I got battery-axed at school because I went to Catholic school and we had to wear uniforms and they gave me lots of shit for it. I was the only person who had enough balls to actually wear the jewelry in school.

In college, she studied contemporary body image and gender relations, comparing them to those of pre-industrial societies. Fairly isolated as a heavily pierced girl punk at a rural East Coast college, she was introduced to the body art movement and its revival of indigenous rituals through the Internet. She particularly admired the bodies of African women, whom she had seen pictured with "beautiful scarring on their faces and stomachs." Against the protests of her boyfriend, she eventually convinced some girlfriends to create a scarification ritual, which imitated elements of Native American and African practices.[38] They went out into the woods outside the college, and as she puts it, "cast a circle and did a little meditation." "We focused our energy," she describes, "on what was going on and tried to push out everything that was going on in the world." The ritual, in which Lisa's two friends made a scar on her arm in a pattern she designed, was targeted at cre-

ating an experience of self-transformation for Lisa. It was also an experience of group bonding for the women.

> I wanted this to be a community thing. . . . It was really nice, just the three of us, Mary, Jen and me. . . . [When the pain started] I was crushing Jen's hand at one point. It was the most intense feeling I've ever felt, almost in my entire life . . . I felt really energized—like my body was on fire—and we danced around in a circle and looked up at the stars. It was a beautiful night out, and we said wow, there was this energy flowing everywhere. . . . It bonded us. We didn't talk for a while, and all of the sudden we just start talking again. . . . It's a really special thing to cut someone and have a mark on their body that you made.

She wears a number of scars now, along with piercings and tattoos. The first one, created by Jen and Mary, consists of three lines, reflecting, she says, the balance between masculine and feminine in her gender identification. The second scar, she describes, is made up of Celtic and rune symbols for protection, strength, and rebirth.

> I always looked at myself as more masculine than feminine. I was a tomboy. [In the first scar], the right line is feminine, the left line is masculine, and the middle line balances the masculine and feminine. [In the second scar], I wanted to find a symbol of protection that I could have scarred on myself. Something that would be permanent, that would always be on the body. Just for protection against everything, like negative feelings . . . [and] not being self-confident. Strength symbols. It'll maybe make me feel safer in situations where I would normally not feel safe. These are all masculine symbols.

Lisa's description of using body marking as a symbolic way of transforming herself into a stronger, more self-reliant person echoes Jane's desire to bring herself out of her "shell" and Mandy's interest in confronting and overcoming fear. As she describes here, Lisa understands this embrace of strength, like having the "balls" to wear body piercings to school, as a kind of gender transgression. Like the body piercings, the transgressions are intended to be public:

I get the marks, I do it because I want the marks, but it's also a very big part of who I am and what I'm becoming with each modification that I do. It's another story, it's another aspect of who I am, and then I get to tell all of these great stories to people about the various things that I've done which freaks them out or intrigues them.

MODIFIED BODIES AND FEMINIST POLITICS

Feminist disagreements over body modification reflect divergent assumptions about subjectivity, consciousness, and the body. Post-essentialist feminists view female bodies and subjectivity as socially constructed, culturally negotiable, and saturated with power relations. Such perspectives have argued that the body is always *already* inscribed by culture. It is socially controlled and regulated, including through gender socialization and violence, and marked by relations of power. The "normal" body, in this view, is not a biological category but rather an ideological construct that serves economic and familial functions. The female body is prescribed roles and practices that lend apparent biological evidence for normalized female identity, thereby naturalizing gender relations.

From this perspective, anomalous body practices may have the potential, at least theoretically, to radically challenge the gendered roles and practices of embodiment. The rituals I describe above create anomalous bodies, and require the acceptance of moments of bodily uncertainty and ambivalence. In the liminal state of embodiment that they promote, boundaries are erased and redrawn; heterogeneity and contradiction are embraced. Transformations between states in rites of passage place the individual into a position of marginality; the body-subject in the liminal zone manipulates and fluctuates her identity by enacting, to quote Rob Shields in *Places on the Margin,* "a performance supported by social rituals and exchanges which confirm different personas."[39]

Postmodern feminists have recognized the liminal, heterogeneous body-subject—the cyborg—as subversive, largely because it resists the

unified, stable, gendered identity enforced in mainstream culture. Liminality might reflect, at least temporarily, a "liberation from regimes of normative practices and performance codes of mundane life," in Shields's terms.[40] As such, it can denaturalize gender categories. The scarred, branded, or tattooed woman may destabilize, in the words of medical sociologist Kathy Davis, "many of our preconceived notions about beauty, identity, and the female body," as well as focus attention on ways in which female bodies are invisibly marked by power, including by violence.[41] Shields writes that marginal bodies also "expose the relativity of the entrenched, universalising values of the centre, and expose the relativism of the cultural identities . . . they have denied, rendered anomalous, or excluded."[42]

Karen, Elaine, and Becky's body markings expose stories of sexual victimization, but also symbolically address women's chances to live in bodies as survivors. All the women have created bodies that rewrite notions of beauty and counter, in Jane's words, the "lifetime of messages" that prescribe and normalize beauty regimens. They have marginalized themselves, but questioned the dominant culture's control over their bodily appearance, behavior, and safety. In marking their bodies, they appear to shift both their private self-identifications and their public identities, telling new stories to themselves and others about the meanings of their embodiment. Rather than depicting hopelessness, the practices imply that their body-stories are in flux, opened to the possibilities of reinscription and renaming.

Yet, radical feminists would claim that body modifiers are "not in control" of their decisions, and that the practices themselves are harmful.[43] Some radical feminists, who are also critical of women's SM, have argued that the practices violate the body and reproduce oppressive relations of power by echoing patriarchal violence. Anti-body modification arguments generally either link the technologies themselves to mutilation and pathology or equate women's body modifications with more mainstream cosmetic practices that are seen as objectifying. Radical feminist scholar Sheila Jeffreys, for example, equates SM and body

modification (piercing and tattooing) with addictive self-cutting and other self-mutilative practices:

> Some of the enthusiasm for piercing in lesbians, gay men, and hetero-sexual women arises from the experience of child sexual abuse. Self-mu-tilation in the form of stubbing out cigarettes on the body, arm slashing and even garroting are forms of self-injury that abuse non-survivors do sometimes employ. . . . Sadomasochism and the current fashionability of piercing and tattooing provide an apparently acceptable form for such attacks on the abused body. Young women and men are walking around showing us the effects of the abuse that they have tried to turn into a badge of pride, a savage embrace of the most grave attacks they can make on their bodies.[44]

This argument asserts that the marked body is injured and attacked, either literally through pain or symbolically through harming the body's appearance. The fact that some of these bodily inscriptions make refer-ence to experiences of victimization has not escaped their critics. While body modifiers themselves suggest that the violated female body can be rewritten in personally and politically meaningful ways, radical femi-nists argue in contrast that modifying the body is a straightforward re-play of that violence. A large part of what is at issue here is the possibility of women's agency, which radical feminists have long argued is ham-pered by the psychological effects of patriarchy. Following this view, Jef-freys interprets the practices as "signifiers of false-consciousness," a criticism also reiterated in mainstream press accounts of feminist oppo-sition to women's tattooing, piercing, and scarring.[45]

Body modifications are also attributed, ironically, to the "tyrannical set of expectations about how they should look, act, and think" that con-tribute to anorexia and other body disorders, in the words of a *Boston Globe* editorial on body modification as a social problem for women.[46] Karmen MacKendrick describes this as the backlash argument:

> Can we in fact read body modification and its increasing popularity in this way—as an intensification of sadistic patriarchal demands for con-

formity to discomfort in the name of beauty? . . . the anti-woman back-
lash might extend beyond neo-conservatism to the more radical-
seeming margins, where women who might once have endured three-
inch heels for their jobs now force their feet into six-inch spikes for
clubs, and women who might once have tolerated the prettiness of a sin-
gle pair of earrings can now be led around by the rings in their septums.
Are relatively extreme styles inherently misogynistic? Are they becoming
more and more stylish in a backlash response to women, nature, and the
constant identification of the two?[47]

MacKendrick thinks not, pointing out that new forms of body modi-
fication differentiate bodies rather than normalize them according to
one ideal standard, and that unlike conventional beauty regimes, they
rather explicitly suggest an awareness of body norms as negotiable so-
cial constructs. Certainly, even though some critics compare them to
more mainstream beauty practices, body projects that are nonmain-
stream are more likely than others to draw attention and be framed as
social problems.[48] Ethnographer Leslie Heywood, for instance, points
out that even women body builders are often considered "monstrous"
in their appearance, and are pathologized as unfeminine, ugly steroid-
users who are "pathetic and self-destructive."[49] Surely, body projects
that not only violate beauty norms but also explicitly refer to victim-
ization are even more likely to be considered repulsive.

 In my view, any critique of women's body practices as inherently de-
luded and self-hating must reveal and critique its own assumptions of
the truth of female embodiment and subjectivity. The arguments radi-
cal feminists make against body modification seem to be informed by
implicit assumptions about the body as naturally pristine and un-
marked. I would argue that these assumptions are difficult to support
in the face of our increasing awareness of the ways in which the body
is socially constructed and inscribed by gendered relations of power. We
have to ask, where is the elusive unmarked female body that represents
women's freedom from bodily intervention? It can be found neither in
history nor in anthropology; in the lives of contemporary women, it

appears not simply as an ideal type but as a myth. One of the powerful messages of radical feminist thinking of the 1970s was that the threat of rape has influenced the lives and bodies of all women. In her reading of these theories of rape, *Rethinking Rape,* Ann Cahill describes how all women's bodies, not just those that have survived sexual assault, can be comported with what she calls a "phenomenology of fear." Women's bodies have been disciplined both to be wary of the possibility of rape or assault in alleys and on dark streets, and also to be weak and vulnerable as a sign of their femininity and beauty. From the perspective of many women who have suffered from victimization or objectification by patriarchal culture, then, the heralding of the unmarked body appears naive and ideological. Should it be pursued for its own sake despite its practical irrelevance? I would argue that women are not choosing whether or not to be modified and marked, but are negotiating how and in what way and by whom and to what effect.

The problems with charges of false consciousness are many, not the least of which is that they presume its counterpart—a proper, "true" consciousness. This now seems unacceptable. Such a notion asserts a singular, universalized, and essentialist version of feminist enlightenment. The extensive deconstruction of such notions in feminist theory in recent years by women of color, "Third World" and transnational feminists, and others whose views and experiences have traditionally been excluded from feminist discourse should give us pause. In these accounts, the wholly knowing feminist consciousness that can manage to achieve the "true" feminist attitude appears as an ideological fiction, much in the way that the wholly natural, pristine body that stands in opposition to culture has been exposed as a myth by post-essentialist feminists. The feminist debates over the universality of rights and feminist consciousness are far from over, but they have brought us at least to an awareness of how diverse are women's understandings of bodily practices, cultural and human rights, agency and radical consciousness.

Any argument that body technologies such as piercing and scarification are inherently pathological must also confront the widespread

use of them in indigenous cultures. To my mind, the deployment of indigenous practices by white Western women engages in a kind of symbolic ethnicity contest in which non-Western practices are pitted against Western ones. I find many aspects of this contest, which I explore further in chapter 4, deeply problematic because it plays with, but does not overturn, the colonialist contest between so-called civilized and primitive bodies. In their efforts to identify women in the West as self-mutilators, radical feminists inadvertently play a part, pathologizing practices that elsewhere may be traditional, indigenous rites, and by contributing to our willingness to subject marginalized cultural practices to the Western psychiatric gaze. Even aside from the cultural problems, radical feminists' willingness to broadly apply the language of pathology—a powerful discourse that has historically been used as a tool of gender socialization and control—to all modified women in contemporary subcultures seems uncritical and dangerous. I return to this point in the final section of this chapter.

I would argue, following a post-essentialist, poststructural approach, that there is no universal standard of the body or of feminist subjectivity against which we can measure the actual practices of lived bodies. Rather, we should look to how the practices come to be surrounded and saturated with meaning. This involves examining the discourses deployed by the people who use the practices and those who observe them, as well as critically situating those discourses in socio-political context. Women's subcultural discourses represent marginal ways of knowing and strategizing the meanings of lived female embodiment. Rather than suggesting self-hatred or even indifference to their own victimization, the subcultural discourse of women's body modification, as I have shown here, explicitly identifies empowerment and rebellion against oppression as integral to their body projects.

But subcultural discourses cannot be accepted as transparent, or as the last word on the importance and effects of these practices. We cannot replace a notion of women as wholly unknowing subjects with one of them as all-knowing ones, as Sarah Thorton has pointed out in her

discussion of subcultures.[50] Despite what women themselves may want to accomplish with anomalous body projects, I reject an overly liberal interpretation that would overemphasize women's autonomy and freedom in writing their bodies. Women are not individually responsible for situating their practices in all their larger collective and historical contexts, for predicting the political effects of their practices, or even for wholly authoring their meanings. Amelia Jones writes in *Body Art* that "it is often hard to appreciate the patterns of history when one is embedded in them."[51] Thus, body marks cannot be seen as solely ideographic or autobiographical. Marking the body is not a process that involves simply an individual author executing a strategic design that is read in the way she intends by her readers. The process is intersubjective, and, thus, to some extent, out of the hands of women themselves.

THE LIMITS OF WOMEN'S "RECLAIMING"

Following this warning, I want to point out some of the possible risks and limitations of these practices. In my view, even though the practices are in many ways subversive, there are still serious political and strategic limits to women's reclaiming projects as practices of agency. These are borne out of practical problems, as well as the fact that bodies and body projects gain meaning intersubjectively. This chapter will end with three reservations about women's body modification. A critical reading of women body modifiers' own aims to reclaim the body from patriarchal culture reveals the ways in which such aims might be hampered by the limits of the project itself, and by the response of the broader culture to women body modifiers.

First, the aim of symbolically recovering the body from victimization is limited by body projects because eventually, the women must stop. Otherwise, the physical effect would be, even by the standards of body modifiers, harmful and not reclaimative. (Like Becky, the women I interviewed all distinguished themselves from self-mutilators in part by arguing that scarification must be controlled, safe, and experienced as

self-enhancing.) The symbolic effects would likewise be unfruitful. While the possibility of a "relentlessly heterogeneous" subject can be "intoxicating" in its subversive possibilities, identity-subverting resistances, as Susan Bordo argues, require an acknowledgment of some limit to the movement beyond which the mover cannot go: "if she were able to go there, there would be no difference, nothing that eludes."[52] In subversion, the normative categories cannot be permanently dispersed; their remains are necessary for the purposes of juxtaposition and inversion.

As if it recognizes this need, reclaiming discourse articulates a project that has a start, middle, and a finish: the need to reclaim the body is felt, the ritual is enacted, and the reclamation is achieved. For example, Becky's ghosts are "banished," Karen and Jane's beauty are "reclaimed," and Mandy's fear "left." The problem, of course, is that whether or not these rituals actually *finish* an experience of objectification or victimization is uncertain. If they do not, body reclamation offers nothing beyond itself to do the job.

Second, bodily resistance, as a private practice, may be not only limited, but also limit*ing*. The language of reclaiming, even written on the body, does not imply material reclamation in an objective sense; past body oppression is not reversed, rape culture is not erased. The rebellion offered is symbolic and communicative, and thus the efficacy of reclaiming rests on the dual private/public nature of the body. Reclaiming projects offer the intimate space of the self-body relationship as their site of communicative praxis. While it is obvious that this space is enormously important for reasons I have already described, it is also often hidden from public view. It is symbolically public, but often literally private. Clitoral piercings, breast carvings and the like usually remain private, even in the lives of women in subcultural communities. To the extent that these marks are hidden, their communicative and symbolic powers are muted. Jane, for example, hides her scarification in settings where she thinks it might be deemed "inappropriate." In this way, reclaiming simultaneously politicizes (makes louder by publicizing) and depoliticizes (makes silent by privatizing) the project of resisting bodily oppression.

Finally, even visibility does not necessarily ensure politically radical messages. Despite women's aims to renounce victimization, objectification, and consumerization, the anomalous female body does not escape these pressures. This is evident in some of the appropriations of body modification practices within mainstream culture. These practices, at their most hard-core still highly deviant, undergo changes in meaning as the broader culture adapts to their presence on the cultural landscape. The fashionalization of some forms of body modification, such as nose, navel, and eyebrow piercings, and small tattoos, is apparent throughout popular culture. Karen expressed worry that her body modifications would be taken less seriously as the practices became fashionable. Lisa, too, complained about this problem: "I've noticed trends with the posers who are doing it purely for aesthetic reasons. To me it seems they look to the people who are *actually* doing it as still freaks and derelicts" (emphasis mine). As much as Karen and Lisa would like to direct the meanings of their practices—and as much as reclaiming discourse asserts the idea of an autonomous self who can do so—I would argue against the notion that the individual self ever has that much power. Their complaints acknowledge that the subcultural body is not made socially powerful only by its intended messages, but *also* by the "spectator's active gaze" which views and makes sense of that body.[53] While Lisa, Karen, and the other women participate in shaping the meanings of their bodies, they do not do so alone.

This problem is also borne out in the commodification of the subcultural female body as an exotic, sexy Other. For instance, the following advertisement for "naughty" videos was published by one of the same body modification magazines that displayed photos of Becky's scarifications and genital piercings: "Adults only! Nine naughty new selections! Order any three for $99! . . . Erotic blood rituals: the latest craze in San Francisco! $49.95. . . . Penetration 3: Yes! Amazing erotic female piercings! $49.95."[54]

RECLAIMING THE FEMALE BODY 81

These videos of women's body modification practices are sold alongside videos of "shaved fetish girls," and "sexy girls rolling naked in fruit cocktail." Peggy Phelan's wary view of the fate of visibility practices to promote identity-oriented politics is fulfilled in this example. She writes that visibility invites "surveillance, fetishization, and the colonialist appetite for consumption."[55] The utopian vision of women's body projects revoking their participation in an objectifying, sexualized consumer culture is complicated by this kind of fetishization by the male consumer gaze. As Amelia Jones points out, body art needs feminist attention and concern precisely for this reason; she cites "the ease with which women's bodies have, in both commercial and artistic domains, been constructed as the object of the gaze."[56]

The complexity of women's agency in relation to the body exemplified in reclaiming strategies, I think, counters the sense of political certainty that seems to inform some of the radical feminist pronouncements on women's body modification and on the victimization of the female body more generally. It would also resist overly celebratory interpretations that imply that, in postmodern culture, we are all now fully in control of inscribing our bodies, or that view the body as fully unfixed and individually malleable. Women's marked bodies exemplify both the praxis of culturally marginal body projects and the limits of that praxis. As I see it, they highlight the female body as a site of negotiation between power and powerlessness, neither of which are likely to win fully.

In pondering the instances I have described here, though, I continue to return to a powerful issue that calls for further feminist thinking: the fact that the women's attempts to reclaim the body begin with their acknowledgments of the ways the body has already been inscribed for them without their consent, often through violence. Such acknowledgments do not make them immune to the projects' political pitfalls or guarantee their radical effects, but they do suggest a critical thematization of the body and bodily experience that might challenge the silencing and normalizing pressures women face, especially in relation to victimization.

SELF-MUTILATION, PATHOLOGY, AND VULNERABLE BODIES

It is, of course, stories of victimization and vulnerability that lead some feminist observers to try to distinguish healthy women's body projects from unhealthy ones. The underlying logic is that victimization can transform healthy body-subjects into unhealthy ones, and practices that address, or are inspired by, such experiences might thus be unhealthy. Addressing this logic, women body modifiers have defended their practices. The women I interviewed all distinguished themselves from "self-mutilators" partly by arguing that body marking must be controlled, safe, and experienced as self-enhancing. They see self-mutilation as something that is inherently bad for the body and the self, performed without any positive intentions. In their view, their own conscious motives and the meanings with which they willfully endow body projects counter such a model of self-mutilation. Of course, it is exactly this issue of intentionality with which radical feminists take issue. During the "sex wars," the debates about intentionality created an impasse—a theoretical crisis, really. The question of whether or not the subject really fully knows what she's doing with her body was debated over and over again but was never resolved.

From my poststructural perspective, this debate over intentionality is fraught with problems. Radical feminists measure the practices against a standard of "proper" feminist subjectivity or "natural" embodiment. I do not make any claim here that women have false consciousness or that women's bodies ought to be, or can be, unmarked. On the other hand, the subject herself cannot be considered the sole author of the meanings of her body practices, as I have tried to show in my critique of women's reclaiming projects. When embodied identity is politicized and put in a larger social context, self-narration as a technology of writing the self appears incomplete. Rather than replay the debate over intentionality, which I see as something of a theoretical impasse, I want to suggest instead that we pursue our understanding of

vulnerable bodies partly by taking up the post-essentialist challenge to view their cultural practices through a political lens, as we have already begun to do. In my efforts here, I have tried to focus on the effects of the technologies, which include *both* women's new experiences of subjectivity and the body, and also a number of unintended political effects. Body art practices are among a whole range of body projects in which women now engage that rely on irony and contradiction as resources for signification. We cannot read these practices only as expressions of agency exerted against forces of power, but must also see them as having varied effects due to the many ways in which they are constituted by such forces. For instance, the practices can differ in how they counter normalizing images of women and foster women's critical and collective consciousness, what images and discourses they make use of, and how they are received. Thus, women's ironic, confrontational body projects resist any forgone conclusions about their political usefulness and revolutionary status. While in my view we cannot automatically celebrate or scorn the practices, we can try to understand their impact on both individual selves and on the larger politics of the body with which they engage.

We can also engage more critically with mental health discourse. I believe that feminism can be helpful in, and profit by, accounting critically for self-mutilation and other pathologizing discourses that "treat" vulnerable bodies. I see such an account as necessitated by post-essentialist understandings of the body as co-constituted by personal and social discourses. When the body is seen as denaturalized and shaped through the social, its pristine status can no longer be privileged as a way of defending vulnerable bodies (such as those that have been raped). Neither can the anomalous body be utilized as a discursive weapon against the sanity and health of vulnerable and victimized subjects. As a conclusion to this chapter, I want to turn the question of "how healthy are these subjects?" to one of how mental health operates to create a "moral synthesis" about them, as Foucault puts it in *Madness and Civilization* (1965).[57] This moral synthesis is informed by a

number of assumptions about the self, body, and truth that contribute to producing the pathological meanings of body practices.

In her article "Fleshly (Dis)figuration," Nikki Sullivan outlines a helpful critique of the mental health discourse of self-mutilation as it has been applied to tattoos, piercings, brands, scars, and so on. She suggests that this discourse assumes: first, a knowable subject whose essence can be discerned through observation; second, a body that operates primarily as a site for the "clinical extraction of abstract and immaterial truths" about the self; and finally, an imperative to interpret and pronounce judgments upon the self of others through reading the body.[58] These assumptions provide for a positivist method of discerning the mental health of the body modifier: there is a self to be understood that is prior to, and that is revealed through, the body's comportment. The method is informed by a scientific imperative to find the truth of the self that is expressed on the body.

There are a number of problems with these assumptions. Most importantly, identities are taken to be distinct from both the body projects and the social context in which they are produced. Instead, as Sullivan and many other feminist writers, notably Judith Butler, have argued, we ought to think of identities as produced intersubjectively and in space and time; identities are not fixed essences to be discovered but rather processes of both reflection and interaction with others that are continually performed and revised through and within embodiment. So, from this perspective, the self isn't, and can't be, "discovered" through reading its body practices, but rather gains meaning within and through such practices. Body projects do not simply display the inner self in a language that only experts—or, alternatively, members of a subculture—can read. Contrary to *both* the "mutilation" model and to the "reclaiming" perspective, the meanings of marked body-selves cannot be severed from the intersubjective processes of the body's reading and writing, including those offered up by both marginal and institutional discourses. The meanings of such bodies are created within and through the processes of living the body; marking the body; inter-

preting its meanings; and contesting and debating those meanings. Reclaiming projects do not return the body-self to any pre-victimized state of body or selfhood, but rather newly co-construct a set of meanings that must share authorship with other intersubjective forces of inscription and interpretation. The "reclaimed" body has to be understood as actually *produced* rather than recovered.

So, what is produced in this intersubjective context? Among other issues, these projects address "who" the body-subject is *as she identifies herself as* having been raped, victimized, or oppressed as part of her biography. The naming of this identity is not without controversy. Foremost, of course, in reclaiming their bodies, women perceive themselves as contesting the forces that have marked them as victims. It is my view that the deployment of self-naming is in tension not just with these forces of victimization but also with the clinical imperatives of social work, psychiatry, and feminism that might, with the best of intentions, pathologize or otherwise "name" women as victims or survivors. Taking the privilege of naming oneself while positioning oneself as a victim crosses the jurisdictional boundaries not just of patriarchy, but also of psychiatry, social work, and even feminism. For instance, when Jeffreys diagnoses body marks as "the effects of abuse" that body modifiers "have tried to turn into a badge of pride," she claims a rather straightforward process of interpretation from a feminist mental health model, and the role of experts in performing such interpretations. It is, Jeffreys assumes, the job of experts (mental health experts? feminists?) to "clinically extract," or write the biographies of, such selves. Not only is such an expert assumed to be a more reliable interlocutor of the body, but such experts, from Jeffrey's presumably humanist and feminist perspective, ought to see themselves as having a *responsibility* to interpret the experiences of victims.

One of the things produced, then, in reclaiming is a contest over this very imperative. By engaging in, naming, and defending their practices, women have produced a new site for dealing with the effects of victimization and violence outside the group therapy session, the clinic,

the counselor's office, the consciousness-raising group, or the court-room. They have challenged the status of experts to be the interlocu-tors of, and have targeted everyday embodiment as a significant space for interpreting, their experiences within patriarchal culture. Thus, as I read them, the practices do not simply call for asking "how healthy are these subjects?," but rather call for rethinking how "healthy" and help-ful are our *social, institutional* processes of dealing with the victimiza-tion of women's selves, bodies, and sexuality under patriarchy and capitalism.

CHAPTER 3

VISIBLY QUEER

Body Technologies and Sexual Politics

THOSE OUTSIDE THE SEXUAL MAINSTREAM HAVE SUFFERED A LONG history of hostility, discrimination, censorship, pathologization, and public persecution for their practices, and even in rights movements have been considered sick and self-oppressing. In the face of pressures to be closeted, mainstream, or assimilationist, the use of spectacular body marks by leather people, radical gays and lesbians, and the transgendered can reflect a defiant aesthetics of deviance. Radical queers have not only eroticized the new body art practices, but also deployed them as a form of sexualized, embodied politics.[1] I argue in this chapter how body art practices can work to queer the body, and mark on the body the political struggles over sexuality in late modernity.

The queering of the body currently in vogue in sexual subcultures must be understood in the context of a long and socially powerful effort, chronicled by queer theorists and historians, within science, religion, psychiatry, and law to construct the body's sexual normalcy. Historically, such constructions often invoked binary notions of the healthy self and the (medically or morally) diseased other, oppositions that involved race, class, and gender as well as sexuality. Biological determinism has been used as a powerful ideological weapon in "constituting and maintaining

dominant ideologies of gender," as Tamsin Wilton puts it in her contri-
bution to the edited volume *Women's Bodies: Discipline and Transgression,*
and sexuality has regularly been essentialized as fundamental to bodily
identity and difference.[2] The nineteenth-century coinage of the term
"homosexual," for instance, was not ideologically neutral, but rather re-
flected an attempt by science to organize and fix sexual desire according
to heteronormative standards. Historian Laura Gowing points out that
the nineteenth century sexologists described homosexuality as a congen-
ital disposition, one based largely on inverted gender identity.[3] She argues
that while sexology initially aimed to create tolerance in identifying a mi-
nority and naming its "incurable" conditions, it has been held responsi-
ble for stirring social anxieties that prompted a new wave of legal action
against homosexuality beginning in the late nineteenth century.

 The condemnation of same-sex desire is not new to modernity, of
course, but as Gowing argues—following Michel Foucault, David
Halperin, Jeffrey Weeks, and others—the essentialization of sexuality as
a core aspect of identity reflects "an extremely modern and particularly
Western" effort to categorize (and ultimately pathologize) individual
bodies and desires rather than simply to regulate pleasures.[4] Essentialist
notions of sexuality have also been employed to construct differences of
race and class. Nineteenth-century scientists and social reformers, for in-
stance, explored the "excessive" sexuality of the working class, especially
working-class women, and of colonized, non-European subjects. They
attempted to identify coherent, "metaphysically stable" norms and their
deviant counterparts which are, in Nietzsche's terms, "never neutral . . .
always 'interpretations' of the world, expressing a certain force, a certain
relationship to power."[5]

 The discourse of contagion is also part of this homo- and eroto-
phobic history, as Cath Sharrock reminds us in her essay "Pathologiz-
ing Sexual Bodies." While earlier theories suggested physiological
causes like hermaphrodism, same-sex desire among women was seen in
the eighteenth century as an outcome of an enlarged clitoris caused by
masterbation, which was in turn viewed as a learned, and therefore so-

cially contagious, behavior. Upper-class women so afflicted were seen to have learnt it from their female servants, and so lesbianism was presented as a form of "cross-class pollution." Eighteenth-century texts of colonial powers also identified male homosexuality as not only a social contagion but also a specifically *foreign* infection, imported from the south like "infected merchandise and cargo."[6] Male effeminateness was presented in texts like *Plain Reasons for the Growth of Sodomy in England* (1728) as a threat to (masculine) colonial strength, and also echoed other fears of "going native."[7]

In addition, erotophobic, racist, and homophobic anxieties have long been employed in the social treatment of *actual* diseases. For instance, as Sharrock describes, nineteenth-century female prostitutes who contracted syphilis were seen to suffer the physical symptoms of moral vice, while the origin of the disease, in the context of colonialism and black slavery, was "conveniently construed as the 'other,' the African."[8] This reflects a process "by which a person with a sexually transmitted disease is held responsible for their own malaise, with the body breaking out into the symptoms which brand them as sexually transgressive."[9] These ideologies of the sick or contagious sexual body are far from expired. In contemporary AIDS discourse, Sharrock argues, the binary construction of the healthy self and infected/infectious other have been employed to blame others (gay men, as well as Africans and Haitians) for the origin of the disease, as well as to represent physical sickness as the manifestation of a pathological or immoral self. Reminding us of its original name "GRIDS" (Gay Related Immunodeficiency Syndrome), Sharrock writes,

If the body of the "innocent [heterosexual] victim" can metaphorically displace the "guilt" for his/her own illness upon the homosexual, the body of the gay man, on the other hand, is forced to bear the mark, indeed the stigmata, of his own transgressive and sinful actions.[10]

The actual sickness of bodies with AIDS, in this view, is an illumination of the perceived sickness of all homosexual bodies, still socially marked as abnormal. In addition to AIDS discourse, modern instances of marking

the gay body include efforts to treat or cure homosexuality (officially a psychiatric disorder until 1973) with hormone and shock therapy, attempts to locate homosexuality in a gay gene, the continued medicalization of so-called gender identity disorder, and public hysteria over the "contagion" of homosexuality in relation to gay parenting.[11]

As Wilton points out, there have been efforts within gay/lesbian/bisexual and transgendered communities to appropriate biological arguments, as in the acceptance of the notion of a gay gene by some gay people and the arguments of transsexuals who claim to be "born in the wrong bodies." In post-essentialist thought, though, the body's naturalness—a primary construct upon which notions of health and sickness/contagion, morality and vice have been built—has been rendered suspect. The new awareness of the role of the body in marking difference has led some social movements to, in Wilton's words, "cast out the body" in their rejection of biological determinism. The assimilationist argument in gay and lesbian communities, for instance, insists there are *no* differences between gay and straight bodies. Feminist efforts to disaggregate gender and biology (e.g., Shulamith Firestone), and feminist biologists' deconstruction of the notion of biological sex, reflect similar rejections of the body as instrumental to identity and subjectivity. As queer theorist Eve Kosofsky Sedgwick puts it,

> The purpose of that strategy has been to gain analytic and critical leverage on the female-disadvantaging social arrangements that prevailed at a given time in a given society, by throwing into question their legitimate ideological grounding in biologically based narratives of the "natural."[12]

By rejecting biological explanations for differences in sex and sexualities, movements can declare the constructedness of dominant ideals of sexuality and gender and expose them as ideological.

One of the problems with dismissing the body, though, is that it is also an important site of desire and pleasure. Given the historical marginalization of categories of pleasure and the corresponding hardships

forced on gay men, lesbians, bisexuals, and others whose desires have been pathologized, leaving the body behind has its drawbacks. (In the feminist sex debates, radical feminists like Catherine MacKinnon demonstrated this with their dismissal of female sexual desire as almost entirely a creation of patriarchy.) Even given the enormous social pressures surrounding sexuality, the body has not *only* been a tool for inscriptions of power, but also a resource for perverse pleasure, invention, and creativity.

The creation of spectacularly queer bodies—those that flagrantly express nonnormative desires, pleasures, and identities—can be read as an alternative strategy, whereby the body is neither dismissed nor essentialized but treated, in Wilton's words, "as the semiotic/lexicographic ground of a conversation about difference."[13] Reflecting in part the intensification of gay radicalism since AIDS, queer practices, including the in-your-face tactics of groups like ACT-UP, Outrage (U.K.), and Queer Nation, have attempted to publicly counter the heterodoxy of mainstream culture.[14] The queering of the body reflects a politicized aesthetics of deviance, where overt bodily display is seen as a powerful affront to essentializing norms. The stylization of the queer body involves not simply the fixing of homosexual identity onto the body, but rather the creation of a body that is always in the process of becoming sexual, erotic, and pleasured. Queer bodies recall Nietzsche's advocacy of the Dionysian and Foucault's call for pleasures and bodies that are "symbolically indeterminate."

The new body art practices have been celebrated in anti-assimilationist gay and lesbian communities, where "wearing" the queer body is politicized as a speech act. As a potentially counter-hegemonic body technology, body art is seen to express and alter individual subjectivities. In addition, it makes visible the body's potential for erotic pleasure. Queer body modifiers use piercing, scarring, branding, and other practices in ways that violate sexual norms and raise homophobic and erotophobic responses from mainstream culture. Like sadomasochists, whom Foucault described as "inventing new possibilities of pleasure with strange parts of their body . . . with very odd

things . . . in very unusual situations," queer body modifiers deviantly and defiantly eroticize the body, inventing new and appropriating indigenous rituals for gender bending, sex play, and even for altering consciousness through pain and pleasure. Queer body modification offends the sexual norms of heterodominant culture, and positions the body as a primary site of struggle over sexual difference. It also circulates images of ethnic Otherness in ways that suggest, following Sandra Harding, "traitorous identities."

Technologies of queering the self are often described in queer theory and activism as the "vanguard of postmodern self-invention" because they appear to produce body-selves that confront the tyranny of normalcy in relation to sexuality.[15] But because by very definition they are situated in relations of power, I would emphasize that they cannot reflect "true" self-invention, but rather complex performances that negotiate between the self and the social. The queering of body modification reflects a radical politicization of the erotic, sexual body, and engages issues that are of particular importance to gay, lesbian, and transgendered communities.[16] It also reveals the role of powerful discourses, such as pathologization and colonialism, in shaping experiences of the body in relation to sexual politics.

QUEER BODY MODIFICATION

Body modification's queer history has played a significant role in the rise of the body art movement. Queer men and women were pioneers in the development of eroticized, ritualized body art, and were the early enthusiasts of modern primitivism. Since the 1960s and 1970s, when radical gays and lesbians embraced tattoos and gay men used body piercing, body art has been a significant part of gay subcultural style. Later, other practices like scarification, branding, and corsetry spread in popularity among leathermen, leatherdykes, and others in the sexual underground who were, as David Wood puts it, interested in "exploring sexuality and the body in relation to ritual and technology."[17] Be-

ginning in the 1980s, non-Western rituals and practices were being celebrated in gay leather communities for expressing cultural disaffection, for rites of passage, and for sex play.

By the mid 1990s, the queer and subcultural press were promoting erotic body art as "the cutting edge of the radical expansion and reappraisal of the sexual territory."[18] Magazines, videos, books, and ezines now promote scarification rites, corsetry for both men and women, genital piercing, and other practices, alongside SM. Among the most prominent of these are *Body Play and Modern Primitives Quarterly*, a magazine that specializes in linking erotic practices to indigenous and spiritual rituals, and *Piercing Fans International Quarterly*, which has long had a strong SM readership. The practices have also been taken up by more traditional queer, fetish, and SM magazines, where references to body modification are now almost obligatory. *Taste of Latex,* for instance, a pro-sex magazine for the "gender bent," has published a consumers' guide to body modification as part of its exploration of "sex on the cutting edge." *Bad Attitude!,* a lesbian SM magazine, admiringly describes how International Ms. Leather is a woman who ends her workday by going home and cutting her wife.

In club scenes, the display of scarring and branding has created public events that, as Anthony Shelton puts it, "ooze from the seams of socially sanctioned mores and norms."[19] Cities like London, New York, Berlin, Amsterdam, Paris, Chicago, San Francisco, Seattle, Los Angeles, Boston, Washington, D.C., and Cleveland have seen grand displays of queer body art. By the late 1990s, for instance, Cleveland's annual Organ Grinder's Ball, an AIDS benefit, was conducting scarring and branding demonstrations to "introduce and entertain" its 1,200 fetishists with body modification. Another venue, London's Torture Garden, is at the forefront of fetish/body art clubs. Founded in 1990, it has institutionalized performances of erotic body art by establishing a membership list, creating video and photographic records, sponsoring performances by internationally known body artists, and eventually attracting monthly attendance of up to 800. While neither strictly a

straight nor gay club, Torture Garden published a manifesto to en-
courage erotic experiments and body modifications by "open-minded
sensualists of any age group, sexual orientation and gender," and to es-
tablish a strictly enforced dress code (cybersex, fetish, body art, SM,
fantasy, glamour). This dress code has been celebrated by fetish pho-
tographers, including Jeremy Cadaver and Alan Sivroni, in a number
of recent collections, which depict fetish divas, performance artists, les-
bian couples, cross dressers, corseted and pierced men, and others wear-
ing, watching, and performing public scarification, piercings,
brandings, and other body art rituals.

The performative aspects of public SM, homoerotic, and fetish body
modifications queer the body, marking it as a site of opposition to het-
eronormative pressures. In queer theorist Steven Epstein's words, the prac-
tices may be seen as intentionally pushing "the limits of liberal tolerance"
in relation to sexuality, suggesting anti-assimilationism and a "greater ap-
preciation for the fluidity of sexual expression."[20] Queer body mod sub-
culture has managed to establish a countercultural aesthetic and raise
public ire. Many of the practices celebrated in queer clubs and the queer
press have been perceived as especially extreme and self-stigmatizing. Not
only did the proliferation of genital piercing and body scarring by
women's SM groups in the Bay Area situate the practices in the crossfire
of the feminist sex debates, but queer body modification also raised
charges from the right of obscenity, perversion, and illness.[21]

Gay and lesbian body modifiers are especially vulnerable to accusa-
tions of pathology and perversion. The controversies surrounding Ron
Athey, the Spanner men, and Alan Oversby illustrate the social dis-
comfort raised by the linking of body modification and nonnormative
sexuality.[22] In 1994, a public scarification performed by gay, HIV pos-
itive performance artist Ron Athey caused widespread uproar. His per-
formance, which had been partly funded by the National Endowment
for the Arts, sparked a public discussion about queer performance art
and outrage from a number of both Republican and Democratic sena-
tors, and has been attributed as the cause of the 2 percent cut in fund-

ing the NEA received in its 1995 budget.[23] Critics charged that the performance was not only offensive and perverse, but also dangerous—not just to Athey and his performance partner, but more importantly, to the *audience,* who were seen to be somehow exposed to the AIDS virus by watching Athey puncture the body's envelope.[24]

The contagion imagined in Athey's performance is literal, but also exemplifies the social contagion feared in homoerotic body modification. Among leather people and queer body modifiers, the following two British cases are well-known examples. In a police operation called "Spanner," 16 gay, middle-aged men were arrested and prosecuted for engaging in consensual sadomasochistic acts. Even though in their defense the Spanner men argued that they were all consenting adults, the men were convicted of assault charges. These convictions were upheld in the appellate court, and some of the men were sentenced to prison terms of up to three years.[25] In their ruling (*R. v. Brown, Laskey, Lucas, Jaggard, and Carter*), the judges determined that:

> it is not in the public interest that people should try to cause, or should cause, each other actual bodily harm for no good reason. . . . Sado-masochistic homosexual activity cannot be regarded as conducive to the enhancement or enjoyment of family life or conducive to the welfare of society.[26]

As a result of Operation Spanner, a well-known body piercer and tattooist, Alan Oversby, was charged with a number of counts of causing bodily harm to his clients in his London clinic. While some of these charges were dropped when a judge ruled that body piercing for the purpose of decoration does not constitute an offense, Oversby was prosecuted for assault for piercing his lover's penis. The court found that decorative body modification was legal, but that body modification performed erotically was illegal.

Gay and SM communities have challenged the persecutions of the Spanner men, Alan Oversby, and Ron Athey as instances of censorship, and in doing so emphasize body modification's status and appeal as a

politicized "speech act." They have also defended body modification as a form of intimate pleasure. For some, piercing, scarring, and branding are new erotic possibilities in private encounters, as they were in Oversby's case. Not just for men, but for women, too, body modification is appealing as an intimate practice. In *Public Sex*, Pat Califia calls the use of scarifications in sex play a rising "obsession" within lesbian SM circles.[27] Cutting and piercing as a form of exploring meaningful, shared body ritual is also linked to the spiritualization of the SM scene and the growing popularity of neotribalism in queer communities. Modern primitivism has been linked to fetish and SM since its beginnings; by the 1990s, interest in non-Western rituals, images, and practices had altered the aesthetics and discourses of queer sex play, body practice, and adornment.[28] Leather and SM communities had long seen body practices "as a path to enlightenment and a transformation of the self," as tattoo historian and ethnographer Margo DeMello puts it; the embrace of non-Western forms of body modification reflects an attempt to create a bodily event that is meaningful for individual and community identity.[29]

The narratives I describe below of Dave, Matthew, Shawn, Bob, Mandy, and Raelyn reflect an awareness of the powerful forces of stigma and pathologization that impact the lives of queer body modifiers. They also reflect the influence of modern primitivism in shaping queer body modification. The body stories are articulated with an oppositional discourse that explicitly identifies body marking as a practice that politicizes and publicly queers the body. They link the "speech act" of nonnormative self-inscription with more affective, erotic, and ritualized experiences of desire, pain, and pleasure, and raise issues important to queer communities, such as passing and visibility, assimilation and the need to create separate, "safe" cultural spaces. Of course, like the "reclaiming" stories I presented in the previous chapter, these narratives are not singularly authoritative, but they articulate and perform the practices' subjective meanings. Both the sense of agency with which gay, lesbian, and transgendered body modifiers imbue their practices

and their political limitations reveal how body modifiers' practices are played out within bodies and spaces already marked by power relations.

DAVE

Dave is a 30-year-old, visually impaired social worker. Formerly married, he now lives alone in a relatively gay-friendly neighborhood of an East Coast city. He is active in local gay and transgendered politics as well as in the local body modification/fetish/SM scene. He describes himself as transgendered, has also contemplated surgery, and sometimes thinks of himself as transsexual in a preoperative stage. He currently considers his gender as having an "'it' sort of status," in his words, liminal or in-between, neither strictly male nor female. He uses a set of body modification technologies, including corsetry, piercing, and branding, to create a spectacularly anomalous body. For him, body modification demonstrates his nonnormative gender identity and expresses his socially taboo desires. He not only links the display of unconventional pleasure with gender bending, but also imbues it with political import.

Dave uses some body modifications as tools of exhibitionism and performance. Corsetry, which creates temporary modification of the figure and, potentially, permanent figure-shaping, is celebrated in some body modification circles as a practice for both men and women that can express a fetish orientation or that, for transgendered and transsexual men, can offer a non-surgical form of feminizing the body by creating an hourglass shape. Dave's use of corsetry is not disciplined enough to create permanent effects, which would require daily use and considerable effort. Rather, he uses corsetry as a tool of adornment that facilitates a temporary shift in self-representation and that, despite the stigma it brings, beautifies him and brings him attention.

> [The corset] definitely makes me feel beautiful and positive about myself. And I like costumes and I like to wear sexy clothes when I go out,

and I'll incorporate my art into my ensemble for the night . . . the brand, and then the piercings, and then the corset. . . . I will show them off when I can when I go out, and they have a lot of levels of meaning for me. And I like the attention, I would have to say, and I'll take the negative [attention].

Unlike the corset, some of Dave's modifications are permanent, such as the brandings with which he has inscribed his chest. These he has created in public performances that dramatize his unconventional embrace of pain/pleasure in the presence of others. In one case, he was branded at an event sponsored by a pro-sex women's bookstore that specializes in fetish, women's SM, and transgender books, films, and clothing and runs "how-to" classes on a variety of sex topics. This event took place in the bookstore after hours, because, as the owner explained, attempts to rent other space for body modification demonstrations were met with hostility and suspicion. The demonstration was attended by about 25 people, mostly bookstore regulars.

Dave's brand, the design of which he had sketched himself on a piece of paper, was created with 13 strikes of hot metal administered by a professional body modification artist, a lesbian woman who caters to queer communities. At first his skin reddened from the wounds it received; later, the nearly foot-long burn scarred, keloided, and browned in a permanent design that crosses the breadth of his chest. At the event, friends surrounded him, and in the audience were people he knew, with whom he felt a sense of "community," to use his term. Dave describes planning this event as an emotionally charged process. The presence of friends and his feeling of community bond eased a sense of personal vulnerability he felt. "[M]ost of these people knew me. . . . I did have friends around me . . . it's an accepting situation, and people understand where you're coming from. You may be a freak but you're a good freak."

Dave describes the branding ritual as a pleasurable, intimate, erotic drama. Raelyn, the woman who branded him, had warned the audience that if she held the metal on his skin too long, Dave's flesh and muscle

would melt under its heat. Within the room, "you could hear a pin drop. You could hear the moans or sighs." From Dave's point of view,

> You hear that torch. You see that flame. She's a really tough woman and she's going to brand you, and you feel very submissive at that moment. . . . There's so much anticipation. You don't know how you're going to react and you know it's going to be intense and then [there is] this submissiveness, which is erotic. . . . You want it to last longer, definitely, because then you know you can take it. And then the next one comes, and then each successive one can put you in this space. It's hard to describe except to say that it's warm and . . . erotic.

Body modification is employed and deployed as sexual and sexually transgressive in sex-positive settings and discourses. In this case, Dave's surrender to his female brander is highly masochistic. For Dave, branding represents a pronouncement of his transgressive pleasures, of "affirming" his SM and transgendered identity in front of a supportive community. As he put it, "I wanted to affirm myself I think at that time as a masochist and that was a way of doing it, and believing and thinking that was positive, that it's not something I ought not to be doing." Here, the brand and the affective performance celebrate the body, its violation, pain, pleasure, and intimacy, and put, in MacKendrick's words, "the entire surface of the body into play, multiplying polysensory possible pleasures."[30]

Male masochism, as Kaja Silverman has argued in *Male Subjectivity at the Margins,* is a violation of the dominant ideology that prescribes sexuality as other-directed, heterosexual, and procreative, in which the male is supposed to be assertive and even aggressive. Masochism subverts binary oppositions, including pleasure and pain, and strips sexuality of its functionality. It thus violates disciplinary sexuality as well as the gender "binarisms upon which [the heteronormative] regime depends."[31] For men, Silverman suggests that masochism is particularly perverse, as it might call "into question his identification with the [normatively] masculine position."[32]

Silverman argues that male masochism is "shattering" in its effects, but even as a "psychic strategy" of rebellion, this seems to be dependent upon its display or visibility. The male masochist

> *acts out* in an insistent and exaggerated way the basic conditions of cultural subjectivity, conditions that are normally disavowed; he *loudly* proclaims that his meaning comes to him from the Other, prostrates himself before the gaze even as he solicits it, exhibits his castration *for all to see,* and rebels in the sacrificial basis of the social contract.[33]

Of course, Dave's erotic event *literally inscribes* the body. With these marks, Dave has permanently inscribed symbols of his unordinary desires and pleasures. Spectacular marks worn on the body can signify meaning to others, and scarifications and brandings, as expressions of deviant pleasure, reveal the body as marginal and display its difference.[34] These marks are socially confrontational—brandings in particular recall images of abuse and slavery—and in this sense might be considered perverse "badges of subjection," as art historian David Mellor puts it.[35]

Inscribing the body with a permanent, visible mark of perversion is not a simply taxonomic matter, then, but rather is perceived as a socially contentious, ironic practice, an expression of defiance in the face of normalizing forces. Dave imbues body modification with, in his words, sexual "freedom" and the aim of "fighting for a larger set of rights," including his right to be deviantly pleasured in an ambiguous state of gender. Branding his body spectacularly suggests, through publicly asserting his gender-bent masochist identity, a claim of bodily self-ownership. As Dave puts it, "I ought to be able to do this. It may be a struggle but it's my choice and my body." Dave describes both his eroticized branding ritual and the mark it creates as rebellions against the contemporary "political climate." Because of social intolerance for sexual difference, Dave argues that "we're hanging by a thread from being a fascist society." In his view, Dave's decision to mark himself situates his body in a moral and political struggle over sex and gender difference and over what is, and what is not, allowed to be done with the body.

Further, Dave's body marking addresses another layer of stigma—he is not only transgendered and masochistic, but also disabled. Dave's social interaction often involves contending with stereotypes about his physical difference. "Someone came up to me and said, 'hey blind transvestite man.' That's what I am to him. I mean, those aren't bad things to be, in my opinion. See, being visually impaired, you're never going to be treated equal." As a disabled person, Dave senses that he is presumed to be asexual.

I have the same desires, the same fetishes, the same struggles as everyone else. And I think people are surprised that someone who happened to be visually impaired, because of a brain tumor that happened to start growing wildly, is into this stuff, or has these desires, or follows through with them.

Another possible effect of his branding, then, is an assertion of the visibility of his desire in the face of a social denial of the disabled sexual body. He displays his masochism and pleasure in the context of an assumed straight frigidity and impotence. For Dave, performing and transforming nonnormative embodiment engenders a sense of agency, in contrast to being passively defined as Other.

Queer body modifications can display symbols of nonnormative pleasure, eroticism, and gender on the body, but Dave manages his body modifications within a larger context of discrimination that shapes his choices. Dave's body-marking rituals are necessarily undertaken within the space of subculture, and in his broader life he moves between passing and revealing his marks and his transgendered identity. In the workplace, for instance, or at the supermarket, he is known neither as a body modifier nor a transgendered person. It is in the company of community that Dave wears his corset and performs his branding. Ideally, Dave would prefer to "show off" his brand and his other body modifications without ill consequences:

Are we fighting for the rights of straight people? Or are we fighting for a larger set of rights including a woman's right to go topless in public,

or . . . for showing off the branding? Because people could see that as sick. [For instance,] I was walking on a beach and I had my pierced nipples and a straight man said, "that's sick."

MATTHEW AND SHAWN

Queer body modification presses the issue of visibility that is already important for gay, lesbian, and transgendered people. In the following two narratives, Matthew and Shawn reject passing as an assimilationist strategy, and see body modification as a way to mark their lived experiences of alterity. Matthew is a 42-year-old male who describes himself as a "crone," a term that suggests an older, feminine, wise member of his community. A registered nurse who left medicine to start a body modification studio, he wears stretched earlobes, multiple piercings, brandings, cuttings, and tattoos. His partner, Shawn, is a younger gay man, a former graduate student in his late 20s, who has stretched his earlobes and had himself pierced and scarred. They share a house in a suburban neighborhood in New England, where their neighbors, they say, find them intriguing. They run a profitable body-piercing studio in the city, and employ a radical, explicitly queer discourse to describe their body projects. They share with Dave an understanding of body modification as a process of linking nonnormative desire and the visibly marginal body to unconventional identity.

Like Dave, Matthew depicts his body modification as an intimate, symbolic ritual in which nonnormative pleasures and desires are performed and witnessed. Matthew was branded on a stage (also by a lesbian body modification artist) at an SM club, a place where "people get whipped and paddled and spanked," and where the atmosphere is created by thumping music and disco lights. The crowd of leather and PVC-clad voyeurs was awed, he said, by what he called the "power coming off the stage." Matthew describes the experience as physically and spiritually "wonderful," one that symbolizes "claiming your body":

Awesome, yes, to the millionth power, spiritual to the billionth power. I wish I could put it, I could dance it better, I could paint it better, than just trying to explain what the experience is like. . . . When it came to the first strike, of course there was anxiety, but I love that anyway. I was gritting my teeth in preparation, and when I got struck . . . with each and everything there was an experience, I just felt lighter and lighter and lighter with each strike of the hot iron. . . . [Afterwards] I had to leave the group because I was getting so high that I couldn't deal with other people being around me right then. I needed to separate out and really go within myself and just float. And I would recommend it to you. Do it. Claim your body and claim your right to do something like this. It was wonderful.

Like Dave, Matthew describes the use of this painful/ pleasurable body technology as an intimate experience enhanced by the sociality of subcultural community. In this setting, Matthew experienced his pleasures as a form of self-authorship, as a way of embracing nonnormative sexuality and desire.

Being branded was an emotional experience. . . . I was surrounded with hands and spirits of love and faced with hot flame. In love. . . . It was important for me. It was my own. I'm "will." I'm "passion." . . . I've come to honor myself and love the gifts and appreciate the gifts, including my homosexuality, that were given to me.

Shawn, who was introduced to body modification by Matthew, shares this discourse of self-authorship and self-transformation accomplished through ritually, performatively exploring the body's affectivity. In his description of a scarification, Shawn also endows body modification with symbolic significance. He describes the pain as part of an important experience of self-transformation and self-affirmation:

It was all about transformation and overcoming fears. . . . When I met [Matthew] I had no piercings, wouldn't dream of doing something like a cutting. I always thought I was unable to handle pain. This [scarification] hurt, but [yet] it didn't. Obviously there was a physical sensation

of pain, but you're able to ride over that. Confront it first with the first feel of the scalpel and realize it's not that bad. And to put yourself in the spiritual space where you override the pain and actually find ecstasy and transformation in it. . . . My particular [scar] is based on creation. It's also on the feminine side of my body. Which was done to get me more in touch with feminine aspects of myself which had been repressed due to family, life experience.

For Shawn, this kind of self-transformation is not a matter of innocuous self-expression, but creates spectacular inscriptions that undermine its programmed masculinity. Gilles Deleuze describes the male masochist as leaving his social identity completely behind and "pass[ing] over into the 'enemy terrain' of femininity."[36] Similarly, Shawn claims that his markings—his scars, but also his stretched earlobes—are a kind of defiant self-exile. For him they reflect that he is "on the other side" of the sex and gender mainstream. Scarification and earlobe stretching create the kind of body that can no longer live a "normal," or normalized, life.

I'm on the other side . . . as a gay man. . . . This was getting to be a point of no return of this normal life, where as a teacher I was getting a Ph.D. in French literature. I taught in Paris. My intention coming to [an East Coast city] was to find a teaching job. . . . But the decision to go to 4-gauge [to larger and more permanent modifications] was the point of no return. These are big holes now. The decision to do that was crossing over a threshold which I'm now unable to go back over.

Matthew and Shawn understand themselves as set apart by their branded, colored, stretched, and scarred bodies as sexual minorities who are not simply gay, but who also refuse to assimilate and to give up pleasures that offend the mainstream. Matthew interprets his brands, tattoos, piercings, and scars as announcing his status as a "queer" and as "contrary," and Matthew and Shawn both describe body modification as a symbolic affront to mainstream authority. They appreciate their "outlandish" or "stigmatized" bodies as a subcultural affi-

lation that is, to quote sociologists Lee Monaghan and others, "learnt through a social process of becoming."[37]

> *MATTHEW:* Difference, especially under this free government—and I use that sarcastically—is discouraged. And that's one thing I love about [body modification]. It's in your face. I will be different. This is my body. I will have it my way . . . I'm queer among queers. Because there's a big movement in the gay community to assimilate. Assimilate shit. I'm a two spirit. Straight people are half. Gay people are two-spirited, equal part male and female. . . . I cannot divide the two equal halves that rise within my soul.
>
> *SHAWN:* Whenever I see these [scars and stretched earlobes] it's a reminder of my decision to take control of that and to say fuck this to the normal conventions of society. That whatever's in my future, these are coming with me.

For both Matthew and Shawn, body modifications are an embodied form of queer anti-assimilation, which seeks to mark symbolic distance from "conventional norms in all facets of life, not only the sexual," as Epstein puts it.[38] Because the faces and heads of both men are radically altered, there is little either could do to "pass." In subculture, as ethnographer Angus Vail points out, commitment is often expressed through risk, time, or effort expended, and as Shawn's "crossing over a threshold" suggests, there is an expression of commitment here in the aim of "fucking the normal conventions."[39] To this end, the marks are symbolically weighted by their visibility. They are also weighted by their signification of Otherness, as in the suggestion of "African" earlobes. The modern primitivist use of stretched earlobes and scars, reminiscent of the Maasai and other indigenous groups, explicitly aims for what Sandra Harding calls the "traitorous" identity, the rejection of (real, potential or perceived) insiderness in favor of a position of marginality (the ethnic Other).[40] In Matthew's words,

> Western societies oppress the most powerful—women, gays, lesbians. In the old ways these were honorary places to be, the vessels of life. So, I'm

not going to assimilate. One of the roles of the gay man is that of chaos, that of contraries, as some of the old tribes used call them. Contrary? Of course. To question the norms of the tribe at the time.

In this scenario, the oppression of tribal groups is symbolically linked to sexual and gender oppression. The critical message of these marks is affirmed not only through signaling "perversion" but also through signaling cultural oppression and ethnic contest.

Paradoxically, Matthew's narrative also reveals insecurity about the critical meaning of these inscriptions, since it is challenged by the spread of body modification throughout straight popular culture. Matthew regrets that the practice of branding has spread to straight men, some of whom began to use the practices as part of fraternity hazing rituals.

Too many of these fraternity meatheads are doing branding. And personally, I don't give a damn whether they're getting it done safely or not. They're not people I really can take a whole lot of time to care about. They're the ones that will become the politicians and the cops and the controllers.

For Matthew, the meaning of (heterosexual) fraternity brands is different from the meaning of queer brands. Ironically, there is an essentializing tone to Matthew's complaint about straight men (as in "meatheads"). But Matthew's resentment of straight male fraternities using branding also illustrates that the meaning of the practices are not fixed. Modifying the body, even painfully, is not dissonant with heterosexual and mainstream culture unless it is deployed as such. Fraternity brands are but one example (cosmetic surgery being another) of painful body practices undertaken within straight or mainstream culture that do not seem to challenge heteronormative notions of embodiment. Matthew's insistence on the difference between these groups of marked bodies reveals something of how the social context of body modifications influences their symbolic meanings.

BOB

Certain forms of body marking as they are employed in a Western context can be considered what Mellor calls "badges of subjection." Since brandings, scars, and other body marks are signified in the Western context as abject, an embrace of them is a form of self-stigmatization. While some radical feminists and mainstream journalists have taken this point as evidence that body modifiers are particularly pathological, many subcultures are drawn to displays that are understood to be provocative and spectacular.[41] In the case of gay body modifiers, choosing marks of "subjection" has particular significance given the historical pathologization of homosexuality.

The narrative of Bob, a divorced father of three in his 40s, illustrates how self-stigmatizing bodily inscription involves negotiating risks of pathologization and stigma. Bob's coming out as gay had been one of many significant life changes taking place in his middle age. Bob's scarification, in his words, marked "major life changes"—the end of his 20-year career as a mental health counselor and his move from the East Coast to California. To scar himself, as he describes, was a "step off the edge" and an embrace of "freedom for self-expression."

In the mental health environment, Bob says he had already felt a "freak" and an "outsider" because of his gay identity. During a time when he was considering a move to California, a place he thought to be more gay-friendly, a lesbian friend convinced him to do a scarification. This scarring, undertaken in an atmosphere something like that of Dave's branding, was photographed for the local newspaper.

> This is where I got into trouble. The [paper] wanted to cover that. I said ok, but I had no idea they were going to feature my cutting as prominently as they did. . . . I had just started a new job. . . . [When the article came out] the Department of Mental Health called my boss and wanted to know if I was sane enough. I was unprepared for the personal and professional hostility that came my way. It made me feel even more vulnerable and as an outsider.

The reaction he received in his workplace played a major role in his body modification experience. As he puts it, his colleagues and boss told him that cutting the body was a "symptom of a diseased mind." Like queer activist Pat Califia's suggestion that body modification is stigmatized primarily because of its association with gay and lesbian communities,[42] Bob interpreted the disgust leveled at him as part of the mental health profession's pathologization of sexual difference:

> It showed me the underbelly of the psychiatric institutions and how they would look at something like this. It's only been 20 years or so since being gay was taken out of DSM III. So now mutilation, we're still considered to be mentally ill to do this. . . . [I realized] this was not a place I was ever going to feel comfortable . . . I always felt like an outsider.

Bob's story does not suggest a stigma experienced passively, but rather suggests an active strategy of risk-taking. He compares himself with the fool of the tarot deck who embraces risk and takes the uncertain path. Rather than being surprised to find himself stigmatized, Bob admits he was exploring the risk inherent in scarifying himself:

> I had already been pierced and tattooed . . . one of my coworkers who was a very butch and out dyke who was tattooed and pierced was talking to me about scarification . . . I became intrigued with the idea. . . . I've always been a little bit odd and a little bit different. . . . I'm the fool, that's my personality. Always stepping off the edge, always ready for a new adventure. That's my main energy. I've become more and more the fool, risk taking, shocking, change . . .

Bob had known that scarring the body was "radical stuff," which articulated, in his mind, a sexual freedom that would provoke disapproval. Like Shawn's "fucking" the normal conventions, he sought out the shocking, spectacular effects of body modification in the face of perceived pressures to be straight or closeted. As Dave and Matthew needed witnesses to their queerness and their masochistic pleasures, Bob, a middle-class father and former husband but also an "outsider," needed to publicly express his decision to "step off the edge."

Every time I have marked my body it has marked a change in my life. . . .
I had already decided to go to California. I was already moving into an
arena where I was going to be freer. That event showed me what an odd
duck I was in [New England]. And I think that's when I decided to have
the scarring. It was one more step off the edge. . . . I need freedom to ex-
press myself. I'd never flourish, never flower [where I was]. I could not be
such a freak. I needed to get out of there. Freedom for self-expression . . .
I think my scarring came when that was really high on my mind.

Bob now manages a gay sex club, where the sexual underground cel-
ebrates his scars: "these things are prized," he claims, "where I work
now." While they were once marks of stigma, the scars have gained a
status as subversively charged, sexy adornments. But in contrast to
Shawn's perception of himself as taking a path that cannot be reversed,
Bob now perceives his marked body as negotiable, passable, and con-
cealable. This fluidity operates both through manipulating the social
context surrounding his body and through shaping the body's display:
"If I cover my body, people will not type me as somebody who would
be branded. I like that. I break some of the stereotypes. I enjoy fooling
people that way. I've got stuff all over my body but I can choose to not
let people know that."

Unlike Matthew and Shawn, who explicitly reject passing, Bob
claims what queer theorists have described as the "queer power to desta-
bilize space"[43] through performing his anomalous body in diverse
modes, through variously controlling and authorizing its display. De-
spite the social pressures that encourage closeting, he celebrates the
queer body's ability to move between, as Affrica Taylor puts it in "A
Queer Geography," "concealment and exposure, protection and im-
prisonment, vulnerability and subversion."[44] And as Eve Sedgwick ar-
gues in *Epistemology of the Closet,* the closet is no longer conceived only
as a space of repression. Because heteronormativity can never be fully
and permanently sustained, the closet can represent a space of danger,
a constant threat to the social order. Scars, brands, and other queered
marks render the body itself the site of this dangerous flux. Bob's nar-
rative suggests that there is some of this kind of agency involved in the

body's movement—between unmarked and marked, straight and queer, invisible and visible, the East Coast and California, the mental health profession and the gay sex club. Of course, it also exposes some of the larger pressures that provide the context for this movement, such as the deeply persistent stigma of pathologization that made his work life intolerable.

MANDY AND RAELYN

Images of "perversion" are constructed along dichotomies of inclusion and exclusion; of the normal, healthy, and familiar, and the abject and exotic. Mandy and Raelyn address the affirmation of marginal, subcultural community through thematizing body marking as a group ritual. The ritualization of body marking is modeled after or modified from indigenous traditions of body marking, and symbolically links Western SM women's "outsider" bodies with the bodies and body practices of ethnic Others.

For lesbian sadomasochists, body modification's violations of bodily integrity, explorations of pain/pleasure, and its link to SM groups must be understood partly in the context of the sex wars in the women's movement, which have polarized communities over the legitimacy of SM and women's porn. Mandy and Raelyn, whose SM group published some of the polemics in the sex debates, imagine body modification as a community-building ritual that affirms the creation of "safe space" for SM lesbian women. Mandy, whom I introduced in the previous chapter, describes herself as both a feminist and "survivor of political correctness" because of her dual interest in SM and body modification. Because for some feminists body scarring is perceived as a form of violence and self-oppression, Mandy suggested that she feels "ostracized" as a body modifier. For Mandy,

> The feminist movement [said that] women who were doing this sort of thing were perpetuating the patriarchy, and you're hurting yourself and you're just recapitulating your abuse that was done by men. . . . And be-

cause I did have piercings and I did have cuttings and I was into SM, I was very ostracized from a large portion of the lesbian community and the feminist community.

For SM lesbians who use body modification, the practices are sometimes understood as an escape from the "repressing and denying," in Mandy's words, the self-doubt and shame over marginal and ostracized sex practices. At one event, a "gathering of leatherdykes from all over," Mandy describes dozens of SM lesbians getting scarred with the same symbol, a spider web, to reflect their interconnectedness. Mandy understands being scarred in her SM community as a public "claiming" of belonging:

> It was specific to the SM world. It was a way of claiming that part of my life, saying that I really was a part of that community. . . . I think we live in a culture that treats sex in much the same way that pilgrims treated sex. That it's bad, it's evil, it's something that you should divorce yourself from and if you do it, it should be for procreation and it should be with your wife or husband.

Mandy suggests that, in the safety of community, the pain of cutting and other forms of body modification can be not only erotic, but also intimate, cathartic, and transformative. One illustration is a "grief ritual about AIDS" conducted by lesbian and gay body modifiers in Mandy's West Coast city, which invoked Native American and Tamil practices, among others. In this setting, Mandy performed a dance with a large number of feathers pierced into her skin.

> It was a very poignantly sad ritual. . . . We made a maze out of parts of the [AIDS] quilt. We walked through this maze and [people] came into a room and we were playing the Plague Mass and two people were chanting the names list and there were drummers and I had five dancers with me. I had these peacock feathers on strings all around my arms and down my back. That functioned not simply as costume, but as kind of a transinduction. To have that time to get into that altered state of consciousness

with the piercings. I find that when I do something like that, with temporary piercings, that there's a real opening.

Here, the opening of the body is charged with significance—it provokes abjection but also eroticism, an altered state of consciousness, and signifies a communal sharing of loss. As Mandy conceives the ritual, the AIDS quilt and the maze confine a safe but labyrinthine space for an oppressed community to grieve, while the dancing, pained figure embodies its empathies, its desire for an alternative state of consciousness, and its physical pain. "The very wild, grief stricken dance turns into a spiral dance which is a very life-giving dance. Bringing down of defenses so you can do some grieving and take another step there."

In Mandy's scenario, body modification symbolically facilitates the building of community and the affirmation of stigmatized identities and practices. Siimilarly, for Raelyn, a well-known body modification artist who has scarred, pierced, and branded hundreds of women, mostly from the lesbian SM community in the Bay Area, body modification constitutes a ritual that expresses the creation of safe space for women, especially SM lesbians, to affirm their marginalized sexual and bodily identities. The physically invasive nature of body modification can express, for Raelyn, an intimate merging of self with others.

> The exchange that happens is very intimate, very intense . . . it's so invasive, so personal, you're violating the integrity of the skin. Puncturing the envelope, you know. Stuff that is in you comes out, stuff that is out comes in. . . . The exchange between people is really great, really intimate. . . . It takes [your body] out of the realm of this dirty little secret. And you're bringing it into the light of day, or the light of understanding. . . . You might put some thought into it, and do something that means something to you. Ascribing meaning to things is a very powerful act.

The theme of body ritual as a community-building exercise reflects in part the modern primitivist character of much of the body modification subculture. Body modification ritual is often modeled after the

rituals of non-Westerners, who, according to Raelyn, enact ritual for "more spiritual purposes." In indigenous cultures, she argues, body modification reflects

> a relationship that [body modifiers] have with their community and their spiritual community. There's reference, there's a social and a spiritual support system, a net where they have prepared for this, they have support during it and then afterwards, and they've done it to commune.

Mandy and Raelyn perceive the "primitive" body not only as a space upon which individual identity can be inscribed, but also as a canvas for inscribing group affirmation and community belonging. The empowerment discourse surrounding body modification, as Matthew's narrative suggested earlier, relies on ideas that tribal communities are more egalitarian and tribal bodies less oppressed.

> *MANDY:* You go to other cultures, women have been in charge of these [body] ceremonies . . . we're taking that power back.

Here, body modification ritual affirms the marginal space of Otherness as safe, positive, and communal. It also, in "traitorous identity" fashion, links the stigmatized practices and identities of white women, gays, and lesbians to those of non-Western women and indigenous peoples in general. Here, the ethnic Other is implicitly understood to be oppressed and subjugated (like the sexual Other), but is also explicitly admired, emulated, and valorized as a symbolic redress to Western cultural problems.

AGENCY, POWER, AND QUEERLY MODIFIED BODIES

Queer body art practices are experienced as playful, sensual, creative, and artistic, but they also reflect tensions between political needs and constraints and suggest identifications that are symbolically saturated

with meanings. I see queer body projects as moves of agency, but limited agency, that employ contested notions of sex and gender, nation and ethnicity, and wellness/perversion.

The narratives through which Raelyn, Mandy, Bob, Shawn, Matthew, and Dave represent their practices suggest an understanding of the body as a contested space within a culture that not only prescribes heterosexuality and binary gender roles, but also labels them perverse for deviating from them. Their stories reflect diverse bodies and experiences, but they share a depiction of the queer body as a space of rebellion and self-actualization, and a perception of body technologies as potential practices of agency. Spectacular body marks are seen to reject assimilation, as well as to open up new possibilities for transforming the body and subjectivity. The narratives assert the political importance of such transformation and identification. Shawn's sense of "fucking the normal conventions" and Dave's of "fighting for a broader set of rights" describe strategies of opposition or dissent aimed at flagrant self-inscription. As Matthew suggests:

> What happens when people start taking charge of their own bodies, and daring not to look like the rest of the world? Changes begin to happen. There's a freedom, a sense of freedom. People beginning to see themselves as individuals and free. To question "they" and "them" and what "they" are trying to do for us.

Queer marks, by inscribing the body with badges celebrating prohibited pleasures and identities, underscore the contested nature of embodiment and sexuality. They fix queer identity literally onto the body as a gesture of rebellion. This fixing, to my mind, does not necessarily reiterate an essentialism in which same-sex desire is naturalized as an innate identity, nor does it aim for an assimilated gay identity. Rather, queer body marks rely on provocation as a symbolic resource for *un*fixing *heteronormative* inscriptions. In this spectacle, bodies are, to use Sedgwick's words, "unstably framed as objects of view."[45]

In eroticism, the body is never finished, always in the process of becoming through affective, symbolic, and phenomenological experience. While much mainstream body modification is anesthetized, affective experiences—pain, ecstasies, altered states of consciousness, intimacies—are celebrated in eroticized body marking. Queer body marking has been understood by researchers like James Myers as a "celebration of sexual potency" because it quite literally oozes with sensation, desire, and masochistic pleasure.[46] The body is made more phenomenologically present in this kind of body marking.[47] Of course, the pleasured embodiment sought here also violates heteronormative discipline. Paul Sweetman writes that in high-tech and medicalized culture, both straight and gay body modifiers embrace aspects of embodiment (bleeding, scarring, healing) normally under the control of experts. Thus they are, he argues, "reclaiming [their bodies] . . . in an act of deliberative, creative and non-utilitarian (self)penetration."[48] And as Karmen MacKendrick writes, this creativity can be radically perverse. She writes that "this is technology with none of the meanings of technology, visible, tangible, playful and perverse. . . . The body takes on the unnatural adaptability of a canvas, not to become a better subject nor a better machine, but to the ends of a poly-sensuous delight."[49]

However, despite the sensual and Dionysian imagery they raise, in my view the pleasures of these body modifications should not be considered only carefree exercises of *jouissance,* but also as part of a serious social contest. In Susan Bordo's words, this involves an

> arduous and *frequently frustrated* historical struggle to articulate and assert the value of their "difference" in the face dominant meanings— meanings which often offer a pedagogy directed at the reinforcement of feelings of inferiority, marginality, ugliness.[50]

The numerous practical difficulties raised by these forms of rebellion reflect such frustration. The "closet" status of the queer body is intensified by body marking. Bodily acts in relation to sexuality have often

been the focus of struggles over concealment and visibility, but now the body itself—its very skin—becomes a space of concealment and revelation. If writers like Sedgwick and Taylor are right, that the closet presents danger to heteronormativity because it implies the possible and unpredictable queering of all spaces, then body marking renders the body such a space of danger that threatens, whenever and wherever it is exposed or revealed, to render all bodies potentially queer. But even if negotiating disclosure and concealment can be radically destabilizing to the social order, there is still no way to secure the meanings of visibly queer bodies. Meaning depends also upon the observer's gaze, and can be recouped through disciplinary and commercializing forces.[51] When visible "mutilations" confront psychiatric and other normalizing forces, for example, the possibility persists that the social body will receive such confrontations not as ironic distortions but as straightforward confirmations of the pathology of sexual minorities, as Bob's narrative suggests.

The practices might also become popularized. As Matthew points out, the practices have become popular within straight male fraternities and other quite heteronormative groups. Of course, Matthew cannot prevent fraternities from using brands, nor ensure that his own body modifications are read in the manner he intends them. Pat Califia points out that there are many "men and women who wear leather or latex, tattoos, and body piercings, who are ignorant about or even hostile toward the SM community that created this look."[52] While subcultural body modification has been celebrated by some writers as inherently transgressive, its bodily rebellion is created partly by a subject's understanding of what is at stake in asserting it. The problem of relying on bodily representation for signifying queer political claims is that the meanings of its signs are contested, positioned in a shifting cultural landscape in which queer communities have only limited influence.

This cultural landscape is marked with the persistent effects of colonialism. The symbols and rituals body modifiers use as resources for exploring pleasure are embedded in this history. The modern primitivism

underlying these narratives reflects a strategy of traitorous identity, but also echoes historical imaginaries of the eroticized "primitive" body that are the legacy of colonial racism. Primitivism and homosexuality were linked by colonialism long before the rise of modern primitivism. Both were used in essentialist and contagion discourses that affirmed the white, European, heterosexual body as pure and healthy, while imagining the bodies of Others as physically and morally polluted by hypersexuality. Ironically, this new use of symbols of Otherness by white queers affirms not only gay body modifiers' outsiderness, but also the privileged position they *share* with all white Westerners and the dominant culture to define cultural and ethnic others. As I will elaborate in the next chapter, there are potentially distressing effects to the deployment of this kind of symbolic power. In the most successfully radical scenario, body modifiers' emphasis on irony and provocation might, in feminist ethnographer Kathy Ferguson's words, deconstruct and reconstruct "the cultural categories they encounter," exploiting the "slippage" between images and their meanings.[53] It is also possible that they could fail to wholly reconstruct them, and buttress some essentialist notions they seek to dismantle.

Not only the aesthetics, but also the pleasures of queer body marking are often deployed as "primitive" experiences of the body. Pat Califia considers the intriguing question of whether this might sometimes reflect a certain kind of erotophobia in which perverse pleasures are "justified" by references to tribal cultures. She senses that the popularity of modern primitivism within sexual subcultures is linked to a new post-AIDS wariness of more traditional SM sex practices and of radical sex in general. In an essay called "Modern Primitives, Latex Shamans, and Ritual S/M," originally published in *The Spectator* and *Skin Two,* Califia writes, "Shame is very hard to eliminate. I sometimes see it crop up when [modern primitivist] spirituality is used to rationalize or excuse S/M. . . . There is [now] a new hierarchy among perverts."[54] To her mind, some SM modern primitivism is used to "sanitize SM and make it sound like something more refined than a complex and unusual way to get off."[55] While Califia is probably guilty of romanticizing traditional SM as more authentic than its

more recent forms, she does point to the symbolic complexity of linking queerness and primitivity. She writes,

> I have to say that many white practionners of S/M magic are shameless in their misuse and romanticization of the rituals and mythologies of preindustrial societies. . . . It seems intellectually dishonest to pretend that hunter-and-gatherer cultures were great places to be queer and female. In our bitterness with the homophobia and sexism of twentieth Century America, it's too easy to fantasize that people with less technology were completely free of these ills. . . . [56]

Even as they are generated out of a queer position of oppression and discrimination, these fantasies also reflect, as Califia puts it, "our privileged place as well-fed, white Americans."[57] In addition to expanding the aesthetics of eroticism in Western sexuality, this body art engages in a symbolic contest that both utilizes primitivism's historical meanings and recirculates them in contemporary symbolic struggles over sexuality. Queer body modification employs symbols of perversion and ethnicity that have not surfaced freely in an open marketplace of symbols, but are wrested out of a complex system of privilege, power, and subjugation.

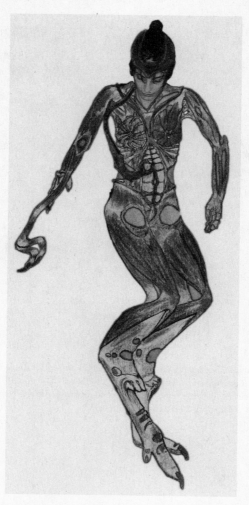

A concept sketch, overlaid on a photo, for *Psymbiote: Hybrid Apparatus for Social Interface,* a collaborative cybernetic performance suit being developed by Jesse Jarrell, Isa Gordon, and others. The drawing shows a possible final configuration of the suit, including a full body exoskeleton, arm extension, leg extensions based on the ostrich leg, and numerous built-in electronic and robotic elements. The project has been funded in part by an Arizona State University Institute for Studies in the Arts fellowship. Date: March 2001. Drawing credit: Jesse Jarrell.

This early promotional image for *Psymbiote* was used on posters for the lecture "On Generating A Cyborg Body" given by Isa Gordon and Jesse Jarrell. The image features the "pedi-palp," a grasping claw-like extension. A computer controlled gearbox is being constructed to drive the system. Date: April 2001. Photo credit: beki b.

This image of *Psymbiote* will be used on a series of performance cards that will be handed out during public appearances, as part of the project's mission to engender dialogue regarding the transformation of our bodies via technological enhancement. The titanium glove shown demonstrates the concept for the whole composite exoskeleton, with a fully articulated organic design, and sensor channels that will allow any joint to provide a data input signal for on-board computing needs. Additional body jewelry, latex, and hair design by Jesse Jarrell. Date: September 2002. Photo credit: DEvan Brown.

Isa Gordon as the host of the SIGGRAPH CyberFashion Show, which she instigated and organized. She wears the *Psymbiote* data input glove, a latex prototype shirt by Jesse Jarrell for Sinthetex Fetish Fashions, and a prop headset constructed for Gordon by DEvan Brown, from an early performance collaboration called *Ex Machina*. She holds a PDA in her hand, from which she reads a narrative of the history and philosophies of technological fashion trends, as the models walk the runway. Date: July 24, 2002. Photo credit: Kristen Massie.

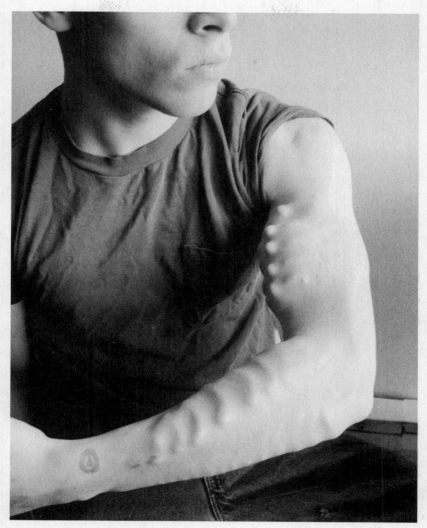

Jesse Jarrell, who's "bionic arm" is pictured here, began his collaboration with Steve Haworth in 1998. Haworth's pioneering practice in the field of implant modifications and Jarrell's interest in sculpting the body brought the two together. The bicep ribs of implant grade teflon were the first ever hand carved, irregular shaped subdermal implants. Jarrell followed this up by carving two additional arrays from implant grade silicone for his forearm. Jarrell himself does not consider the arm bionic as it does not have enhanced functionality, however he hopes this will change when science catches up with his imagination. Date: October 2001. Photo credit: Isa Gordon.

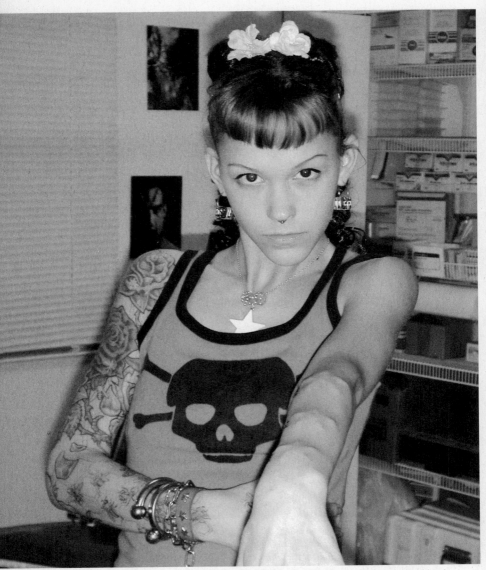

Although implant-grade silicone can be hand carved into almost any design imaginable, the most requested shape has been these five pointed stars designed specifically for implantation. Here, body-modification aficionado and model Lza shows off her new array of stars, carved by Jesse Jarrell and implanted by Steve Haworth. Date: May 2001. Photo credit: Steve Haworth.

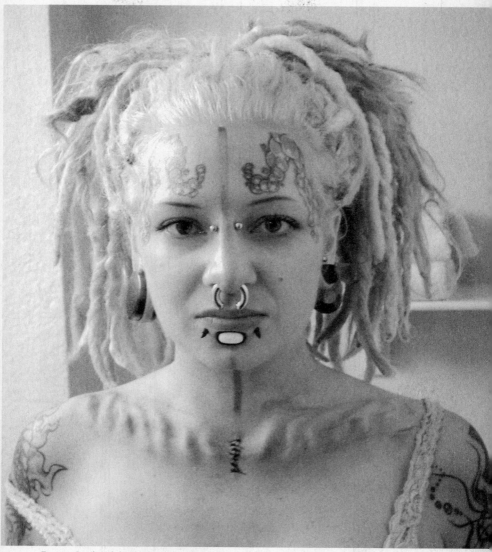

Frances Sand with her new subdermal implants. They were carved from silicone by Jesse Jarrell and implanted by Steve Haworth. The design was the result of a collaboration between the three. This image was taken shortly after the work was completed; note the sutures between the collar bones and the extensive visible bruising. Date: August 2001. Photo credit: Steve Haworth.

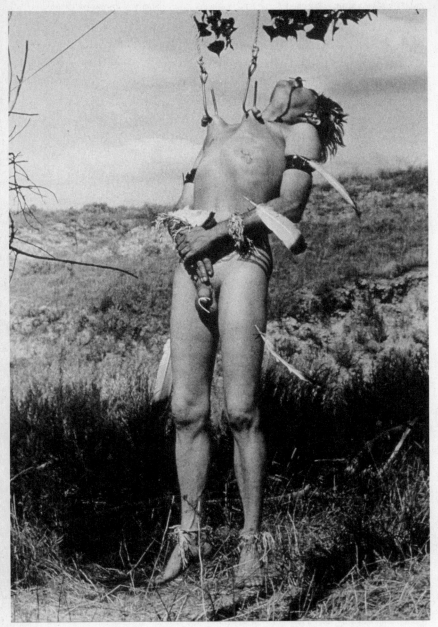

Caption: Fakir Musafar performing a flesh hanging, modeled after a Native American prac-
tice. Date: 2002. Photo credit: Charles Gatewood.

Fetish fashion model beki b wears a handmade latex top designed by Jesse Jarrell, and pierced in place with 10-gauge flesh hooks. The possibilities of a transformative tattoo lifestyle captured beki's imagination in her late teens. She began to take on the likeness of a cat through leopard spot tattoos in 1996, on her 18th birthday. She continues to add arrays of spots, using them to highlight the natural curves of her body. Date: October 1998. Photo credit: Steve Haworth.

CHAPTER 4

MODERN PRIMITIVISM AND THE DEPLOYMENT OF THE OTHER

THE MIMESIS OF TRIBAL BODILY PRACTICES AND STYLES IN CONTEMPORARY Western culture, seen most overtly in the "modern primitivist" movement, plays on the modern West's long-held ambivalence toward indigenous bodies and cultures. The semiotic charge of modern primitivism depends upon the Othered status of foreign bodies and body practices in the Western imagination. As Alphonso Lingus describes in *Foreign Bodies,* many indigenous body modification practices, including African forms of scarification and lipstretching, Meso-American teeth filing, Sara lip plates, Burmese neck rings, head shaping, Chinese foot binding, and New Guinean nose rings, are viewed by Westerners with a kind of repulsed fascination. He writes,

> They paint, puncture, tattoo, scarify, cicatrize, circumcise, subincise themselves. They use their own flesh as so much material at hand for—what? We hardly know how to characterize it—Art? Inscription? Sign-language? . . . All that excites some dark dregs of lechery and cruelty in us, holding our eyes fixed with repugnance and lust.[1]

As offensive as this description is, Lingus uses it to show how, in Western and colonial representations, indigenous bodies have been exoticized and fetishized to draw symbolic boundaries between "us" and "Others." Bodily differences, including culturally specific body modifications as well as bodily colors, textures, and shapes, have been unconsciously viewed as well as purposively framed as expressions of some deep ontological difference between Westerners and those constructed as "exotic ethnics," to use Rosemarie Garland Thompson's term.[2] This dualist perspective has consistently presented those of other cultures as irretrievably mired in the needs and desires of the body, while according Westerners a "privileged state of disembodiment," as Thompson puts it in her edited volume *Freakery: Cultural Spectacles of the Extraordinary Body*.[3] Seen as somehow more deeply embodied, indigenous bodies have been framed as simultaneously abject and appealing, wholly Other and more desiring and desired.

A number of scholars have recently described how these modern imaginaries of primitivism were exemplified in the nineteenth- and early twentieth-century freak shows and ethnological exhibits.[4] These exhibits created a public theater for the discursive production of the "primitive" as exceptional and anomalous. As Thompson, Anne Fausto-Sterling, Bernth Lindfors, Christopher Vaughn, and others have described, by the end of the nineteenth century ethnological show business had become a primary form of mass entertainment for Westerners. In addition to displaying singular bodies that were visually different, such as those created by birth anomalies, freak shows constructed racial and ethnic boundaries of difference.[5] Among the most famous instances is that of the "Hottentot Venus," the African San woman who was displayed in the early nineteenth century in a cage outside Piccadilly Circus in London. Sara, as she was called, was "displayed, treated, and conceptualized as little better than an animal" and repeatedly compared to an orangutan, as Lindfors puts it.[6] Her story was echoed in many other exhibits across cities in Europe and the United States in which foreign bodies, especially women's bodies, were

represented not only as essentially different than Western ones, but as uncultured, savage, wild, sexually unrestrained, and dangerous.[7] As Fausto-Sterling describes, some of these bodies "entered into the scientific accounting of race and gender" after their deaths by being medically dissected and analyzed for evidence of their lower evolutionary status.[8] Revealingly, the French scientist Georges Cuvier's first act after taking Sara's corpse, which had been handed over to him to "benefit" his work at the French Museum of Natural History, was to "find and describe her hidden vaginal appendages," which were then described at length, suggesting the voyeurism of the scientific attempt to catalogue foreign women's sexuality.[9] (Shockingly, up until the early 1980s, Sara's body continued to be displayed in another Paris museum, the Musee de l'Homme, with "her preserved brain and a wax mold of her genitalia . . . stored in one of the museum's back rooms."[10])

The viewing of "exotic" bodies as freaks is highly political. In Thompson's words, "culture maps its concerns upon [foreign bodies] as meditations on individual and national values, identity, and direction."[11] Bernth Lindfors points out that in Europe, colonial interests were buttressed by such displays of Africans as "freaks and savages." He also notes that the construction of the cultural and racial image of the freak "also served the vested interests of those in the New World."[12] An example of such spectacular racism in the United States was the "Igorot Village," constructed as part of the 1904 World's Fair in St. Louis. The Igorots, who had already been introduced to American readers of *National Geographic* in its photographs of bare-breasted indigenous women of the Phillipines, were represented in advertisements, newspapers, and cartoons with thick lips, wearing body piercings, wielding clubs, and sacrificing dogs. With the Igorot Village by far the most popular exhibit at the fair, thousands of Americans watched the Igorots eating, dancing, sitting about, and doing any other tasks they could undertake in their simulated village. Such exhibits' "conscious and exaggerated presentation of difference," as Christopher Vaughan describes, provided a similar kind of ethnological spectacle and entertainment to

the Hottentot examples, while also buttressing America's particular colonial policies both outside and within its borders. Demarcating a bio-cultural line between citizens and savages and differentiating "as starkly as possible" Filipinos, Cubans, Puerto Ricans, and Hawaiians from European-Americans, as Vaughn describes,

> served to bolster claims that "natives" were incapable of self-government and thus required American supervision. The civilizing mission, a standard justification for establishing control over—and expanding onto the lands of—non-European Others . . . remained the primary moral stance favoring the colonial project.[13]

But ironically, even while they were being treated so negatively by Western colonialism, non-Western bodies were also being valorized as "a source of excitement and inspiration" for European and Euro-American artists, writers, travellers, expatriots, scholars, and others, as art historian and postcolonial theorist Deborah Root describes.[14] Since the eighteenth century, Root writes in *Cannibal Culture,* the colonies were not only viewed as administrative and public relations problems for colonial powers, but also seen as sites of adventure, as a backdrop for Westerners' fantasies of individualism, aristocratic power, and erotic freedom. Indigenous cultures were seen to provide "aesthetic titillation" in the form of their body practices, rituals, foods, and social institutions. Even as colonized cultures were being destroyed with increasing brutality, Europeans and white Americans romanticized them as closer to nature, more communal, and more sexually pleasured—notions of the "primitive" that continue to persist in the Western imagination.[15] As Aidan Campbell writes of the contemporary West in *Western Primitivism: African Ethnicity,*

> Whereas humanity used to be equated with civilization, that is, with independence from nature, the meaning of humanity has transformed into proximity to nature. Indeed, many of the problems currently associated with society—wars, corruption, repression, pollution—are ascribed to the fact that humanity has lost contact with nature. . . . It is

[now] often claimed that primitive societies are the really civilized ones. . . . Only the ethnic is held to be genuinely human nowadays.[16]

Such nostalgia has existed since at least the nineteenth century, when Europeans and Americans were already regretting the loss of the very cultures it was their mission to assimilate and "modernize." As Root puts it, the notions of progress used to buttress anti-aboriginal policies also "came to be coupled with a nostalgia for so-called primitive life, which was believed to exist in the state of nature, without rules or constraints."[17] The supposed authenticity of "primitive" life was seen in direct contrast to the deadness of industrialized Europe, with its linear notions of technological advancement and scientific certainty.[18] Root argues, however, that this nostalgia was largely aesthetic, finding expression in galleries, private art collections, museums, and tourism, and did not translate into progressive attitudes or policies toward indigenous groups. In her estimation, most Westerners saw traditional societies

as a set of signs that . . . ultimately referred to and reinforced the hegemony of the West. Westerners with rarified tastes wanted the fascinating art forms, the foods, and the amusingly costumed people to remain available for various forms of consumption. The nostalgia for the old ways was, and in many respects continues to be, no more than regret for the loss of aesthetic styles, not for the loss of the social, political, economic and ceremonial institutions on which the aesthetic traditions were dependent and through which meaning was achieved.[19]

These problems persist, as Root and others have argued. As foreignness continues to be fetishized as exotic, policies toward indigenous groups as well as immigrants have continued to be variously ambivalent and egregious. And as Gargi Bhattacharyya points out, "some foreigners are [still] too close to home to be fancyable," and so while the "exotic" has been fetishized, it has often been constructed as wholly unfamiliar rather than as making any "strict reference to nationality or country of origin."[20]

Modern primitivism both confounds and plays on historically produced borders between so-called primitive and civilized bodies. The modern primitivist movement self-consciously rejects the deeply ethnocentric tradition of the West, and instead extends nostalgic views of indigenous cultures as more authentic, natural, and communal. It does this partly as an extension of modernity's longstanding unease with its own technological advances, ecological destruction, and cultural homogenization, generating images of primitivism that appear to offer alternative, more traditionally rooted modes of negotiating nature and the body. At the same time, the movement also employs very contemporary, postmodern notions of identity, culture, and the body, presenting each as malleable and elective. Refusing the role of the anthropologist, art collector, or museum curator as interlocutor or expert, modern primitivism presents tribal body practices—including many of the very ones Lingus describes as so abject—as accessible resources for individual self-invention and political and artistic expression. In exploring these, modern primitives create a new kind of spectacle that shifts representations of primitivism from indigenous bodies onto the bodies of largely white, urban Westerners. In so doing, they preserve the historically imagined exceptionality and anomaly of indigenous bodies and cultures while promoting new notions of identity for postmodern subjects.

PRIMITIVISM IN POSTMODERNITY

The documentary film *Dances Sacred and Profane* depicts two white, middle-aged men simulating Native American rituals, the sun dance and the O-Kee-Pa. By an isolated tree on a vast plain of the Thunder Basin National Grasslands in Wyoming, Fakir Musafar and Jim Ward, both body mod pioneers, are filmed preparing for the rituals by cutting rope and wood and adorning the rope with bells and feathers. They paint two red circles on their chests and tie bracelets of sage around each other's wrists. The men stand, one with arms at his waist, the other

with arms to the sky, in prayer or meditation. Musafar describes the first ceremony:

> Jim's role in the first part of the sun dance that we'll do will be as a pledger, as a sun dancer, we'll be sun dancers together. Both of our chests will be pierced, and attached with a rope to this cottonwood tree, and we'll dance against the piercings until we break the skin free.[21]

They hold eagle feathers in their mouths. Bells announce the movement of the ropes pulling at the pierced skin. They rip at the flesh for hours until they break free. Later, Musafar disrobes. Eagle feathers are pinned to his legs, arms and forearms in preparation for a flesh hanging. "If anything goes wrong," says Musafar, "we'll be in a bad way. But we don't think about that because the Great White Spirit is in charge of this ceremony, and if we're lucky we'll meet the Great White Spirit." After being wound up into the tree from a branch, he hangs from ropes tied to steel hooks inserted through the flesh.

The image of Musafar performing the flesh hanging is famous in the body mod subculture, especially among those who call themselves "modern primitives." Modern primitives simulate the practices of a number of indigenous or tribal cultures and represent those cultures on the Western body. They affiliate the body with tribal cultures through such modifications as stretched earlobes, blackwork tattoos, bones worn through the nose, feathers or wood through the skin, earlobe plugs, and through miming tribal rituals.[22] Modern primitives have enacted the Native American O-Kee-Pa, the Tamil Hindu kavadi ritual (wearing a frame of spears which poke the body), the Sadhu ball dancing ritual (dancing with weighty items sewn into the skin), and many other indigenous practices. They have ritualized body modification using props such as sage, cedar, grass, smoke, incense, feathers, bones, stones, thorns, spears, and fire, and use prayer, meditation, ritual bathing, dancing, and drumming. The modern primitivist lexicon includes vision quests, spirits, spirit guides, totems, and talismans. In

the book *Modern Primitives* and in body modification magazines, tribal cultures are celebrated and revered. In Boston, San Francisco, New York, Los Angeles, and elsewhere, body modification studios with names like Nomads, Tribal Ways, and Urban Aboriginals advertise themselves as offering "ritual settings" for the production of tribal body art and display cultural artifacts and photographs of indigenous people.[23] In one such place, for instance, a tribal body modification studio in New York, I was shown dozens of cultural artifacts, including Inuit lip plates and Borneo earplugs. One of the shop's owners also showed me a snapshot of a "real Sadhu," in his words, which was pinned on the wall. Himself wearing stretched earlobes, dreadlocks, tattoos, and a bone through his septum, he spoke, as did nearly all of my interviewees, of tribal peoples with awe and reverence.

In large part white urbanites enacting the traditional body practices of native cultures, modern primitives invert hierarchies of ethnicity by valorizing the "primitive" as politically, culturally, and spiritually superior.[24] The sensibility toward, and the discursive production of, cultural Others in modern primitivism is thus highly nostalgic. Following a long historical tradition of nostalgia toward non-Western cultures, modern primitives valorize tribal societies as more spiritual, communal, and environmentally sensitive than their own. The movement, though, presents a new way of establishing cultural affiliation. Through the material and somatic space of the body, modern primitives aim to express solidarity with indigenous cultures; educate others about them; foster a more "natural," communal, and spiritual view of the body among Westerners; and articulate cultural dissent.

Modern primitives also, according to Musafar, embrace tribal groups partly in order to represent a lifestyle "that's looked upon with disdain or doubt by most of the mainstream society."[25] Musafar, a white Californian who took his name from a nineteenth-century Iranian Sufi, has said that as a bisexual, he was motivated by an affinity he felt for other oppressed groups, including gay men and Native Americans, to explore indigenous body rituals.[26] His magazine, *Body Play and*

Modern Primitives Quarterly (BP&MPQ), links the gender-bending and erotic interests of gay men and women, transvestites, and other "erotic pioneers" with the tribal body practices of Mayans, Nubians, Ibitoe, Mandans, Sioux, Sadhus, and other indigenous groups.[27] The practices of indigenous cultures are presented as appealing not only for sexual minorities, but for "whole groups of people [who] socially, are alienated," and who want to "re-empower" themselves.[28]

As a self-defined movement, modern primitivism has evolved from a small subset of SM culture in the late 1970s and 1980s to a counter-cultural aesthetic embraced by many. Through the wildly popular book *Modern Primitives,* magazines like *BP&MPQ, Piercing Fans International Quarterly (PFIQ)*, and *In the Flesh (ITF)*, films, and tribal-style body piercing and branding schools, modern primitivism has spread its message of cultural affiliation. It is difficult to quantify its popularity, partly because its influence has spread to body modifiers of varying styles and levels of commitment, but its view of body art as reflecting what are seen as the "pre-technological" values of indigenous peoples has saturated the body art movement. Modern primitivism's tribal aesthetic has also become one of the most fashionalized of contemporary body arts. It has contributed to the development of middle-class tattoo culture, and is also now a primary feature of alternative fashion for youth. It has been celebrated on the catwalk, at Lollapolooza and other alternative music venues, and at major museum exhibitions, including The American Museum of Natural History.

Modern primitivism has been highly controversial. Pointing to what they see as its superficiality and narcissism, a number of writers have criticized modern primitivism as inauthentic. Margo DeMello describes it as a form of elitism in contemporary tattoo culture, where its aesthetic is explicitly middle-class, highbrow, and distanced from tattoos' working-class, biker, and sailor associations.[29] While DeMello's criticisms are directly largely at the class problems modern primitivism poses within Western tattoo communities, she also points out that modern primitivist practices aren't really "tribal." Instead, she argues,

modern primitivism deploys the "exotic" partly to rehabilitate the tattoo from its working-class associations. She writes,

> It is my position that the creation of this *new past* sanctions a cultural tradition that was once seen as low class and, through the essentialist language of primitivism, naturalizes it. The rationale is that because "all primitive societies" practiced tattooing and piercing, it is only natural that we should, too.[30]

Similarly, Aidan Campbell describes modern primitivism as an insincere way of making life in the social margins seem more attractive by appropriating non-Western cultural rites. He emphasizes how modern primitives are not really enacting traditional ways of life because they do not abandon their own Western cultural practices or lifestyles.[31] Marianna Torgovnick also emphasizes how modern primitivist rites are dissimilar to those used in "traditional societies." She points out that modern primitives employ practices that are reportedly rare outside Western subculture (such as genital piercings). She also criticizes modern primitivism for rendering private, erotic, and marginal practices that were traditionally employed as socially sanctioned, public rites of passage.[32]

But as Campbell and DeMello both recognize, modern primitives themselves are often unconcerned with authenticity, and instead see themselves as capable of modifying traditional practices to fit their own needs. For many body modifiers, modern primitivism operates as a political statement, as an expression of cultural dissent. They describe modern primitivism as a way to promote critical thinking about issues such as ecology, cultural boundaries, sexuality, bodily ownership, and community. As I see it, though, modern primitivism is generally less committed to a coherent political message than to challenging boundaries of identity. I describe in this chapter how modern primitives produce what Mike Featherstone calls "category turmoil," which challenges the necessity and fixity of all forms of identity.[33]

But while modern primitivism is rebellious, it also as an exercise of Western privilege. Much more worrisome than any dissimilarity be-

tween contemporary and traditional rites is that modern primitivism can be seen as a legacy of colonialism, as Christian Kleese and Valerie Eubanks, among others, have argued. The production of images of the cultural Other through the body asserts radical alterity without shedding the Western binary understanding of cultural difference. As in earlier historical attempts to mimic or appropriate the ethnic Other, modern primitivism can be seen to produce an ethnic difference that is idealized and essentialized, and raises ethical issues that even some body modifiers have begun to debate. These include those raised in popular and high culture, responses to body art that are largely inspired by the modern primitivism movement, including in fashion and museum culture. These representations of modern primitivism, to my mind, play out some of the movement's most uneasy politics.

SUBVERSIVE IDENTITIES

Body art is presented in modern primitivist discourse partly as an opportunity to educate others about what they perceive to be indigenous values. Along with the "tribe," the shaman is part of the modern primitivist lexicon. The role of the shaman, the tribal wise person or educator, is applied to body modification gurus like Musafar and Ward, but also to professional body modification artists working in tattoo parlors, body piercing studios, and other body art venues. Andrew, for instance, a white 23-year-old body piercer, modern primitive, and cyberpunk, who has worked in several cities in the United States and Canada, describes how he aims to use body modification shamanistically. While performing body piercing, scarification, branding, and other practices on paying clients, he urges them to be critical and to "use their intelligence" by emulating the more "natural" way of life of tribal cultures. As Andrew puts it,

> You go to other cultures, they live on nuts, berries, the earth. If they behaved anything like us—I mean, we piss in the kitchen all the time, so

to speak. We've gone from wagons to nuclear power, space travel, in vitro fertilization in the last hundred years. Nuclear waste.

By expressing solidarity with other cultures, modern primitivism is perceived by adherents to confront symbolically the repressive and destructive aspects of Western societies.

Blake, a white modern primitive in his 30s who wears dreadlocks, stretched earlobes, blackwork and full-sleeve tattoos, scars, burns, facial piercings, and a bone through his septum, has written about how he is educating people about global cultures. For several years he co-ran a body-piercing studio that displays a sizable collection of indigenous cultural artifacts. Blake explains that modern primitives are "helping modern people discover ancient rituals":

> My primary objective is to educate people so that there is a sense of global cultural identity, to see that we're all connected as human beings. It doesn't matter how we look and what our skin color is—we're all part of the same tribe. When we learn to respect each other enough, then that makes us more understanding about the people we're destroying in the rain forest![34]

Concern for the fate of indigenous cultures is an important part of modern primitivist discourse. Marsha, a white 28-year-old body piercer who wears stretched earlobes, full-sleeve arm tattoos, and a number of facial and body piercings, argues that tribal-inspired body art is a way of valuing and preserving those cultures which are being "killed" by Westernization. She considers primitivist body art as part of a "youth movement" to revive non-Western values. For her, ritualized body art can be an event that signifies a rethinking of the relationships between the West and indigenous cultures. "No matter how many people do it," she argues, "it will be an act of changing consciousness."

But modern primitivism is not only focused on the fate of tribal groups. Rather, primitivism is seen as a way of life, a set of values and relationships that can be experienced and signified even within and upon

the Western body. Primitivism is perceived as accessible to modern individuals through "living exclusively through the body," as Andrew puts it. Andrew's body modifications, which are radical enough that they have earned him renown even within the subculture, include scars on the cheeks and forehead, a full back tattoo, highly keloided scars on the neck, and a subincision, which is a partial splitting of the penis that he modeled after an aboriginal practice. These modifications represent for him a liberation of his bodily "urges." According to him, "living through the body" is a "right" that has been denied Westerners. "Every other culture knows [that] and we don't," he argues. "That is what is steeped in their ritual and not in ours." Andrew views tribal rites of passage as more "natural," because they allow for moments of pain, release, marking, and healing, which he sees as important aspects of the self's relationship with the body. He also points to indigenous cultures' different understanding of the relationship between the individual body and the group. In his words,

> Every culture has a rite of passage that involves a moment of pain, a length of time of healing and then the talisman to show for the experience that the society and the individual collectively recognize as that journey and where you are now. We don't have any of that.

The communal rituals of indigenous cultures are seen to recognize the body as a significant resource for social and spiritual life.[35]

In valorizing tribal cultures, modern primitivism circulates a countercultural "ethic," to use social theorist Michel Maffesoli's term, a notion of a "different morality" developed in lifestyle politics.[36] *BP&MPQ*, for example, suggests that tribal cultures have more "acceptable values" than Westerners, and that through emulating them, modern primitives express "radical viewpoints and behaviors." "Their behavior will reflect treasured values of other cultures—like Native American, African, or Asian. They'll be pagans or shamans, "greens" and/or vegetarians."[37]

In addition to environmental and spiritual issues, modern primitivist discourse also addresses women's rights and sexuality, arguing that

tribal cultures were often more egalitarian and less sexually oppressed. For example, Mark, who was introduced in the previous chapter, argues that: "[Western societies] oppress the most powerful—women, gays, lesbians. In the old ways these were honorary places to be, the vessels of life." Similarly, LamarVan Dyke, a women's body modification artist, argued in *Stigmata* thus:

> I think in some tribal situations women have been in charge of those particular [scarification] ceremonies and have been in charge of taking your power and making marks on your body to mark that this has happened to you. But in this society that we live in, that power was taken away from women.[38]

But modern primitives do not literally recreate indigenous rituals. Campbell calls the movement "a genre blurring of the abandoned and the untried."[39] Modern primitivism suggests a "decentering of habitual categories, a form of playing with cultural disorder" that Featherstone describes as characteristic of the postmodern.[40] Modern primitivism provokes a sense of instability and disruption—that cultural borders have become unstable and that culture, to put it in Featherstone's terms, "has become decentered, that there is an absence of coherence and unity."[41] Despite the earnestness of its discourse, then, modern primitivism primarily operates not as a practice of mimicry but rather as one of queering identity. Neotribal bodies gain meaning as they are deployed in contrast to the perceived "deadness" and oppression of the bodies of Western culture.[42] Producing signs of primitivism on the body asserts conflict and promotes a sense of self-control and self-invention. According to *Modern Primitives,*

> What is implied by the revival of "modern primitive" activities is the desire for, and the dream of, a more ideal society. Amidst an almost universal feeling of powerlessness to "change the world," individuals are changing what they do have power over: their own bodies.[43]

Modern Primitives describes how individuals can create some form of social change, "however inexplicable," through creating visible bodily

changes, while also asserting a radical message of self-invention.[44] The practices of modern primitivism are clearly meant to be symbolic. They might signify, for instance, that "I'm not even in this culture anymore," as Andrew puts it. Andrew aims for a traitorous identity, in Sandra Harding's sense of the term.[45] He symbolically aligns himself with the cultural Other as a way to question the meanings of Western identity.

Modern primitivism does not replace, then, but rather *displaces* Western cultural identity and creates a subversive subcultural style. Rather than establishing believable "tribal" identities and communities, the gestures of modern primitivism call into question the fixity of identity as such. The white American or European who wears stretched earlobes, facial scars, or bones in her nose creates visual and symbolic "noise,"[46] to use Dick Hebdige's term. As Hebdige pointed out in his writing on British punks, subcultural styles have "much in common with the radical collage aesthetics of surrealism."[47] Stretched earlobes and dreadlocks against white skin, facial scars and Western clothing, feathers and corsets, body piercings and flesh hangings, render the position of the speaking subject disrupted and chaotic. The figure of the "modern primitive" or the "urban aboriginal" is a ludicrous, contrary figure that acknowledges "a sense of absurdity," as Simon Gottschalk puts it, but its ludicrousness and contrariness are also the source of its subversive power.[48]

Modern primitivism can thus be seen as a subversive subcultural performance, although not an unproblematic one. In modern primitivism, "modern" and "primitive" signs are represented together, but the distinguishing differences are preserved, "strategically reconstituted in a war of position."[49] The gaps, the oxymorons, and anachronisms are the places where subcultural bodies disrupt. At its most radical, the neotribal body might testify to the permeability of the Western subject's boundaries, challenging the efficacy and necessity of fixed identities. "Primitivism" in the Western imagination implies bodily openness and boundlessness, as in the expression "go primitive."[50] Along with its negative connotations, it implies for Westerners permeability, sensuality, lawlessness, and freedom. Modern primitivism encourages bodily

experimentation and multiple cultural affiliations. They might identify themselves as queer, bisexual, straight, transgendered, modern primitivist, pagan, vegan, androgynous, sex radical, leatherdyke, green, cyberpunk, or freak, or some combination of these. Primitivism is seen as a state of being that accommodates any "urge," to use Andrew's term, for bodily experience or adornment, because it is seen to be rooted in natural, cosmic, or universal bodily desires. It can merge simulated Native American, African, Asian, and other practices and rituals with high-tech practices. The modern primitive is not bound by traditional rules, nor by Western prohibitions. She is, rather, a child of the universe, a cultural wanderer full of contradictions.

For instance, *BP&MPQ* describes Idexa, a white female worker at an all-female tattoo shop, as a queer, androgynous "radical primitive she/boy."[51] Idexa wears Borneo blackwork tattoos, a metal spike through her septum, and on her shaved head, lizard tattoos, which she describes as representing her personal "totem." As a young tomboy, Idexa often fashioned herself as "an Indian brave, an Apache warrior" who could "fight hard and run fast," who found rigid conventional gender roles limiting. She later turned to modern primitivism to express that she is, in her words, "a part of this culture but I don't believe in it."[52] She is pictured tattooed and naked, posing in one photo holding a long spear. Her Borneo "magical" blackwork tattoos are described as "empowering her queerness." They signify, according to *BP&MPQ,* "parthenogenesis, double sexedness and self-penetration" and visually establish that "her true gender residence [is] somewhere between the poles."[53] Here, primitivism refers to a fluid gender identity, a marginality with respect to conventional Western culture, and an alternative, more empowered sense of embodiment. Her narrative reflects the view popular in modern primitivism that indigenous cultures are more open to gender differences. But her mimicry of the androgynous Native American warrior and the tattooed Pacific Islander is not literal. Rather, Idexa's body dramatically expresses the ironic nature of subcultural performance. In Peggy Phelan's words, the performance's meaning "emerges in the failure of the body to express

being fully and the failure of the signifier to convey meaning fully."[54] The gap created between the performer and the performance—between Idexa's status as a Westerner and genetic female and her presentation as an androgynous, tribal foreigner—is what renders identity visibly un-fixed. As Phelan writes, "Identity is perceptible only through . . . resisting and claiming the other, declaring the boundary where the self diverges from and merges with the other."[55]

The identity de/construction at work here is seen as radical in mod-ern primitivist discourse, especially for gays and lesbians, but also for straight women and others. Marsha argues, for instance, that her stretched earlobes, nose piercing, and full-sleeve tattoos not only "raise consciousness" about other cultures, but "open the mind to more [body] particularization." As she puts it, women's modern primitivism can assert that "we don't look like fucking Barbie dolls." She argues, "Wouldn't it be better if we saw beauty as something where we could incorporate our instincts and what we perceive as beautiful in a cus-tomized way as opposed to a pageantry way or a way that's dictated by a blond hair, blue eyed Western ideal?" Marsha uses her permanently stretched earlobes and otherwise radically modified body to question the credibility of the white Barbie doll ideal for herself and other women. The disruption of the "blond-haired blue-eyed Western ideal," the Barbie doll, or any other prescribed identity, appeals to body mod-ifiers who want, as they have repeatedly articulated, to "reclaim our bodies."[56] Marsha, along with Idexa and Andrew, asserts a refusal of any fixed conventional identity. The ambiguity regarding the "status and condition" of their bodies renders subjectivity, as Anthony Shelton puts it, "on trial," opening it to the possibility of scrutiny and change.[57]

DEBATING ETHNIC REPRESENTATION

Critics of modern primitivism point to the problems of appropriating the cultures of oppressed groups and of representing such groups under the unified category "primitive." Even though I find that modern primitivist

body modification is in some ways creative and radical, I agree that its challenge to Western subjectivity is undertaken at the expense of the cultures and peoples it emulates. Modern primitivism is deeply problematic in its Othering of cultural groups for its own use. Further, the representations of indigenous people deployed in modern primitivism are not free of the historical problems of racism and ethnocentrism. Even while it valorizes other cultures, modern primitivism circulates essentialist views of them as more sexual, natural, and "closer to the earth" than Westerners, views that have fueled oppressive relationships with such cultures for centuries. In my view, then, the "identity freedom" aimed for in modern primitivism is not achieved, primarily because of the many ways in which modern primitives are located in, and actively locate themselves, in historic relationships of power.

Modern primitivism uses syncretism and symbolic inversion as tactics that utilize difference in a semiotic "war of position," to put it in Marcos Bequer and Jose Gatti's terms.[58] Syncretism creates hybrids that retain a charge of dissonance; symbolic inversion stands a conventional value on its head. Modern primitivism's "primitive" gains its subversive meaning, its ability to "particularize," as Marsha puts it, when it operates as a contrast to white, conventionally gendered European identity. This deployment of the "tribal" is not multicultural, which would mean appreciating the differences of multiple cultural traditions in their complexity and multiplicity, but rather oppositional, in the sense of using difference dichotomously. The "tribal" body is defined by what it is *not* (for instance, the blond Barbie). The "primitive" *itself* is not particularized, but rather unified as "Other than. . . ." This is a form of oppositional difference that Patricia Hill Collins has described in *Black Feminist Thought*. It preserves an objectified, manipulated representation of the Other as a tactical tool.[59]

Because it capitalizes, albeit ironically, on the Othering of non-European cultures and romanticizes "the differences that do exist," in Deborah Root's words, modern primitivism may reinforce the dualist notions of the primitive/civilized and other binarisms it seeks to dis-

place.[60] This use of the category of "primitive" potentially sustains views of tribal and Third World peoples as essentially, and not merely culturally, different.[61] In seeking primitivism as a universal category, Aidan Campbell complains that modern primitivism has been accused of glossing over the vastness, complexity, and variation of tribal heritages.[62] Certainly, the historical, geographic, and political contexts of traditional cultures are greatly diminished in its representation of primitivism, which highlights neither the differences between tribal groups nor the negative aspects of traditional cultures. In fact, despite incessant references to tribal cultures, no interviewee in my research mentioned any problematic feature of any non-Western culture or traditional ritual, including African female genital mutilation, which is now widely recognized as a major human rights problem. Criticisms of indigenous cultures and historical practices in the subcultural literature are also rare. *BP&MPQ* remains celebratory about footbinding and corsetry, for instance, while largely ignoring their deeply oppressive histories.

In asserting the view of tribal cultures as uniformly positive, progressive, and otherwise superior, modern primitives believe that their practices are antithetical to racism, colonialism, and the negative effects of globalization. Yet, as Valerie Eubanks and Christian Kleese argue, modern primitivism not only romanticizes tribal groups, but also fetishizes them as it projects white Western desires onto the bodies of non-Westerners. Kleese describes how the "gender-specific sexualization" of indigenous bodies has been historically coded into colonial narratives, including those employed in *National Geographic,* a text that has been highly influential to modern primitives. Quoting Homi Bhabha, Kleese describes how such narratives, which have found their way into the modern primitive magazine *BP&MPQ,* produce "the colonized as a fixed reality which is at once an 'other' and yet entirely knowable and visible."[63] As Kleese describes, "In particular Fakir Musafar, but also other Modern Primitives, like to juxtapose photographs of themselves with temporary body modifications with older ethnographic material that show their 'primitive' models in the same

position."⁶⁴ Kleese describes how this move produces the notion of the "essential, universal 'primitive' urge" to modify the body that conflates the motives and practices of "moderns" and "primitives" alike.⁶⁵ While this move may be aimed at pushing primitivism across cultural boundaries, the cultural Others that are constructed here are fixed in their fetishized difference.

In her critique, Eubanks points out that in the modern primitivist literature, "modern" Westerners are rarely American or European people of color. White bodies are often used to represent the "modern," while bodies of color are used to represent the "primitive." When "modern" body modifiers of color appear, they are often presented as more "authentically" "primitive." "Primitive" bodies, moreover, are imagined as more sexually pleasured and erotic. I found repeated examples of this in modern primitive magazines. Take, for instance, *BP&MPQ*'s description of the labret, a chin piercing, which is accompanied by photos of two bare-breasted women, a Yanomamo and an African:

> No one knows how the custom of lower-lip labrets got started in most of the non-Western cultures. But the lower lip is obviously a great place for a decorated piercing. Lots of myth and magic is associated with the mouth; it's the opening connected with eating, suckling, speech, song, kissing and breathing. It is also an erogenous zone. So jewelry or talismans in the lower lip seem highly appropriate to enhance and protect those functions. A labret, nestled on or projecting from the lower lip, attracts attention to sensuous lips. It can be erotically attractive and sensuous to the wearer.⁶⁶

Women of color are often presented as especially erotic or sexual. Here, the sexual interests of body modifiers are projected onto the women, whose body modifications are linked to their libidos. In another example, an American body modifier with both Japanese and European lineage named Midori is described as a "Eurasian fetish diva" who is "beautiful and luscious, who can take her young body and arrange it as she pleases."⁶⁷

Whether they are defined as sexually freer, closer to nature, exotic, spiritual, or otherwise, ascribing an essence to other ethnic groups from across boundaries is problematic given the unequal relations of power between those defining and those being defined. The right to self-definition is not only the interest of radical body modifiers, but of many groups who are situated in unequal relations of power. As Hill Collins writes, the "attempt to express the totality of self is a recurring struggle in the tradition" of oppressed groups.[68] Given this, members of indigenous communities may not appreciate the homage of modern primitivism. For example, a letter to the editor published in the magazine *ITF* criticizes the use of the O-Kee-Pa by whites:

> Some people of European descent believe they are justified in appropriating the O-Kee-Pa ritual because they assume that a sacred ritual taken out of context still provides the user with instant access to the spiritual meaning behind the symbol. . . . Outsiders like Murfin (or Fakir Musafar) lack the cultural predisposition to experience what these sacred symbols invoke for insiders. . . . Exploitation of a culture's sacred symbols hurts the people in the appropriated culture because of its potential for trivialization and invalidation.[69]

In response, the editors of *ITF* defend the use of the O-Kee-Pa by pointing to the shared marginality of ethnic minorities and modern primitivists:

> The premise that sacred symbols and rites are invalid once removed from their historical/cultural context is rather dogmatic on a number of levels. . . . It's ironic to read of Devin Murfin and Fakir Musafar referred to as "outsiders" in a derogatory tone. We're sure they'd be the first to admit they're outsiders—not only to Native American culture but to European culture—they hang by hooks in their flesh, for crissakes.[70]

The outsider status is applied here to equate modern primitivists with all those who do "abject" things with their bodies. In this ethnic posing, the white male colonizer becomes the colonized ethnic Other

through consuming Native American rituals and creating cultural spectacle.[71] It seems unlikely, though, that real solidarities can be generated in this way, not only because oppression is contextual, but also because solidarities by definition require mutuality and consent.

As they have spread in popularity, body art spectacles have become politically untenable even for some modern primitivists. The flesh hanging, scarification, and the ball dance have spread throughout counterculture, where they have often been stripped of the spiritual constructs of modern primitivism in favor of more secular spectacle. In the mix of body art created in clubs and other subcultural spaces, modern primitivist ritual is only one of several options for spectacle, provoking what might constitute the "trivialization" feared by indigenous communities. Idexa, writing in *BP&MPQ,* describes her discomfort at the evolution of the flesh hanging into "suspensions" enacted as subcultural performance art:

> Initially meant to be a small gathering, [my O-Kee-Pa] ritual turned into an event in front of 100 people in a big building. . . . What I see today in many of the borrowed rituals is a lot of "white people" doing it for entertainment, even money, for a bunch of spectators. It (suspensions) being so popular, so obviously a "white thing" (nontraditional), has opened my eyes. I feel the movement is taking part in a continuing genocide of indigenous cultures that started here with Columbus.[72]

Similarly, in her interview, Raelyn Gallina articulates worry and disgust at the popularization of the O-Kee-Pa and other indigenous forms of flesh hanging. Here she compares the indigenous significance of the rituals with their representation in SM clubs and body art studios:

> Hanging by flesh has become popular to a point that they happen in warehouses with lots of people on a club night. Hang 'em up and swing 'em around by a crane. It feels like, well there's nothing on TV, let's go watch somebody get hung tonight. These rituals, where they came from they were done for more spiritual purposes. . . . And there's a relationship they have with their deities, their community and their spiritual

community. There's reference, there's a social and spiritual support system, a network they have, where they prepare for this, they have support during it, and then afterwards, and they've done it to commune, for a higher purpose. And when you take it out of that context and do it for purposes of just plain old mundane entertainment, what can I say about that? It's real disrespectful. It cheapens a whole culture in a way.

These developments leave modern primitivists to defend a slippery slope of authenticity and ethics. In an article on the use of flesh suspensions on the West Coast, Musafar compares what he considers the spiritually successful flesh hanging of Sharon under the branches of a thousand-year-old Redwood tree with the exhibitionist flesh hanging of Paul, which took place in a warehouse using a crane. Musafar describes his attempt to educate Paul in order to redeem his flesh suspensions.

> Paul belongs to a group of young Modern Primitives and performance artists who have just recently been experimenting with body suspensions. . . . Paul invited me to his first "flying suspension" in which he would be moved about freely in 3 axis by a 3-ton crane inside a huge warehouse building. I asked about his intent, his expectations, his view of traditional suspensions like the O-Kee-Pa of the Mandans. He knew very little about traditional body rites, so I explained my views and gave him some *Body Play* magazines to read. I did feel his intent was good— that he was a true seeker and explorer of inner space.[73]

Musafar's criticisms of Paul are based on his lack of knowledge of the origins of flesh hanging practice. (Musafar writes that in societies like the Mandans, flesh hangs are "intended to lead one to a transformative experience—an ecstatic state, a disassociation from the body."[74]) However, Paul gained approval from Musafar for his "good intent," meaning in part his seriousness as a "seeker" of the self-transformative benefits of ritual, and by agreeing to learn the indigenous meaning of his rituals.

While the popularization of indigenous practices is vexing for some modern primitivists, I believe these problems are inevitable. While body modifiers like Musafar, Idexa, and Raelyn present concerns with the

problems of disrespect and trivialization, the movement's postmodern interest in pursuing bodily and identity freedom renders it less able to perceive itself as accountable for representation. As the body mod magazine *ITF* argues, "the only rule to body play and modern primitive acts is that no one unwilling gets hurt, and the participant performs it as he/she feels it."[75] The editors further argue that in a globalized culture, all cultural rituals are available for individual consumption:

> As citizens of a world that has become, truly, a global village, we have been blessed with access to an amazing reservoir of myths, rites, symbols, traditions and religions. It's impossible to ignore the inevitable merging of cultures and the spiritual/ intellectual/ aesthetic evolution implicit in gaining this vast body of ancient knowledge. . . . We each have the freedom to put our individual interpretations on any rites or symbols we choose because, so far, there are no thought police. Honestly, who among us feels qualified to determine who is drawing inspiration and who is appropriating?[76]

Such freedom seems to demand that the subculture escape the responsibilities of representation. If no one is qualified to determine who is appropriating, neither is anyone responsible for critical thinking about the problematic aspects of representing cultural Others.

MODERN PRIMITIVISM IN POPULAR AND HIGH CULTURE

The politics of representation raised by modern primitivism have found a number of avenues for expression in the broader culture, including in popular and high fashion, as well as in the high culture of the museum. The consumerization of modern primitivism by mainstream culture, already bemoaned by *Modern Primitives* in 1989, only expanded as part of the "supermarket of style" at the millennium.[77] *Modern Primitives* complained that body modification was being "co-opted faster and faster" by the fashion industry.[78] Indeed, in the 1990s, since the likes of Jean-Paul Gaultier adopted piercings and tribal tattoos

on the catwalk and MTV celebrated tribal body art, the modern prim-
itivist aesthetic has experienced an astounding fashionalization. Even
though the most deviant practices, normatively speaking, have re-
mained abject, others have been celebrated as "the next big thing," in
Marsha's words. Body piercing and Mehandi, a traditional art of hand
and foot painting, Polynesian blackwork tattoos, Eastern jewelry, and
the like have been embraced as forms of popular "ethnic" adornments.
Sometimes, this appropriation is represented as strictly fashion. Other
times, in Henry Giroux's words, the line between "popular cultures of
resistance and the cultures of commerce and commercialization" is
blurred.[79] For example, one popular photo book on modern primi-
tivism, *Return of the Tribal,* describes the connection between politics,
"tribal" body modification, and entertainment in the alternative music
tour Lollapalooza:

> Musician Perry Farrell created the first so-called Lollapalooza tour. With
> Farrell himself being tattooed, scarified, and adorned with multiple
> piercings, and the show being a kind of wild, tribal-like gathering com-
> bining entertainment with political and human rights concerns, the
> tribal renaissance already in process was enhanced.[80]

Through this kind of proliferation, neotribal body modification has
been popularized as a "route of individuation and resistance" for
youths, to borrow Jose Munoz's phrase.[81] It has also lent an appeal of
authenticity to a number of products hawked by the culture industries.

Modern primitives have contributed to this proliferation through
their own cultural entrepreneurship (magazines, web sites, body modi-
fication studios), but they often express disdain for commercialization
when they see it as superficial. As Raelyn put it, "when you do it for
TV and bread and circuses, that's a denegrating of it." Mark, a body
piercer, refuses to perform piercings on "bimbos" and "meatheads," and
reserves scarification for only a select few: "I'm not going to participate
in these types of blood ritual with just anybody. I don't want people
coming to me for this experience just because it's cool, because it's the

raving thing to do." Certain popular marks have entirely lost their alternative appeal. The naval piercing, for example, is regarded with suspicion. In Andrew's words, "it's become cliché and lost any of the meaning when you can go to JC Penney's and get it—it's kind of done."

The culture industry's use of the modern primitivist aesthetic is often disturbing for reasons other than its superficiality. As Anne Balsamo argues in her reading of *Elle* magazine, the high-fashion industry has used multicultural models to promote a "primitive" "anti-fashion high fashion look."[82] Anti-fashion is the charge of authenticity, resistance, and rebellion that is seen to emerge from street-level subculture, but it has been easily packaged for high-gloss consumption. The packaging of modern primitivism usually involves, not too surprisingly, racialized representations of the "primitive." In *Elle*, black bodies display the "primitive" look, where they are, in Balsamo's estimation, "coopted to a cultural myth of racial subordination."[83] *Elle* explained in one article that primitivism is now "in season," and reflects the American "love of the exotic." *Elle* defended the use of black women to sell the "primitive" clothes that cost up to $1,000 as a terrific opportunity for black models. As Balsamo suggests, though, these bodies can be seen as "billboards" that fetishize black identity "as the cultural sign of the ethnic primitive." Paradoxically, this primitivism so closely linked with bodies of color is available primarily as a commodity for well-to-do white women. Balsamo argues,

> The focal figure and preferred mannequin of these fashion campaigns is the eroticized dark brown female body, but the valorized subject is the white, Western woman, whose white body can be liberated, temporarily, from the debasement of everyday life through her consumption and mimicry of anti-fashion style.[84]

In this context, primitivism as represented on the bodies of American women of color is really a sign of exoticism meant for those whose identities are implied to be squarely located in the camp of the non-exotic, "civilized," Western world—not African Americans, but whites.

Alternatively, when white models wear the "primitive" look, as they did on fashion designer Jean-Paul Gaultier's catwalk, they can reinforce the idea of "voluntary" ethnicity and exoticism for the white consumer.[85]

Modern primitivism has also traveled high up the cultural ladder, provoking a different, more high-brow kind of interest from museums and galleries. From Washington, D.C. to Los Angeles, San Francisco, New York, and elsewhere, museum and gallery exhibits have presented tribal body art in an anthropological light, where the visitor is charged with the task of learning about other cultures, and their own, through exploring the subject. One of the most prominent of these, "Body Art: Marks of Identity," claims to present "some of the many ways that body art signals an individual's place in society." This exhibit, which ran in The American Museum of Natural History in New York City in 2000, was inspired by the explosion of body art in American culture, and situated the new American body art movement in the context of body art's long and geographically widespread history. The exhibit displayed photographs of "neotribal piercing" and the "new hybrid identities" alongside anthropological images of body art from Africa and the Pacific Islands. A video of working-class American tattooing runs alongside the museum's collection of sixteenth-century European paintings of bodies, ancient Greek pottery, and tiny antique Chinese shoes.

Unlike the high-fashion images of ethnic bodies, this display included a critique of colonialist representations of traditional cultures, asking the question, "who is looking at whom?" In addition to conventional anthropological displays of paintings, it included sculptures and photographs of body art from Japan, Nigeria, Ecuador, New Guinea, Polynesia, Native America, and elsewhere that were meant to document the variety of indigenous body art, and described the exoticization of such bodies in the Western imagination. The film *Cannibal Tours,* for instance, depicts the ugly aspects of Western tourism in traditional societies, showing discomforting clips of Western tourists paying natives in New Guinea to pose for photographs. The film critiques this tourist practice, in New Guinea and elsewhere, pointing out its a

culturally devastating effect on traditional body art rituals, turning them from social events to daily profit-making spectacles. The exhibit also included descriptions of the World's Fair spectacles and other events that exploited native bodies for entertainment in the nineteenth and early twentieth centuries. The focus on representation urged visitors to think about how Western images of "exotic" bodies reveal as much about Westerners themselves as the bodies and cultures viewed.

The exhibit's take on the new body art movement is that of cultural relativism. Body art, according to the museum's literature on the exhibit, "allows people to reinvent themselves—to rebel, to follow fashion, or to experiment with new identities." The tone is a celebratory one: new body art is not abnormal, but rather is a culturally widespread, creative, and artistic human practice. American tattoo artists and modern primitives are, like countless indigenous groups, expressing "who they are and what they believe in." Moreover, American innovators of body art contextualize our understanding of "exotic" bodies and denaturalize Western body norms, and suggest that all bodies are capable of undergoing modification. The twofold explanation of body art in the exhibit is this: for some, body modification is rooted in longstanding historical traditions and cultures that are vulnerable to colonial exploitation; for others (Westerners), body modification is a process of "reinventing" the self. The museum exhibition guide explains,

> Body art today is inspired by the ideas and traditions of other cultures. Look around you, at people in your neighborhood, in movies, in advertising, and in this room. Body art is used by people as a way of expressing their unique personalities.

Following this logic, the final display is a slide show that links subcultural forms of American body modification with less stigmatized versions: costumes at Mardi Gras, face painting at football matches, fingernail art, and hairstyles. As they leave the exhibit, visitors are faced with a giant mirror and asked to imagine how they themselves are modified. "What

is your body art?" the mirror asks in large letters. "What does it say about you?" This is a familiar tactic in contemporary anthropological exhibits, as Patricia Sharpe and Francis Mascia-Lees describe in their review of one at the Smithsonian. The mirror is "designed to disrupt the viewer's notion of these practices as exotic." They describe how "we are invited to overlook the vast differences of culture that separate human beings and find unity in the body: it is portrayed as a ground on which all cultures inscribe significant meaning."[86]

Disturbingly, at The American Museum of Natural History, visitors exiting the exhibit were greeted with a gift shop that expressed precisely some of the consumerizing, fetishizing, and trivializing tendencies that the exhibit's focus on the politics of representation sought to critique. Visitors were urged to buy not only videos and books on indigenous body art, but also chocolate tattoos, jars of body paint and tribal face painting kits, a $110 "neotribal" bracelet, henna hand- and foot-painting kits in "beach" or "Celtic" themes, temporary tattoos labeled "ceremonial body art," tattoo coasters, "Japanese tattoo-inspired" boxer shorts, and "Polynesian-tattoo inspired" handbags. What is implied here is that indigenous cultural forms are still available for Western consumption, and which both popular and museum fashion handily render *prêt a porter.* Apparently, there are no limits of taste and sensitivity when it comes to consuming the Other, not even in the museum. As *ITF* magazine argues, as consumers "we each have the freedom to put our . . . interpretations on any rites or symbols we choose."[87]

DEPLOYING THE OTHER/INVENTING THE SELF

To differing degrees, the ethnic Othering and the fetishization that I described earlier are at work in the "tribal-like gathering" of Lollapalooza, in Balsamo's *Elle* magazine, and in the museum display. I want to highlight three related issues raised in these examples that to my mind implicate modern primitivism at all levels—in subculture, popular culture, and high culture. First, modern primitivism extends the notion of self-invention

popular in postmodern culture to ethnic identity. According to this view, bodies and identities are no longer seen as immutable, and, moreover, cultural and ethnic identities are now part of the supermarket of style available for consumption. This ideology celebrates a sense of freedom and authentic choice that is underwritten with what I see as a myth of non-locatedness. According to the myth, traditional social constraints and cultural and technological limits all have been surpassed in postmodern culture, *so that we are now individually free to choose our identities, bodies, and cultural affiliations.* None of us are permanently located in subject positions, because these can be disrupted and changed at will. For some of us, there is some (albeit limited) truth to this notion. However, this position also obscures the many ways we *are* privileged and constrained according to systems of power—through what are often deeply entrenched categories of race, sexuality, gender, class, and citizenship. At its most radical, modern primitivism in subculture aims to disrupt these categories. Whether it succeeds, even at the level of subcultural performance or display, is by no means certain.

Second, I want to argue against this myth that privilege is operating in these postmodern representations, as it has for centuries in representations of colonized subjects. Globalization is often cited as the current force circulating representations and practices across cultural and national boundaries. Modern primitivism can be seen as one aesthetic and lifestyle response to this process. But it is a response that originates almost entirely among white Westerners, and is also easily commercialized for our (privileged) market interests. Postcolonial scholars such as Chandra Mohanty and Jacqui Alexander talk now about "processes of re-colonization," the assertion of economic and cultural hegemony over formerly colonized subjects through exploitative relationships across cultural boundaries.[88] At all levels, modern primitivism can be seen in this light. In the museum display, for instance, tourism is the primary model of experiencing cultural difference. The display's location in the space of the museum—between scientific and anthropological exhibits and its Body Art gift shop—creates a voyeuristic subtext

that reinforces the museum-goer's role of learning and consuming. The objects sold in the gift shop glaringly underscore non-Western body art as signs easily fetishized and consumed by Westerners.

Third, modern primitivism in each of these cases constructs a monolithically white audience. The gaze upon the bodies of radical tribal punks, "exotic" black models, and victimized indigenous people is a white, middle-class one that can make sense of each of these representations as meeting points of the "civilized" and "primitive" worlds. Of course, this construction obscures the real racial, cultural, and class diversity of Western and Northern citizenry as much as it homogenizes the so-called primitive. But these points of contact, nonetheless, can ultimately be seen as opportunities for the expansion of white privilege. The museum's mirror, which asks visitors to think about themselves, is a literal example of what modern primitivism may have accomplished. Foreign bodies are constructed not only as Other, but also as a mirror for the white, Western self, through which we can see ourselves, imagine ourselves differently, critique our social problems, or adorn ourselves in identities that satisfyingly contrast with and compliment our own.

In the postmodern cultural production of the "primitive," the body is imagined both as an empty, free canvas and also, paradoxically, as a biological archive for ritual and identity. In the deployment of modern primitivism in popular and high culture—whether in subculture, youth culture, MTV, museum anthropology, or high-fashion advertising—this contradiction plays out in racialized ways. It is the white Westerner whose body appears a blank canvas ready for self-inventive writing through various forms of consumerism. The bodies of non-Westerners, however, are not blank. Instead, they are already marked as "exotic," sensual, "primitive," or traditional, and, like the other objects in the anthropological museum, are read under a privileged Western gaze.

CYBERPUNK, BIOMEDICINE, AND THE HIGH-TECH BODY

MOLLY MILLIONS OF WILLIAM GIBSON'S CYBERPUNK NOVELS *Neuromancer* and *Mona Lisa Overdrive* has artificially enhanced vision, a modified nervous system, and electro-prosthetic razor blade fingertips. For her, body modification is an endless process of customizing and upgrading. As she warns another character in *Neuromancer,* one can't let others "generation-gap you," or surpass your own body modifications with the newest gadgets and technologies, lest you lose the competitive edge.[1] Millions is a samuri, a hired gun whose modifications are more than helpful. In Millions' universe, body modification technologies are not controlled by the dictates of biomedicine nor guided by cosmetic surgery experts. Customizing the body is rather a quotidian and populist project of survival and success. Millions' existence is structured by the demands of a high-tech, post-industrial cyber-universe, and her fate depends upon constant adaptations.

The development of cyberpunk as an iconic futurology began with the science fiction of the 1980s—most importantly the work of Gibson—that narrated imaginaries of post-humanism. Because of their status as human-machine hybrids and the ontological implications of always being under

construction, Molly Millons and other Gibson cyborgs have become tropes for post-human subjectivity. In post-humanism, human ontology is disrupted by the "disappearance of the unified, organic human body into ever more complex relations with technology," as David Brande puts it.[2] Cyberpunk assumes a world in which endless body transformation, and the hybridity of humans and machines, is taken for granted. Gibson's work is sometimes read as critical in its depiction of high-tech post-industrial society. As Brande reads it, Gibson's novels address the "sense of the future that crowds the present . . . [where] characters struggle to make sense of this rapidly changing technocultural environment."[3] More often, though, cyberpunk is criticized as post-ideological, for envisioning life beyond politics, as Andrew Ross has argued.[4] The very limitlessness of the cyberpunk world in terms of space, consumption, innovation, and embodiment seems to suggest the dissolution of all material and symbolic barriers, creating a state of freedom to choose one's body and identity.

As Brande points out, post-human visions overlap with those of postmodernism. The denaturing processes of technoscience, the shifting of the body past presumed "natural" constraints, can be seen to make literal postmodernism's celebrated deconstruction of the subject. Postmodernism's insistence on denaturing and deconstructing identity means that the subject undergoes reconstruction, which could "fundamentally alter[] what it means to be human."[5] The unmaking of modern identity into multiple postmodern possibilities parallels post-human visions of cyborgian freedom and limitlessness; the postmodern/post-human subject is perceived to be freed from both modern and human constraints. For this reason, the cyberpunk character, or the cyborg, has been received with great ambivalence. The post-human vision excites, on the one hand, ideas of a liberal, post-ideological relativism in which the norm is one's individual freedom to choose a body and identity. It also inspires, on the other hand, critical, materialist, and feminist theories in which cyborgs become agents of social change by resisting or subverting forces of power.

These issues are increasingly pressing as high technology, which now includes cyberspace, information technology, virtual imaging, virtual reality, and biomedical methods of body reconstruction, is rapidly influencing the ways we inscribe our bodies and narrate our identities. The past 15 years have seen the advance of "actual" post-human bodies in the expansion of biomedicine and cosmetic surgery, the development of hacker and game-player cultures on the Internet, new forms of performance art, and the explosion of body mod communities. Body modification cultures, where the body's status as a work in progress is celebrated, are particularly salient places to investigate the cyborgian body. In a sense, the body modification movement as a whole is a post-human experiment. All facets of the body modification community identify the body as a space of self-writing, including those linking their bodies to those of indigenous peoples, rebelling against traditional gender norms, eroticizing the body, or embracing cutting-edge fashions. They accept, to varying degrees, a denaturalized notion of the body, often pointing to the rich cultural and historical diversity of embodiment as evidence of its malleability.

Cyberpunk body modification is distinct, though, in its futuristic aims to exploit the denaturalization of the body and escalate the literal deconstruction of the body's limits. Cyberpunk is an aesthetic that pursues futuristic, high-tech body projects beyond the limits of fashion, history, and culture. Cyberpunk body artists are distinguished by their use of biomedical, information, and virtual technologies; by their interest in body experiments and inventions; and by discursively positioning the body as a limitless frontier of exploration. In cyberpunk fashion, they unblinkingly assume the technologized body and champion its possibilities.

Having emerged in the 1990s out of body modification, punk, performance art, and cybersubcultures, cyberpunk body artists are often called "extreme," even from within body mod communities. The modifications in Gibson's novels—tooth reshaping, subdermal implants, neural extensions, body/Internet hook-ups, among others—have been

actualized by cyberpunk-inspired body artists in the performance art and body modification communities. Among these is Stelarc, an Australian performance artist who earned early renown for his "suspensions," in which his body hung from wires and hooks in a number of seemingly impossible poses. In other instances, he made himself a neurally connected "Third Hand" that he could write with, and turned himself into an Internet-wired robot. Cyberpunk body modifiers also include the performance artist Orlan, as well as other body modifiers such as those who participate in creating a cyber-subcultural community on the Internet. Here and elsewhere in the body modification communities, cyberpunk has begun to materialize in the flesh, radically extending the denaturing of the body that already characterizes postmodern body projects.

In this chapter, I explore the politics of cyberpunk body modification. High-tech body modifiers often interpret their body projects through the highly individualist languages circulating in cyberpunk and post-human discourse. I will suggest, however, the many ways in which high-tech body modifiers engage in highly social and ideological contests over the body. I will argue against the individualist vision that there is an inextricable link between technologies of the body and knowledge/power in postmodern culture. Following feminist, queer, and postcolonial theories of technoscience, I position high-tech body art in a contest of power over the colonization of new territories of identity and the body.

IMAGINING CYBORGS: FROM TECHNOINDIVIDUALISM TO FEMINISM

High-tech body modification has been hailed in cyber discourse—in science fiction, theory, and cyber subcultures—as freeing the body-subject from the constraints of biology, language, and history. The cyberpunk model rejects the Enlightenment understanding of the body as biologically fixed, presenting the body rather as always already

shaped by human technologies. It also eschews bodily conventions and norms, pursuing instead technological inventions and interventions to expand or transform the body's performance, appearance, longevity, and purpose. Its futurism envisions high-tech hardware and software as tools for change and customization, and it assumes and sometimes champions the breakdown of traditional categories of subjectivity that are seen to be located in the body, such as sex and race.

Beginning with this celebration of technology's denaturing of the body, cyberpunk for some approaches a highly individualist, post-ideological fantasy of limitless (virtual) space and technological transformation. In place of the natural body or the socially constructed body over which the individual has no control, the cyberpunk aesthetic often hails the modified body as a harbinger of, and vehicle for, individual freedoms. For instance, even as it has painted a generally dismal picture of life in the future, cyberpunk science fiction has created iconic, celebratory images of high-tech body modification. Hard-wired characters have been rendered psychologically, physically, and intellectually super-heroic through biomedical and electronic modifications. Cyborg heroes and heroines are celebrated for their ability to leave the "meat" behind by "jacking" the body into cyberspace. Their creativity and agency in fashioning new bodies through customization often gives them a competitive edge. While writers like Gibson have envisioned worrisome aspects of cyborg technology, such as the pressures for individuals to subject their bodies to continual upgrading, they have also presented body technologies as sites of cyborg rebellion. Amid worries about the dystopic possibilities of a high-tech future, the cyberpunk aesthetic often celebrates "mythical feats of survival and resistance" through the personalization and embodiment of technology, as Ross puts it.[6]

In cyber subcultures on the Internet, the cyberpunk trope has emerged as the opposite of the passive subject of technological manipulation or as the passive consumer of mass media. The cyberpunk figures instead as someone "who thinks clearly and creatively" about technology, in Timothy Leary's terms.[7] Leary describes cyberpunks as

mavericks, self-starters, nonconformists, and troublemakers who use technology to rebel and trouble authority:

> The "good person" today is the intelligent one who can think for him/herself. The "problem person" in the Cybernetic Society of the 21st century is the one who automatically obeys, who never questions authority, who acts to protect his/her official status, who placates and politics rather than thinks independently.[8]

One important example is the hacker. Hackers represent enormous trouble for authorities and are perceived as social problems, but they are also admired. They are seen, writes Ross, as "apprentice architects of a future dominated by knowledge, expertise, and 'smartness.'"[9] And as Ross argues, they perform a social service by demonstrating the vulnerability of systems and discourses "that might otherwise be seen as infallible."[10]

In addition to computer, electronic, and surveillance networks and industrial, government, and corporate sites, the body is now beginning to be seen as such a system. Technology's potential to change actual bodies and customize them may allow humans to transcend our physical limits. Further, it may appear to dislodge us from our social limits, or our embeddedness in social constructions. Body customization might suggest for some a sort of "hacking" of the body toward a radically individualist self-construction. Even though cyberpunk science fiction has often depicted body customization as a social (even corporate) process that creates new patterns of cyborg kinship, high-tech subcultures have celebrated customization as a highly differentiated process of individualization, as Tiziana Terranova, Mike Featherstone, and Roger Burrows have described.[11]

For instance, the Extropians, a cyber subculture, have articulated a utopian and libertarian version of the post-human body. Terranova has examined the Extropians' Internet discourse of post-humanism. The Extropian Manifesto, published on-line by the Extropy Institute in California, describes post-humans as "persons of unprecedented physical, intellectual, and psychological ability, self-programming and self-

defining, potentially immortal, unlimited individuals."[12] Rather than fearing technology as taking over the human, Extropians celebrate the potential of a human-machine hybrid, which they see as the next stage in human evolution. Terranova writes:

> The story-line underlying . . . [post-humanism] can be summarized in this way: there has been a huge ontological shift not only in the nature of human society, but in that of our very bodies. The "invasion" of the human body and psyche by the machine is destined to increase over the years (it is already doing so spectacularly) and give rise to a potentially new race of human beings whose symbiosis with the machine will be total.[13]

Extropians argue in their manifestos that those who seek to become post-human are already *trans*-human, to the extent that they envision human life beyond the biologically given. Post-humanism would embrace science and technology to "seek the continuation and acceleration of the evolution of intelligent life beyond its currently human form."[14] Extropians suggest that evolution through science and technology will be a matter of individual choice and individual planning. Evolution, in other words, will be personally customized. They describe themselves in another text as experimentalists who actively follow the research and development of new body-transforming technologies and who are willing to explore untried forms of self-transformation. They see this as a rationalist project of self-development: "Shrugging off the limits imposed on us by our natural heritage," they announce, "we apply the evolutionary gift of our rational, empirical intelligence as we strive to surpass the confines of our human limits."[15] The scenario outlined here is of the individual on a journey of self-customization through technology. This self-customization is the product of individual will combined with a vast expansion of technological choices for transforming embodiment.

These visions of the high-tech body raise questions about how trans- or post-human individuals are located in social relations, and whether technology can be used to free individual bodies from social inscription. Will we all have the ability to choose our own bodies? How will

we use our enhanced abilities? To what extent is body modification a personal matter, and to what extent is it a social and political one? For their part, Extropians assert that this will be a post-ideological age. They presume that heightened intelligence, reason, and self-customization will disengage the body from politics and render questions of power irrelevant. For instance, they define their "extropia" not as utopian, but as an "open, evolving framework allowing individuals and voluntary groupings to form the institutions and social forms they prefer."[16] These presumptions rely on libertarian ideas of individual rationality, choice, and voluntarism.

In contrast to this techno-individualism, there are also critical discourses that embrace high-tech bodies. For instance, the denaturing of identity implied in the high-tech body is also a point of departure for cyberfeminism, which emphasizes the presence of power relations in embodiment and is concerned with deconstructing them.[17] Cyberfeminist enthusiasm for technology centers around the possibilities of reworking embodied roles such as gender and sexuality, although it does not assume these outcomes as inevitable. Cyborg technologies, for instance, might free women from biologically based roles such as pregnancy. They also can denaturalize other gendered roles. Transsexual surgery, for example, a twentieth-century cyborg technology, has already challenged the fixity of nature-based sex and revealed the ways in which femininity and masculinity are scripts that can be learned. (Transgenderism, a much older body project, more radically disturbs the taken-for-grantedness of the dominant sex/gender formula. Transgenderism implies that gender does not automatically follow from biological sex, and so unfixes the meanings of biological differences.) Theoretically, cyberspace also offers opportunities beyond traditional limits of the body to denaturalize gender and explore new forms of embodiment. Cyberspace has been embraced by a number of feminist and queer theorists as a privileged space for radical sexualities and genders. Because the body in some ways disappears in cyberspace, it takes a backstage to gender as a performance that can be re-scripted and modified across virtual space

and time. In cyberspace, new bodies and sexualities might be represented, imagined, and created outside of physical contraints.

Yet, the enthusiasm surrounding cyberculture has been tempered with acknowledgements that cyberculture has not achieved freedom from normative gender constraints, or from racism and other oppressions related to identity.[18] As Caroline Bassett suggests in her study of a virtual "city" in which participants can choose their own on-line genders, *actual* on-line gender performance involves *both* gender play and "rigid adherence to gender norms."[19] For instance, homophobia has not disappeared from the gender-experimental on-line universe, and Bassett finds "extreme conformity" in some of the body images employed.[20] Neither does race disappear in cyber culture. Among many other examples, the expansion of neo-Nazi and other reactionary cybercultures on the Internet suggest that cybersubjects can simply map their notions of the body and identity onto virtual spaces, and use information technology to circulate racist, patriarchal, and heteronormative discourses.

Nonetheless, cybersubjectivity in its many forms may lend itself to an identity that is fluid, mobile, and unfixed. It may favor, cyberfeminists hope, a consciousness that breaks down the dominant cultural narratives governing social life. As Donna Haraway argues in her foundational text of cyberfeminism, "A Manifesto for Cyborgs," a cyborgian consciousness may reject the dualisms of dominant Western discourses that construct problematic oppositions of mind and body, female and male, nature and civilization. Haraway writes:

> High-tech culture challenges these dualisms an intriguing ways . . . [a cyborg] does not seek unitary identity. . . . Up till now . . . female embodiment seemed to be given, organic, necessary; female embodiment seemed to mean skill in mothering and its metaphoric extensions. Only by being out of place could we take intense pleasure in machines, and then with excuses that this was organic activity after all, appropriate to females. Cyborgs might consider more seriously the partial, fluid, sometimes aspect of sex and sexual embodiment. Gender might not be global identity after all, even if it has profound historical breadth and depth.[21]

In a cyborgian consciousness, bodies, borders, and boundaries appear to be displaced. That these displacements can be multiple, ongoing, and in flux raises cyberfeminist hopes for a culture free of gender and further, for the deconstruction of all binary oppositions naturalized in the body.

For cyberfeminists, technology can "queer the ontic," in Patricia Clough's phrase, meaning that it can reveal subjectivity as always impermanent and moving, and identity always partial and negotiable.[22] It offers politically radical possibilities borne out of its insistence on change, as Chela Sandoval writes in her essay on "cyborg feminism."[23] But in contrast to the visions of individual freedom endorsed by the Extropians and others in cyberculture, feminists have also recognized that technology and technologized bodies cannot ever be conceived as outside of power. The individualist rhetoric often dominant in cyberpunk discourse belies the ways in which technology is linked to hierarchies and systems of power.

Feminist theorists of technoscience have argued that technologies are never neutral and apolitical. Rather, they are structured by their economic, political, and social contexts, and they are "haunted," in Clough's terms, by our histories, languages, memories, and unconscious desires.[24] Further, technologies create privileges and constraints, and access to and control of technology are highly political matters. For instance, high technology is characterized by speed, movement, and the breakdown of borders. These impact upon the abilities of individuals and groups to define themselves and their bodies, and thus are forms of cultural capital. As Clough argues, the technology of self-writing "is not only about movement; it is about negotiating with the speed of movement as a way of knowing and not knowing, as a way of being and not being exposed, over- and under-exposed."[25] Thus, cyborg bodies— bodies connected to machines and/or restructured through technology and no longer "reducible" to human bodies—are saturated with power relations in a culture that increasingly links human agency to invention, knowledge, and speed.[26]

HIGH-TECH BODY ART

The discourse of high-tech body art often embraces the themes of individualism celebrated by the Extropians and other cybercultures, although high-tech body modifiers are unique in having "put speculation to the test and engaged in the process of actualising hypotheses," as Jane Goodall puts it.[27] To varying degrees, cyberpunk body artists link high-tech body projects to personal freedom and depict them as a matter of individual choice, self-expression, and self-customization. But the actualities of body modification—of putting "the body on the line," in Goodall's terms—also suggest that high-tech body customization is a deeply social process.[28] As their rhetoric sometimes acknowledges and sometimes obscures or denies, high-tech body modifiers experience a constant engagement with issues of identity, culture, and power. Following feminist theory's insistence on the inherently political nature of the body-technology interface, I argue that cyberpunk practices reflect the ways in which high technologies of self-representation are inextricably linked with power and saturated with sociality.

STELARC: INDIVIDUALIZING EVOLUTION

Australian performance artist Stelarc's vision of the human body as a frontier of innovation foreshadowed the rise of cyberpunk. Beginning in the mid-1970s, he achieved a wide repertoire of bodily suspensions, including hanging the body by metal hooks inserted into the flesh and having it moved and "flown" by a machine.[29] His later work has focused primarily on pursuing the hybridity of humans and machines. For instance, he has wired his body up electrically as a human-robot hybrid, adding a "Third Hand" controlled by neural networks connected to the legs and abdomen. He has also used medical technologies to film his body's interior, rendering visible its internal structure and interior movements and recording its sounds, as cultural critic Mark Dery writes. Dery describes in detail one of his performances that explore the

visibility and audibility of the interior body, as well as the breakdown of the interior/exterior distinction:

> On occasion, his events take place in the midst of sculptural installations of glass tubes crawling with plasma discharges or flashing and flickering in response to signals sent by his body. A cage-like structure perched on the artist's shoulders emits argon-laser pulses. Synchronized to throb in time to his heartbeat, the beams are made, through eyeblinks, facial twitches, and head movements, to scribble curlicues in the air. . . . The artist's heartbeat, amplified by means of an ECG (electrocardiograph) monitor marks time with a muffled, metronomic thump. The opening and closing of heart valves, the slap and slosh of blood are captured by Doppler ultrasonic sound transducers, enabling Stelarc to "play" his body.[30]

In interviews and other writings, Stelarc has outlined a literal and mechanistic vision of high-tech body modification. Stelarc has described his projects as pursuing "the general strategy of extending performance parameters by putting the body into cyber-systems, technological systems, networks, machines that in some way enable the body to function more precisely or more powerfully."[31] Although he is interested in pursuing it only through actual embodied experience and experimentation rather than speculation, his work echoes the Extropians' interest in evolution that radically expands human capacities. He also agrees that this evolution should be individual and customized:

> I'm not talking about redesigning species, or creating a master race. I'm saying that you may decide, either for aesthetic, ritualistic or medical reasons to have implants. It was just to make the distinction between the notion of post-evolution as being more one of choice.[32]

In Stelarc's vision, "miniaturized, biocompatible technologies will one day make each individual a species unto him or herself," as Mark Dery puts it.[33] At the same time, Stelarc argues for updating our notion of human individuality, given the complications to it promised by human-machine symbiosis. His recent Internet Upload projects aim to electronically link his own body motion to remote, random sensors on

the Internet. This means that his body becomes activated not through his own agency, but through the collective activity of the Internet. Through remote control and feedback loops, he pursues breaking down the distinction between the individual and technology, and ultimately, the obsolescence of the human body as a coherent boundary between self and other. According to Stelarc:

> The muscle stimulation system [of Internet Upload] enables the possibility for the body to become a host for remote and spatially separated agents. Metaphysically and historically we've considered the grounding of our humanity to be the coherence of our individuality. To be individual means to be human, to lose our individuality means to be a machine, to be somehow sub-human. But consider a body with a multiplicity of agents. The pathology of that sort of a body . . . would not be a pathology but rather a new complexity and multiplicity of choice that one would have.[34]

Stelarc denies any ideological underpinnings to his work. He argues that he is interested in pursuing what is possible and likely in the body-technology interface rather than what is politically desirable. More important, it is clear that he sees in the breakdown of boundaries between individual bodies and between bodies and machines the increasing irrelevance of power:

> When technology stretches the skin, pierces the body, the skin in effect is erased as a significant . . . Foucauldian site for inscription of the social and of the gendered. It's no longer the boundary of the container of the "self," and skin is no longer the beginning of the world. It's no longer the site of collapsing the personal and political if it's no longer there.[35]

Stelarc's notion is that the breakdown of the body's boundaries implies the dissolution of relations of power in controlling the activities, identities, and social meanings of bodies. While his work diverges from the excited hypothetical rhetoric of some post-human cybercultures in its insistence on embodied praxis, at the same time, in his insistence on literal and technical interpretations of his work, and on the irrelevance

of power, he earns some of the same criticisms—including that he ignores or represses the complexities of social life that structure technological choices. Even though the Upload project challenges the integrity of the boundaries between individuals, his interest in the cyborg as a project of customization and self-designed evolution emphasizes liberal notions of choice and individual freedom uncomplicated by social hierarchies and inequalities. In Dery's words, Stelarc posits the notion of "ideation unperturbed by ideology, of the social space in which the collision of bodies and machines takes place outside 'the politics of power.'"[36]

ORLAN: SERENITY AND DISTANCE

If Stelarc sees in high-tech body modification the dismantling of the socially inscribed self and the opening of a "multiplicity of choice" for human ontology, the French artist Orlan situates such choices in a long socio-historical context. Like Stelarc, Orlan has pursued medical technologies in body modification performance art. Since 1990, she has been undergoing filmed, photographed, and televised cosmetic surgeries. The surgeries are not conventional, directed toward normalizing or beautifying her visage, but rather are aimed at exploring the meaning of femininity, appearance, technology, and the body in relation to her subjectivity. The famous series entitled "The Reincarnation of St. Orlan" included a chin implant and lip, nose, and brow reconstruction. The surgeries developed a face that signifies Western images of beauty—the chin is from Botticelli's *Venus,* the brow from the *Mona Lisa.* The effect is not the perfect face, but a slightly bizarre look, resulting from the incongruence of the new features, which is exaggerated by "bumps," or implants she had inserted into her temples in 1993. In contrast to the earlier surgeries that seem to represent the negotiation of historical and cultural body norms, the implants radically underscore her individuality and uniqueness. Taken together, the modifications seem to assert a sense of individual agency to be found in

negotiating (and surpassing) historical regimes of representation.

Her work is highly controversial, but has been hailed by some as deeply radical and feminist. Many feminists, including Kathy Davis, are offended by what seems to be Orlan's cavalier use of cosmetic surgery, but many, including Davis herself, have also been keen to understand her work as rebellious, critical, and radical. Davis writes,

> Hers is not a sociological analysis which explicitly attacks the evils of cosmetic surgery and its pernicious effects on women (Lovelace 1995). Nevertheless, her project is an *implicit* critique of the dominant norms of beauty and the way cosmetic surgery is being practiced today.[37]

Beyond the obvious radical feminist horror at Orlan's use of cosmetic surgery, much of the debate about Orlan has centered on just what is the artist's aim. Davis writes that even though Orlan's work can be interpreted as radical, feminists should worry that the artist's attitude is self-serving, in that it dismisses ordinary women's suffering in relation to cosmetic surgery. Anthony Shelton's reading is exactly the opposite: in sum, his argument is that what Orlan is trying to do is *spare* women from cosmetic surgery by showing us in graphic, unsettling ways how horrible it really is. Shelton argues that she "consciously demonstrates that the image of the ideal woman is untenable, and promotes public attention to the physical horror of the process used by women to attain patriarchal images of female perfection."[38] This reading acknowledges the grotesqueness of her performances, which includes all the horrors of viewing surgery—much blood, tissue, and inner-body exposure. Yet, even though her work is designed to make the viewer squeamish, Orlan is not opposed to cosmetic surgery. In fact, she appears to celebrate the potential of cosmetic technology and she aims to reflect "serenity, happiness, and distance" during cosmetic surgeries by avoiding any pain and suffering:

> There are still two surgical operations that I'd like to do . . . not plastic surgery, but something that is intended to change my appearance much less, but which is intended to heighten my faculties . . . a first in the

medical world . . . the other one simply consists of opening of the body to produce images like this one on the front of the *Collection Iconotexte* book: of my body opened up with me at the same time having a completely relaxed and serene expression as I watch these images being transmitted by satellite with my surgeon. I'll be able to answer any questions asked. It'll be "opening up and closing the body" and it'll be a perfect illustration of my manifesto of body art which, in particular, denounces pain.[39]

Rather than aiming to be a martyr to a feminist anti-technology cause, her work appropriates high technology to pursue extremes of customization. Like Stelarc, Orlan presents a cyberpunk attitude toward technology—she unblinkingly assumes that the body is already technologized, and pursues individual agency within that context.

On the other hand, her work is radically divergent from Stelarc's in its insistence on acknowledging the ways in which our choices about appearance and beauty are social and historical. Her surgeries and the performances surrounding them have made reference to Western aesthetics, Judeo-Christian symbolism, French literature, and other cultural mythologies. She describes her new work, *Self-Hybridation,* which digitally modifies her face, as a "world tour of standards of beauty in other cultures, civilizations and epochs."[40] The images she creates, with the help of Photoshop and a technician, digitally map photographs of her face onto representations of faces of other cultures. Her image is virtually modified with scarifications and skull deformations according to the standards of pre-Colombian, Egyptian, and African cultures, among others. In this project, Orlan seems to want to demonstrate the relativity of ideals of beauty. In her words, "it's simply the idea of saying that beauty can take on an appearance that is not usually thought of as beautiful."[41] By saturating her work with history and culture and by highlighting gender as a powerful social category, she acknowledges, rather than denies, the relevance of power on the body. At the same time, she asserts the possibility of individual choice to navigate through history's imperatives and move the body beyond them.

BME AND "EXTREME" BODY ART

The interface between high technology and the body is also pursued by body modifiers who gather in cyberspace, for example in *Body Modification Ezine (BME)*, an on-line body modification community and electronic magazine. Not only do readers post photos and stories of their own body modifications, but they also participate in on-line chat to debate, discuss, and create ongoing discourse about the personal and social meanings of body modification. Diverse factions of the body modification community meet at *BME*—male and female, gay and straight, tribalist and fetishist, as well as those interested in high-tech and surgical forms of body modification.

Shannon Larratt, the founder and editor of *BME,* began the site in 1994 and saw it thrive in the late 1990s. Through his promotion of *BME* (which is now recognized as the leading body mod site on the Web), his display of his own "extreme" body modifications on the site, and his editorial writing, he is recognized by insiders as part of the vanguard in the body modification movement. Shannon credits *BME,* and other sites on the web, with the spread of body modification as a subcultural movement. He describes the purpose of *BME* as building a community of body modifiers that may be geographically dispersed but share a common sense of alienation from mainstream society. As he puts it, *BME* "lets people know that what they're doing is OK, that it might just not be insanity."[42]

In keeping with its aim to provide support to body modifiers who elsewhere might be highly stigmatized, body modifiers who use *BME* find there a high level of tolerance for the most radical body modification practices. *BME* publishes photos and stories of all kinds of body modifications, including what it calls "extreme" body modifications.[43] These include high-tech practices such as subdermal implants in which metal, bone, and plastic items are surgically inserted into the face, arms, head, and elsewhere, and Western, high-tech versions of indigenous practices, such as aboriginal subincisions, or surgeries of the genitals. Shannon's own

modifications include not only the subincision, but also multiple body piercings, tribal tattoos, stretched earlobes, brandings, and a tongue splitting. Shannon's description of the latter reveals a highly deviant appropriation of medical technology. Shannon describes multiple techniques for tongue splitting. One involves the assistance of a willing dentist (he describes, for instance, an Italian dentist who has performed this surgery). The dentist uses a scalpel to create small (5mm) cuts, and then uses a cautery agent to stop the bleeding. After healing, this procedure is repeated again and again until the tongue is split down the middle to the desired length. Another process involves using tongue piercings and fishing line. A third technique, the one he used for himself, involves the assistance of an oral surgeon and a laser. Shannon reports that he after his surgery, his tongue still has its original sense of taste, and that the tongue remains at least as agile: "In most cases," he writes, "separate control of the two halves [of the tongue] can be achieved."[44]

Shannon's vision of body modification embraces the cyberpunk attitude of bodies without limits, provacatively asking, "do we really need bodies? What kind of bodies could we create?"[45] In his essays and editorials, he focuses on the techniques of body modification and, like Stelarc, on what is technically possible. He embraces the denaturalized body and, in post-humanist fashion, resolutely denies any moral or ethical limits to body modification, arguing that "all of us" are modern primitives.[46] His argument is that the worldwide, diverse use of body modifications across cultures means that it is "normal" for us to modify ourselves. He argues for diversity and "would like to see more extreme visible modifications happening," which, as he puts it, "makes the world interesting."[47]

The discourse of *BME* denaturalizes the body and endorses an ethic of individualism: we should neither be forced to conform to the dictates of our own culture nor be limited to body modifications that have already been invented. Echoing others' embrace of choice through technology, there is a liberal emphasis on customization, individuality, and personal freedom. At the same time, it is clear that *BME* members

need to address the body's sociality in ways that others—those for whom extreme body modification remains only a theoretical possibility, or those who are able to make a living as performance artists—may not. For many members of *BME*, extreme body modification carries social and material consequences with which they have to cope. Shannon warns that being heavily modified will significantly affect one's job marketability and social acceptability, and describes implants, stretched earlobes, and facial tattoos as "a permanent stigmatization to most."[48] The highly individualistic discourse of *BME* is tempered with these acknowledgments that members of subculture face social and material consequences for what they do with their bodies. Although the aim of customization is often articulated as the expression of personal freedom and individuality, body modifiers are measured against social norms that provide ideal and proper models of embodiment.

Meanwhile, *BME* addresses another social pressure for body modifiers: commercialization. Subcultural style is often commodified by the fashion and culture industries as not only acceptable, but self-consciously hip forms of fashion. In fact, as David Bailey and Stuart Hall have described, the same features of subcultural style that for some exemplify anti-fashion status are also valued for their "authentic" expressions of nonconformity and for their shock appeal, both qualities which have high marketing value in contemporary culture.[49] Punk, for instance, was "highly vulnerable to the modification,"[50] in Ken Gelder's words, and began to be seen as an expression of middle-class consumerism, as "the almost-routine route of individuation and resistance" for youth.[51]

Tattoo culture is already "rapidly losing its deviant status," as Angus Vail puts it, and some of the newest cyberpunk inventions and neotribal appropriations are readily consumed in the popular culture marketplace.[52] Even Orlan's modifications have found commercial appeal, having been mimicked by fashion designers on the catwalk.[53] While Orlan appears flattered by this "tribute," she also expresses disdain for the popularization of her body modifications, and she isn't as happy to be the inspiration for subcultures:

> I wasn't surprised to be imitated by people who have body piercing and tattoos. I'm not against these things, but it's quite obvious that the majority of people who are into those things believe that they're liberating themselves from the dictates of a certain society, but in fact it all boils down to the same thing because they are conforming to the dictates of a smaller, mini-society . . . someone told me they had recently seen a San Francisco group on TV who have bolts and plaques on their heads, as well as needles. They were just punks, or they might as well has been.[54]

Orlan's disdain for punks seems to reflect, to my mind, a surprising lack of appreciation for the creative aspects of subcultural fashion. Certainly, her dislike of subcultural body art reveals her reverence for individualism: although cyberpunks might be rebellious, the collective nature of their rebellion is, for her, unacceptable. For their part, subcultures draw the line at fashion; they have long been concerned about commercialization and often attempt to distance themselves from it. (In his well-known work on subcultures, Howard Becker described such a process in 1963.[55]) As Shannon puts it in a *BME* editorial called "Rejection of Current Trends in Pop Culture," there has been what he terms a "ridiculous surge" in the popularity, newsworthiness, and marketability of body modifications.[56] Opposed to conformity, *BME*'s anti-fashion discourse applauds a willingness to provoke disdain, accept risk, and push the envelope of body aesthetics.[57] In this vein, Shannon asserts that of all body modifications, his favorites are "facial implants, because I admire people who are willing to make that kind of *pioneering social sacrifice.*"[58]

Among those who make such "sacrifices" is Andrew, a well-known body piercer in his mid 20s who has been celebrated on *BME* and other sites for his extreme approach to body modification. Like other body modifiers, Andrew links the body and technology to personal agency, and envisions that both natural and social constraints can be surpassed through body modification. Andrew argues that through technology, "we can take control of what we otherwise could not." While his body modifications are aimed at self-empowerment and individual cus-

tomization, he acknowledges that this vision is threatened by fashional-ization: "when you can go into JC Penney's," he argues, "and get a body piercing." Through experimentation and invention, Andrew has pur-sued self-customization far beyond the limits of fashion. He has appro-priated biomedical technologies, endured physical risk, and provoked stigma in the project to customize his body.

Andrew has undertaken over one hundred body piercings, hundreds of hours of tattooing, multiple brandings and scarifications, and several self-surgeries. His first body modification was a full-piece back tattoo. The tattoo took many weeks to complete, and he undertook a night job to cover the financial cost. The most important cost, though, was that he "traded in skin," in his words, to create a unique modification. Later, he began to explore more extreme modifications, which include scars on his face. These were undertaken, he suggests, to express his com-mitment to self-customization.

> *VP:* So which was your first cut?
> *ANDREW:* My face.
> *VP:* Your face? Why your face?
> *ANDREW:* It is the commitment to being true to myself . . . you can't dress like me, *you can't be me* (emphasis mine).

As a body piercer and body modification artist, his turn toward high-tech experimentation and invention has earned him some renown in the subculture. He has experimented with quasi-medical techniques such as self-surgeries, the use of lasers to make precise, cauterized brands, and body piercings in highly difficult places, such as the uvula in the back of the throat. Like other "extreme" body modifiers, his nar-rative reveals a fascination with biomedical and technical knowledge. The following is part of his own list of his body modifications:

> I've had bipedal flap surgery below the erectile ligament and trans-scrotal surgery, a bipedal flap surgery on the anterior wall of the scrotum, a subin-cision that's two weeks old, three 10-inch long chest cuts, a full upper

chest brand with a cautery scalpel, three facial cuts echoing the contours
of the chest cuts that are respectively 4 ½ to 3 ½ inches, a symbol scari-
fied on the forehead with a scalpel, two equilateral frenums to balance a
center frenum, three other frenums, a ladder of eight 6-gauge scrotum
piercings at once . . . a fullback piece as the first tattoo, and tribal jewelry
bands [tattoos] on all appendages.

Andrew's aesthetic of body modification combines a modern prim-
itivist interest in cultural appropriation with a cyberpunk fascination
for high technology and biomedical knowledge. Among his other self-
surgeries, Andrew conducted a subincision on himself. The slicing of
the penis was modeled after a traditional aboriginal practice. However,
he fused his understanding of traditional uses of the practice (begin-
ning with *National Geographic*) with knowledge gained from studying
the anatomy textbooks ordinarily used by medical students, and he
used a topical anesthetic, sutures, and scalpels.

> I had a working knowledge of anesthetics both topical and injectible. I
> had everything down, done all my homework, tested [the topical anes-
> thetic] on different areas of the body. I tested on genital tissues, no prob-
> lems—it's standard in the [medical] industry to be used for this.

This kind of experimentation involves physical risks as well as fears of
stigma. Andrew's subincision, a procedure he has successfully per-
formed on others, did not proceed without incident. Alarmingly, he ex-
perienced a reaction to the anesthetic and had internal bleeding. Yet
given the highly stigmatized nature of this practice, he found himself
unable to seek medical attention. He explains,

> I'm not going to go [to the hospital] because I'm not an Australian
> aborigine am I? You can't take the chance to explain yourself. You
> have to weigh [the situation]. . . . I had a second degree chemical
> burn in reaction to an anesthetic that ended up burning some of my
> urethra . . . had an allergic reaction, and coupled with the fact that
> the vessels that had been sealed off had become uncauterized, I had
> large blood vessels draining inside subcutaneous tissues. I blew up

and that's a real bad scene. So either go there [to the hospital] with an inch and a half split among the underside of the phallus, and explain that, or try to surgically [fix it myself].

VP: So you didn't go to the hospital?

ANDREW: I didn't go to the hospital . . . I've had to do about 25 small surgeries [to fix it]. . . . Now it's fine. Your body can do anything . . . I'm doing fine.

Andrew's cyberpunk attitude toward body modification is reflected in his highly deviant appropriation of medical procedures to create implants and conduct self-surgeries, as well as his insistence on the body that can "do anything"—a remarkable point of view given his experience with subincision. His pursuit of the body as a site of exploration and experimentation presumes both the denaturalized body and the body at risk.

> It's amazing. . . . There are [indigenous] cultures that have been there decorating themselves . . . they are not afraid of scars, they're not afraid of it not working out, they're not afraid of getting infected and dying. That happens anyway . . . but it's a moment of divine clarity if you get to come up with something new.

Indigenous cultures, he argues, have experimented with the body for so long that there are few body modifications in contemporary culture that are truly new inventions. For him, high-tech body modification opens up the possibility of "coming up with something new." In contemporary culture, high-tech body modification also promotes self-individuation, which he sees as integral to self-ownership and self-control. "You get your body. It's the one thing you get to have still . . . you can be you. You can stay true to yourself."

THE PSYMBIOTE

Often, but not always, conceptions of the customized body and the cyborg champion the individuality, survival, functionality, appearance, or

competitiveness of the human self. Sometimes, though, the cyborg appears to take on a subjectivity of her own. Since January, 2000, body artists Isa Gordon and Jesse Jarrell have been building what they call the "Psymbiote," a cyborg created through merging Isa's body with an interactive, computerized performance suit and corresponding cybernetic units that are worn with it. These units include a computerized data input glove, which has mechanical joints and sensors that connect it electronically to other elements of the suit. A prosthetic "pedipalp" is another unit, which Isa describes as a "mandible-like device" that protrudes in front of the face or can be worn folded up behind the head.[59] For the project, the Psymbiote will appear in public spaces, at times unannounced. The performance art engendered by the Psymbiote's appearance is aimed at creating opportunities for public debate over cyborgian interventions into the human body's boundaries. As Isa describes in the on-line lecture, "The Psymbiote Speaks: On Generating A Cyborg Body," their progress so far raises a number of questions about the human body's functions and boundaries. Isa and Jesse aim to push the technologized body toward "new and unexpected" forms of technological hybridity:

> [W]e have been exploring innovative ways to extend the body's capabilities, building elements that will eventually add both function and aesthetic appeal. [The pedipalp] could be used as a feeding device (when you're busy or on the run), an expressive element (like our hands), or perhaps in performance as a way to touch audience members in an intimate gesture that lacks skin-to-skin contact. . . . [The data-input] glove will give me new tools, and will provide triggers for other functionality. But how will it affect my ability to use my hands in the ways we're accustomed to using them? To reach and grasp, to interact with my environment, to touch a friend or caress a lover? How will this change me? The glove is fully articulated, but still it alters my means of function, and the body itself. These are some of the interactions we hope to test in our work, and in public performance.[60]

Isa and Jesse argue that the body has already been technologized—through, for instance, the use of the keyboard, the cell phone, and con-

tact lenses—and that a "deeper intergration of the interface into our bodies" can correct what are often clumsy or otherwise problematic connections between bodies and technology. Eventually, they suggest, cybernetics will be individualized, personal, and will seem "naturalistic" rather than mechanistic and cumbersome. Moreover, they will extend the body's functions. The Psymbiote has been conceived, like other cyberpunk projects, with an interest in the body's evolution, customization, and self-development. Isa argues that ultimately, we must "accept our ability to improve [the body] as a necessity, cease to define our beings by the formalities of the vehicle we currently use, and reconsider the boundaries of the self."[61]

Isa and Jesse's aims, to generate high-functioning, electronic bodies through technological invention, are pure cyberpunk. However, unlike the Extropian project and other cyborgian conceptions in which the human's individual and rational will has the prominent role, the Psymbiote is articulated with a keen sense of the personal subjectivity and intimacy of cyborgian technology. For Isa, the Psymbiote is a "strange creature" that is still premature but growing and evolving. The Psymbiote has a learning curve, and she may eventually have an independence. In Isa's terms, she is "like any newborn" who must "discover herself in her environment":

> She will take time to learn control of her functions, and to speak for herself. She still speaks only through my voice. . . . [But] I feel her developing energy swelling inside me. We have built so many of the components directly on my body, creating a personal and intimate link between my self and this embryonic apparatus.[62]

In articulating the Psymbiote's potential, Isa gives her cyborg a voice and a female subjectivity, and also acknowledges a sense in which her own subjectivity is transformed by creating/becoming her. In this configuration, technological evolution is not deployed only at the behest of the rational individual's will, nor is the cyborg only the tool of a human master. The Psymbiote ultimately appears as a hybrid identity who has

her own powers of influence. She becomes a temptress who attracts the human and makes promises of transformation. As Isa-as-Psymbiote calls to us in a poem, "let me extend myself into you / we can blur the edges together / i can make you more / i can build you into something new / let me under your skin / and i will make you whole."[63] As cyberfeminists like Donna Haraway have imagined, the fixity of human identity is challenged here. The body-subject is transformed, and the movement toward cyborgian subjectivity is not predictable but messy, "blurred." And here, in terms that theorists like Haraway, Patricia Clough, and Sadie Plant might appreciate, the technology itself appears seductive, promising to transform human identity into something better—something new, more, whole.

If the cyborg has a transformed, transforming subjectivity, she also still has a body. Rather than champion the obsolescence of the body or charge it as "meat" to be left behind, Isa describes a deep ambivalence about mechanizing the flesh that is rooted in an acknowledgement of the persistence of the material body. She describes what might be a highly gendered difference between herself and her male collaborator—who already designs subdermal implant surgeries for aesthetic body modifications—in regard to the prospect of implanting machines under the flesh:

> Jesse and I have often discussed our own personal future integration with technology. He is much more eager to put micromachines beneath the skin; he can't wait for the medical technology to catch up to his imagination. I have not been so certain. Machines are unreliable I say. So are bodies he says. I can't argue there. But I think about having surgery every time my hard disk crashed. I'd be living in the hospital. This is the fear, of melding imperfect technologies into my body, of forever trying to fix the problems that the last fix created.[64]

Isa's fears, confirmed in Andrew's experience of self-surgeries described above, are understandable. For all the risks, though, Isa's answer, of course, is not to avoid technological intervention, but to "face it head on" and embrace it. The interface between humans and machines, as

she sees it, is already well underway, and the interdependence of humans and machines is inevitable. The cyborg, she says, is a product of our "techno lust," or our fascination with technology. As she sees it, "we all [already] have a psymbiote gestating inside of us, and it will be a personal matter for each one of us whether or not to encourage the seed to maturity, and whether to birth this hybridization from the inside out or from the outside in."[65]

CUSTOMIZING BODIES

The high-tech body modifiers described here share an enthusiasm for technology's capacity to facilitate self-customization. Stelarc, Shannon, and Andrew employ radically individualist language to describe the meaning of their body projects. Stelarc affirms some of the enthusiastic rhetoric for high-tech body customization that circulates in cyberculture by advocating individual self-evolution, which employs individual will and choice to shape, improve, and customize the body. Shannon and Andrew pursue self-customization that outpaces fashion, and embrace a body that is, in Shannon's words, "anything you want." Andrew's scars announce that "you can't be me." Orlan, too, seeks to break down natural boundaries and to customize her body, aiming for a new body modification that is a "first in the medical world."

This individualism is partly predicated on the disappearance, shrinkage, or obsolescence of the material body through technological intervention. For instance, Orlan's "serenity, happiness, and distance" during cosmetic surgery implies at least the temporary repression of bodily functions. She explores the possibility of calmly watching her body being literally opened and closed during surgery. (In an inversion of more traditional feminist approaches, her "denouncement" of pain depends upon, rather than avoids, bodily intervention.) Other body modifiers expand this possibility by performing the surgeries and procedures themselves. Further, high-tech body projects are narrated with language that often denies the body. Shannon asks whether we really

need bodies, and Stelarc argues for the obsolescence of the body altogether. Shannon, Andrew, and Stelarc employ metaphors of loss to describe their body projects. As Stelarc puts it, cyberpunk body modifiers "take the physical consequences" for exploring and inventing the human cyborg.[66] Shannon describes the "pioneering social sacrifice" undertaken by extreme body modifiers, and Andrew refers to "trading in skin" as the ultimate cost of extreme body modification.

The disappearing body is often equated with freedom from the effects of power. For instance, Stelarc's notion of customization as a matter of individualizing evolution, or making each individual "a species unto him or herself," suggests that technology is a vehicle for liberating the self from the social, a view also endorsed by cybercultures like the Extropians. In his words, the body is "no longer the site of collapsing the personal and political if it's no longer there."[67] He implies not only that technology itself is a neutral instrument of individual agency, but also that the socially marked body is increasingly irrelevant. He suggests that embodied categories of power such as race, gender, sexuality, and class are both uncoupled with the body-subject and denied by technology. In an interview with Ross Farnell, Stelarc explains that the high-tech world has less at stake in terms of gender politics and other issues:

> *FARNELL:* Do you see your work addressing racial and gender difference in any way?
> *STELARC:* Well, not really. . . . Of course there are some gender distinctions [between the ways males and females utilize technologies], but the other thing that one has to realize in the world of ambiguous gender, in a world of gay and feminist rights, in a world of transgendered operations, gender becomes a blur of lots of shades of subtle distinctions rather than male and female, a heterosexual or gay, polarization.[68]

Stelarc envisions a world of postmodern relativism, in which all identities and bodies are denatured, liberated from any inevitable effects of power. To my mind, although Stelarc describes some of the radical possibilities of techno-ontology, this relativism problematically denies his own social situatedness.

While the body is named "obsolete" and its barriers and borders are deconstructed, it is also situated as a *frontier* that is "an advance" and a "not fully explored region" of ideas, as well as a "border of civilization."[69] A frontier suggests the body's expansion, its limitlessness, rather than its contraction. Stelarc's claims about the mechanical possibilities of technology are rooted in knowledge, trial and error, and physical risk, rather than in speculation. When Stelarc captures images of his internal body on camera, he has already endured the arduous process of swallowing a recording instrument, as Goodall points out.[70] Despite the rhetoric that denies the body, his practices are deeply embodied, as he admits when he criticizes the speculative aspects of cyberpunk ideologies:

> It's not enough to speak in metaphors and paradigm shifts, with the notion of empowering the human. . . . For me, it's inadequate simply to postulate or simply to theorize, or simply to write SF because . . . for me the authenticity of an idea is made concrete by the constraints and unpredictable possibilities of practice.[71]

The narratives of *BME* also catalog attempts at painful, pleasurable, and otherwise affective experiences of bodily invention and experimentation. Individual narratives list dozens of bodily procedures and often reflect hundreds of hours of body work. Orlan, Stelarc, Isa and Jesse, Andrew, Shannon, and others all aim to enhance the body's capacities and to discover something new.[72] The body, then, is far from removed from cyborg technology. As Isa puts it,

> I agree that we can evolve ourselves but I do not believe that we can distance the body or our humanity to do so. The body is our launching pad. A point of departure. The soil in which to germinate our psymbiotes. The womb in which she gestates.[73]

Frontierism not only demands physical pioneering and risk, but also implies struggles over jurisdiction and contests over naming. The naming and writing of the body-subject, a deeply political matter, is what is at stake in cyberpunk. While cyberpunk body art often articulates a

liberal, relativist view of the body, with the body as potentially free from any natural and social constraints, it also reveals a constant engagement with social pressures and power relations. Cyberpunk body modifiers gain and employ technical knowledge to engage in strategies of self-representation. Despite Stelarc's insistence on the increasing independence of individuals, these strategies are inextricably linked to issues of power. For instance, cyberpunk body artists appropriate medical technologies, challenging the authority of medical experts to define, control, and distribute these technologies. They face, and sometimes resist, the commercialization and fashionalization of their practices. They face the material and social consequences of stigma. They circulate and contest cultural signs, such as those of civilization and primitivism, technological progress and naturalism. These contests take place on unchartered territories of the body.

TECHNOLOGY, REPRESENTATION AND POWER

Access to technology influences the methods and speed of representation and self-representation as expressions of cultural capital. In the high-tech world, empowerment is often a matter of controlling knowledge, and disempowerment is often lack of control over the creation of meaning, or being dependent on and within the flow of information, as Alberto Melucci argues.[74] One way of being dependent is to be subjected to Western, patriarchal, hetero-norms of beauty and fashion; another is to be subjected to biomedical surveillance and pathologization. Postmodern culture links information, representation, and power. Access to what Melucci terms the "power of naming" is differentiated between classes and genders, as well as races and nations. When identities and bodies are exposed as constructed categories, the extent to which they can be named and represented becomes a power struggle for participants in all sites of culture.

Cyberpunk expresses a deep interest in appropriating and circulating power/knowledge over the new geographies of the body. Like other

body modifiers, cyberpunks appropriate technologies from indigenous and non-Western cultures. When Western subcultures and other groups appropriate these practices, they might establish "traitorous identities" while at the same time expressing privilege in naming cultural Others. Identity tourism is as much a part of futurist cyberpunk body modification as it is of more nostalgic versions. The notion of spanning epochs and cultural geographies for creative inspiration is consistent with the frontierism of cyberpunk. As it breaks down borders and speeds up the circulation of information, representation, and bodies, cyber-technology may accelerate the possibilities of identity tourism. As Mike Featherstone describes,

> We no longer need to travel to see and understand the other, the images flow into our living rooms. . . . The development of the new information technology in the direction of virtual reality and cyberspace have added to this problem through the potential which will soon be available, to access all the information and images in human history.[75]

Orlan's "world tour of beauty," for instance, extends cultural appropriation through many civilizations and epochs. Since the body modification itself is virtual, Orlan's tour expands exploration while eliminating the physical costs.

Cyberpunks simultaneously appropriate forbidden practices from within their own cultures. The use of the hypodermic needle for piercing, as Karmen MacKendrick points out, is already an appropriation of medical tools. High-tech body modification extends such appropriations to lasers, scalpels, sutures and anesthetics, implants, and inner-body surveillance equipment. The subversive effect lies in using technology in inefficient and culturally unauthorized ways. MacKendrick suggests that this "technology never intended for pleasure, certainly such mischievous pleasure, is turned away from its aims."[76] Andrew's subincision, for instance, appropriates medical technology to an extent that would be startling to the medical experts. In studying anatomy textbooks, acquiring anesthetics, handling scalpels and lasers,

and conducting surgery on himself, Andrew is an outlaw robbing his own cultural elites of their control over high technologies. He not only subverts the authority of experts to define body norms and acceptable body practices, but also even to govern the handling and use of medical tools. This is quite a daring body project. All surgeries have physical risks, but this surgery presents social risks as well, not the least of which is Andrew's understandable fear of being pathologized by medical experts.

I agree with MacKendrick that these practices, so personally risky for participants, can create important critical effects. Cyberpunk can be seen as a subversive response to the corporate/capital colonization of the high-tech body, raising crucial questions about who owns and controls it. Eugene Thacker writes of cyberpunk science fiction that it can critique the authority of biotechnology and biomedicine, highlighting "the contingencies and limitations in biotech's self-fulfilling narrative of future medicine."[77] Cyberpunk body art does this in ways more material than fiction. As a potential hacker of the body, the cyberpunk body artist might interfere with the new body designs created by the corporate/medical/fashion industries, and with the authority of these institutions to control body norms. For instance, in choosing iconic (and male) representations of female beauty with which to reconstruct her face in her "Reincarnation," Orlan creates a highly contentious intervention into the high-tech creation of female beauty in cosmetic surgery. In many respects, her designs can be seen to counter the hegemonic dictates of medicalized beauty.

However, high-tech body modifiers do not wholly eschew dominant ideologies in their body projects. For instance, both cyberpunk and cosmetic medicine link the denatured body to the liberal subject who can personally choose her identity. The vision articulated by cyberpunks that a person can "be who you want to be" is also the mantra of high-tech cosmetic culture. As Anne Balsamo describes, the cosmetic industries are served well by this liberal sense of identity freedom:

[These industries] have capitalized on the role of the body in the process of "identity semiosis"—where identities becomes signs and signs become commodities. The consequence is the technological production of identities for sale and rent. Material bodies shop the global marketplace for cultural identities that come in different forms, the least permanent as clothes and accessories worn once and discarded with each new fashion season, the most dramatic as the physical transformation of the corporeal body accomplished through surgical methods.[78]

Cyberpunk surgeries have a lot in common with their culturally legitimized counterparts. They are informed by a sense of identity as ontologically freed by the breakdown of the body's limits. Cyberpunk subjectivity, like that of the cosmetic surgery consumer, is seen as the product of individual choice to shop, invent, and create bodies and identities through technological means.

My likening of nonmainstream body art to cosmetic surgery is not meant to paint them with one brush. Cyberpunk body art can radically question the ownership of both the body and medical and cyber-technologies, and so offers critical potential as an outlaw(ed) practice. Yet, the radical aspects of cyberpunk body art often coexist with a liberal rhetoric of self-customization, rhetoric not inconsistent with the corporate model of the postmodern consumer whose shopping for identity is her primary expression of freedom. In both cases, empowerment and freedom are often imagined as highly personal matters that appear to be no longer tethered to embodied power relations.

An alternative reading identifies the making of high-tech bodies as always a social process, rather than solely one of individual persona. The frontier of the high-tech body is not post-ideological, but rather an emerging site of cultural and political struggle. As Orlan's "Reincarnation" suggests, while body technologies can be used as tools to invent personal style and imagine new bodies, they are artifacts of cultural capital. Cyber-technologies, medical technologies, and technologies of representation are now methods of moving and shifting identities and bodies across cultural and subcultural borders. They are resources for

identification and pleasure, and the ability to shift the meanings of these is an expression of power to which people have differential access. In many ways, cyborg technologies may express personal choice, but even when employed by the nonmainstream, their appropriations of technology are marked by power through the assertion, contesting, and appropriation of privilege. I would argue, for instance, that by exploring the historic forces informing the construction of the ideal female body, Orlan does not claim an unimpeded ability to name herself. Rather, she wrests such agency out of the grip of historically powerful regimes of representation.

We need what we might think of as an "ontological-epistemological humility," or an acknowledgement of the limits of our abilities to declare the truth and essence of our individual selves, whether they be based on nature or invention. This might be generated from, but is no means guaranteed by, nonmainstream consciousness and practice. Such practice may have the potential to transform ways of knowing and seeing our connections to others as well as our definitions of self. I think the techno-bodied subterfuge that takes places within attempts to pioneer the body, the self, and technology in cyberpunk at least demands a radical questioning of the ways we see all of these. Such pioneerism requires a rejection of liberal certainty from the new practitioners of body technologies, and demands humility from the hegemonic forces that would otherwise colonize them.

READING THE POSTMODERN TECHNO-BODY

THE TECHNOLOGIZED HUMAN OR THE "CYBORG" IS BECOMING increasingly visible in postmodernity with the acceleration of high-tech body practices, such as those being undertaken in conventional medicine, gene therapy, transsexual surgery, in vitro fertilization, cloning, cosmetic surgery, pharmacological interventions, and so on. In addition, the explosion of information technology, linked to what Mike Featherstone calls "global compression," has accelerated the possibilities of exposure to "the various others around the world," such that we see increasing "mobility, movement, and border-crossing" of bodies and identities.[1] This mobility has ushered in a cultural relativism in the West, such that classical ideals of the body are no longer unchallenged as the only aesthetic option for embodiment. Together, these developments, which find themselves so spectacularly expressed in street-level and subcultural style as well as in high fashion, art, and medicine, are forcing us at this historical moment to face the technologized and cultural character of our bodies.[2]

Because of its theoretical access to material and representational technologies, the postmodern body is often seen as unlinked from traditional

ontologies and identities. Technology is often represented as a resource to free us from what are seen as the natural constraints of the body, transforming the body into a "purely discursive entity," as Anne Balsamo puts it. The limits of the embodied self, such that it must be connected to place, that its movements and actions are limited to how much it can literally shuffle itself back and forth in "real" space, that it can live only with its birth-given organs and parts, visibly showing its age and background, seem already outmoded in high-tech culture. Relatedly, technology has also been imagined as freeing us of *cultural* constraints, so that the postmodern body appears as a highly flexible, unmapped frontier upon which an ontologically freed subject might explore and shift identities. The body is theoretically freed then from its traditional miredness in the cultural constructions of race, gender, and sexuality, among others. At its most extreme, as Balsamo describes, this view sees a body reduced to its surface, and ultimately, the disappearance of the body altogether, such that we are left only with "designer subjectivities," or self-created identities that are "floating sign-systems" with no fixed meanings.[3]

A political reading of technologized bodies, though, problematizes a view of the body as purely discursive as much as it problematizes one of the body as purely "natural" or material. A feminist reading, for instance, identifies constraints to subjectivity that are linked to the rootedness of bodies in the material, lived realities of gender, race, and other power relations. Unless race, class, and gender stratifications actually disappear, individuals are limited in the ways in which they can imagine themselves and shape their bodies and identities—even within a culture that celebrates such choice and freedom. From a critical feminist perspective, what might appear to be emerging freedoms offered up by new technological practices are instead seen as new subject positions forged *within* power relations, rather than outside them. Such a reading would insist that technologized bodies are not outside of culture and power, nor are they uniformly meaningful. Rather, bodies are conceived, technologized, and debated within politically and socially meaningful contexts by people who face different and multiple situa-

tions of power. This renders postmodern bodies multiply, heterogeneously significant.

Postmodern subjects are, for instance, differentiated in their acknowledgement of, desire for, and embeddedness in sociality, which Balsamo sees as linked to gender. In her analysis of Pat Cadigan's science fiction novel *Synners* (1991), Balsamo describes how male and female cyberpunks interact with and conceive of technology in multiple ways. For instance:

> Where Sam hacks the net through a terminal powered by her own body, Visual Mark actually inhabits the network as he mutates into a disembodied, sentient artificial intelligence (AI). Although both Gina and Gabe travel through cyberspace on their way to somewhere else, Gabe is addicted to cyberspace simulations and Gina merely endures them.[4]

Balsamo differentiates the characters along gendered lines between those that use technology to produce the "body-in-connection" (feminine) and those that use it to produce the "body-in-isolation" (masculine). Bodies seeking connection, as Balsamo has it, are bodies that "actively manipulate the dimensions of cybernetic space in order to communicate with other people."[5] The *Synners* characters, she argues, are gendered in their relation to technology, such that while the females use technology in ways that seek connection and link themselves to others, the male characters "are addicted to cyberspace for the release it offers from the perceived limitations of their material bodies."[6] Balsamo's point is that these differences—the individualism of male cyberpunk and the sociality of female cyberpunk—show how broader social relations like those of gender find themselves reflected in technologized bodies and body projects. Women are encouraged to see themselves and their bodies relationally, "in connection" to others, while male socialization has been profoundly more individualistic, and these differences influence the uses of, and ultimately the meanings of, technologies. We might think about how technologies are employed differently along such lines in real, rather than fictional, body projects;

how they are gendered in terms of their framing and production in connection with—or in isolation from—others.

As Balsamo points out, body technologies are differentiated because of the various ways in which, to begin with, bodies are differentiated, such as through their gendering. But body technologies are also differentiated through the stratifications woven into the technologies themselves. As critical scholars of technology have argued, the deployment of technologies by individuals, groups, and nations both reflects and creates privileges and constraints, and access to and control of technologies are highly political matters. Technologies are high- or low-tech, are outmoded or updated, are widely accessible or controlled by experts. They are characterized by speed and acceleration, such that some technological practices are inserted more quickly into the ever-changing matrix of culture, politics, and economy. In the age of information overload, they are engaged in contests over the extent of visibility and exposure, how they are sorted, and whether they surface on the radar screens of culture. In the media-saturated environment of postmodern culture, technological practices are linked to struggles over framing and defining social problems and groups identities. They are appropriated—as, for example, cyberpunks and performance artists have appropriated cosmetic surgery—and they are reappropriated, for example by the fashion and culture industries. Bodies become territories for technological innovation, for politics and for trafficking goods, and are fought over by social movements as well as medical, cosmetic, fashion, and culture industries, among other interests.

These aspects of technological society—speed, exposure, and processes of territorialization and reterritorialization—impact upon the abilities of individuals and groups to define themselves and their bodies. The ability to self-define is not only, then, about how flexible are bodies and identities in postmodern societies. Rather, as technoscience feminist Patricia Clough describes, "it is about negotiating with the speed of movement as a way of knowing and not knowing, as a way of being and not being exposed, over- and under-exposed."[7] Self-definition is linked

to technological power. From this perspective, body projects must be conceived not only as planned or unplanned, conscious or unconscious acts of the subject who negotiates among an increasing number of technological and cultural options for body styles, self-definition, and group identity. They must also been seen as practices that are cybernetic—situated in a flow of images and information—and that may be unfixed but are nonetheless socially stratified.[8]

The Italian social theorist Alberto Melucci describes how collective action in the information age involves a whole host of acts of "challenging codes." By "codes" he means the agreed-upon meanings of bodies, identities, and cultural and social issues. Challenging codes can involve breaching the "limits of compatibility of the system of social relationships within which the action takes place,"[9] or pushing the limits and boundaries set by established norms and social interests. There is a whole range of codes challenged by the body art movement. Its display of the spectacular body is created through the manipulation of primary categories of identity—ethnicity, gender, and sexuality among them. For instance, neo-tribal body art not only appears to represent political affinity with indigenous cultures, but also poses ethnicity as an elective identity for largely white, urban body-subjects. The use of deviant body practices by women appears to subvert gendered norms of female docility and beauty. Body modification is also perverse in its exploration of sexuality. The affective pleasures of body modification breach the ways sexuality is ordered in heteronormative culture. Such infractions are "inventions," in Foucault's sense of the word, because they break the orderedness/ordinariness of bodies and pleasures.[10]

But the radicalism of body modifiers is limited by social forces—sometimes the very same forces they seek to oppose, including patriarchy, Western ethnocentrism, symbolic imperialism, pathologization, and consumerism. Even the most radical body art does not rescue the body from these. Radical body artists, for instance, share with consumer capitalism an interest in the ever-changeable inscription of the body. In other ways, too, rebellious body projects echo powerful historical regimes. In the

deployment of images of the primitive, for instance, we see an ironic, powerfully symbolic tactic, but also uncertain and problematic political effects. The "primitive" as described here, despite the stated aims of neotribal body modifiers themselves, remains an image of colonialism: nostalgic and characterized as natural, uncivilized, sexualized, and wholly Other. Thus, the intentions of body artists are limited in how much they themselves produce the meanings of their practices. Bodies and technologies are not ever fully authored by individual subjects, but are always experienced and understood through the historical forces that shape them.

Body technologies, including those that are said to express self-narration, have methods and speeds of representation and self-representation that express cultural capital, resources and status. As Melucci argues, in the high-tech world empowerment is often a matter of controlling knowledge, and disempowerment is often lack of control over the creation of meaning, or dependence in the flow of information.[11] These stratifications not only *reflect* our subject positions within relations of power, but, as Clough argues, also participate in *creating* them. As Clough describes, categories like race and gender are not givens, "not simply matters of identity and surely not of authentic subject identity."[12] Instead, we need to think about how they are continually constructed through body practices and the inscriptions of culture, which in postmodern societies are linked to the media and culture industries, to information technology, and to economic and political relations. Some bodies, such as those of women and people of color, are more vulnerable to "territorialization" than others, to underexposure (in terms of their own definitions of self) or overexposure (in terms of their usefulness as spectacles and commodities). This means that political struggles now involve "the when, where or how of acknowledging, elaborating, resisting or refusing," as Clough puts it, the ways in which bodies and identities are coded within high-tech and consumer culture.[13] The "when, where, and how" of participating in how one's identity is marked and produced is precisely what is at stake for all of us as we participate regularly in body projects, radical or so-

cially acceptable. What a critical perspective on body projects points to is how our bodies and identities are constructed and reconstructed with differing levels of technological access, speed, and visibility in a postmodern and transnational, *but highly stratified,* social world.

Body projects can be seen to highlight how self-narration is linked to techno-representational access. Body art practices link the denatured body to the subject who can choose her identity. The practices are informed by a sense of freedom or liberation that is accomplished by the breakdown of both the material and the symbolic limits of the body.

As it breaks down borders and speeds up the traffic of information, representation, and bodies, however, technology not only increases possibilities of claiming and naming identity for those who find themselves so positioned, but also decreases the chances of self-definition for others. Virtual technologies, medical technologies, and technologies of representation are now among the methods of trafficking and producing identities and bodies across cultural boundaries. Cosmetic surgeries, botox and collegen injections, endlessly paraded in the media as part of the high-tech beauty ideal, are among the "medical" technologies on offer by high-tech consumer culture. The Internet offers space— through chat rooms, personal web pages, and digital photographs—to imagine and play out cyberidentities, as well as to surf the world's fashions, cultures, and styles for an astonishing range of information about bodies, from medical to cultural to spiritual. "Multicultural" fashion spreads, televised *National Geographic,* and the Travel Channel bring us exotic images of indigenous Africans, Asians, and others, while news programs, talks shows, MTV, and "reality" cop shows present people of color at home in variously sensationalized and damaging ways. These representations and technologies can all be used as resources for identification, but the ability to participate in creating the meanings of these is a function of power, to which people have widely differential access.

In the consumer model, self-narration is a highly personal matter, where shopping for identity and style is an individual's primary expression of freedom. A critical reading, however, must insist that the

fashioning of the body is always a social and political process, rather than one of individual choice and persona. In this view, the technologies of body projects are forms of cultural capital. "Technologies" here would not mean *only* the literal, materially transforming practices, such as the cosmetic surgery in Orlan's "Reincarnation" and the digital technology in her "Self-Hybridation," but also the technologies of making *visible* her body art projects, and of speeding up her identity "shopping." What Orlan accomplishes, beyond reshaping the material body, is the appropriation of various images of bodies of multiple cultures and epochs, as well as an ability to create a public spectacle, to be seen. What privileges does Orlan take in representing the bodies of indigenous people (in "Self-Hybridation")? What privileges does she challenge when she uses cosmetic surgery in ways that would shock most surgeons and the culture industries that champion such practices (in "Reincarnation")? How does being a woman and also a white Western European with a great deal of technological resources affect her ability to name and rename herself and define her bodily boundaries? What speeds of access, degrees of exposure, and points of representational insertion and interruption in the trafficking of images of various bodies are accomplished? How do they insert themselves, or make themselves visible, and at what speed, in the flow of "codes" or information that inform the lives and mark the bodies of women, people of color, radical queers, and others? How, and when, are these technologies of meaning themselves interrupted? When we can think of body art projects as processes of asserting, contesting, and appropriating various forms of privilege, we can ask these questions of them.

Thus, in critically thinking through how body projects and technobodies are differentiated, we can focus on a number of lines of stratification, including how they reflect or achieve: access to the flow of information, or the ability to navigate cultural systems to "borrow" images from multiple cultural options; visibility, or to what extent they command the social gaze in one's direction; speed, or the rate at which they can accomplish all this; and also how they are gendered in their

deployment of access, visibility, and speed along the lines of connection and isolation, to the extent that they acknowledge their social situatedness, their social and political linkages.

I see women's reclaiming projects, for instance, as interrogations of the individual body's ownership and governance, but also as ritualized in practices that both literally gather women together and mark women's collective position in gendered relations of dominance and violation.[14] Thus, these are body projects that put women in connection with each other, that make social what might have otherwise been solely private and silent sufferings, and that insist upon a political and to some extent "visible" reading of bodily and sexual victimization.[15] In reclaiming projects, agency is conceptualized as surmounting internalized oppression, perceiving that oppression as political rather than personal, and healing with the help of others.

I would also describe agency in these instances as the practice of commanding the social gaze, including the clinical gaze, such that the insertion of women's own meanings of surviving victimization usurp, at least temporarily, the experts' role in naming women's bodies—as in defining beauty, or diagnosing and treating victims. The task of "put[ting] symbols on our bodies to show that in fact we have been actively involved in taking our power back," to quote the tattoo artist Lamar Van Dyke, involves *interrupting* the circuits of meaning in what Melucci would call "symbolically wasteful" ways. "Symbolic wastefulness" is the ability to *slow down* the circuits of information flow, to interrupt the meanings being generated, to force a gaze upon oneself in ways that breach the system's symbolic limits. As he describes it,

> [symbolic wastefulness] serves . . . as the expression of an irreducible difference, of what is "valueless" because it is too minute or partial to enter the standardized circuits of the mass cultural market. The symbolic extravagance of female output [in cultural practices of the women's movement] introduces the value of the useless into the system, the inalienable right of the particular to exist, the irreducible significance of inner times which no History is [otherwise] able to record. . . . [16]

When women engage in anomalous body projects, meanings can be produced outside of what is functional, efficient, or otherwise fruitful for the social order. The circulation of norms can be, at least temporarily, interrupted, so that the ordinary relations of power over women's bodies, including those governing beauty, consumption, health and mental health, are challenged. The minute, partial, marginal "inner" histories of women's bodies can be made visible and inserted into the flow of information, such that the dominant ideologies are forced to confront their subjugated knowledges.

Modern primitivist projects, which sometimes overlap with reclaiming projects but are also uniquely deployed (often by straight, white men), also produce symbolic wastefulness, but I find them more masculinist, to use Balsamo's understanding, in terms of their *non*-recognition of connectedness. Modern primitivism emphasizes the global connection of bodies, the meeting of cultures, and the historical roots of all humans in tribal societies. To the extent that this represents connection, though, it is an *ideal* of connection that is not reflected in existing global cultural politics. Modern primitives participate in the historical, global economies of representation, which are highly stratified between producers and consumers, such that white Westerners have more technological access in terms of generating cultural meanings and defining selves and groups than those whom they seek to emulate. Melucci writes of such groups,

> The true exploitation is not the deprivation of information; even in the shantytowns of the cities of the Third World people are today are exposed to the media, only they do not have any power to organize this information according to their own needs. Thus, the real domination is today the exclusion from the power of naming.[17]

Ironically, the production of the modern primitive depends upon a sense of elective identity unfettered not only by one's personal or collective social history, but also by the cultural hierarchies within the "power of naming." In its refusal to acknowledge the relational politics

of identity and meaning production, modern primitivism embraces a "body-in-isolation." Like cyberpunk, modern primitivism is a trope of postmodern liberalism: we can be who we want to be, personal and social history notwithstanding.

Although as a feminist I want to privilege notions of the body that offer possibilities of recognizing others and their relatedness to ourselves rather than those that do not recognize them, there are no fixed, guaranteed political meanings generated out of either conception. These notions of the body, as connected and isolated, located and dislocated, traffic across cultural sites in multiply significant ways, and I would argue that myths are operating on both ends. I hope that bodies-in-connection have the potential to produce a politics of recognition, such that technologies of representation are linked to their larger historical, social, and/or political contexts. Such recognition is generated, for instance, in the anti-globalization movement when consumer bodies (those that wear Nike shoes and the Gap clothing of urban and suburban America) are linked to the laboring bodies of exploited women, men, and children. The recognition of our linked histories and futures may be required for any democratic attempt at sharing cultural, technological, and social resources, and for creating the conditions that might allow us to use body technologies in ways that multiply our existential possibilities rather than further stratify us culturally, economically, and socially. The danger of connectedness, of course, is that such a vision can easily contain essentialist myths, such as that women are really "one body," a distinct class with a defined set of bodily and social values and needs, as radical feminists have asserted (or that we are all really "primitives" underneath).[18] In working out the unification of women (or other groups) based on such unitary notions of the body and subject, we can problematically naturalize our bodies and ontologies, infusing them with dominant values to the detriment and marginalization of others.

Bodies-in-isolation, alternatively, are born out of an individualism that celebrates disconnection, distinction, and difference. Sometimes Romantic, other times meritocratic or even social Darwinian, bodies-in-isolation

are underwritten with a myth of non-locatedness, the dream of freedom from the tethers of body, culture, group identity, and history. The body-in-isolation is, of course, a privileged body. Such a refusal to recognize the social, economic, and political links that tie us together, and that inform our body technologies, encourages the myths of individualism that makes consumer capitalism so appealing to so many. The "right" to individuality, to standing alone, negotiating to get one's own, self-defined needs met through technological access, is a powerful force operating in the world of body technologies and one that is much broader than I have addressed in this book. It is the source of a great deal of the ethical crises in biotechnology, in cloning and "designer genes," in increasingly popular cosmetic surgeries, in increasingly high-tech, expensive, and economically stratified health care. Enough cannot be said, in my opinion, about the problems of individualism when it comes to such issues, especially since what are ultimately at stake in body technologies are not only appearance, style, and identity, but also material and cultural survival, human equality and dignity. For instance, the increasingly high-tech quest for beauty in the United States, and even our hailing of expensive, high-tech medical breakthroughs that will prolong life for the few who will have access, are part of a global stratification of economies, technologies, and health resources that also include health crises of astonishing proportions. Many of these, such as starvation and malnutrition, do not necessarily require high-tech, but rather political and economic, solutions; others involve redrawing rights of ownership to life-prolonging drugs, such as in the controversy over the use of AIDS drugs in poor nations.[19] The framing of technologies as individualized problem-solvers and as producers of individualized bodies and identities comes, I think, at great social and ethical expense in the context of a world that contains both impressive bodily luxury and great bodily suffering.

The "postmodern" bodily style of flexibility and choice is part of a larger capitalist-driven ideology of consumption, and this is partly what gives the global stratifications of economies and technologies their means and justification. What I have tried to show in this book,

though, is how the Western flexible body, or the body-seen-as-project, described here in one of its more startling subcultural permutations, is saturated with political meanings and is symbolically, culturally, and even materially stratified. It is differentiated by these stratifications, and so the flexible postmodern body is really many bodies and deployments of body technologies. The flexible body is a body of privilege. At the same time, under consumer capitalism, it is a body under contract, so to speak, to produce its own identity through consumption practices. So *how* the body is composed can become a matter of recognition and non-recognition, avowal and disavowal of its social and political meanings and consequences.[20] One promise of dislocating the body-subject from the most sedimented of cultural meanings might be that she could disavow categories of identity that have primary roles in cultural stratification, that she might symbolically invert or overturn the naturalization of the body, or that she might queer ontologies that participate in producing the stratification of bodies/selves across naturalized lines of race, gender, and ethnicity. And so, such bodies—such cyborgs and monsters, in Donna Haraway's terms—remain in some ways rebellious, unfixed, unclosed to possibilities that might be contained within and without them. They fiddle with cracks in technology's stratified systems of function, purpose, and ownership. Perhaps they open paths for other challenges to myths of bodily integrity, identity's nature, and technological expertise. The body technologies described here— technologies that are deployed to queer the body—also queer technology in terms of its expertise and purpose.[21] Such bodies are disruptive not because they are wholly unintelligible, but because they remain partly unintelligible while also speaking the common language of consumption, flexibility, and technological invention/intervention. They are haunted with ordinary relations of power while they so spectacularly contest them.

NOTES

INTRODUCTION

1. See Margo DeMello, *Bodies of Inscription* (Durham, N.C.: Duke University Press, 2000). My argument is that contemporary body modifiers are often tattoo enthusiasts, but the rise in the body art subculture is not simply an outgrowth of conventional tattoo subculture. In contrast to conventional tattoo culture, which has its roots largely in heterosexual and male working-class culture, gay men, lesbians, and other queer groups have been important innovators in body modification, along with "pro-sex" SM women, fetish enthusiasts, artists, and later, cyberpunk youth.
2. In "ball dances," items like fruit, decorative balls, or other weights are pinned to the flesh. While the person is dancing, the items tug at the flesh. Kavadi frames are made from a series of inward-poking spears; when they are worn the spears poke into various places on the torso.
3. Ibid. As Clinton Sanders points out, ancient tribes in the West, such as those in the British Isles, were practicing tattooing, although in the Christian era tattooing was often banned. Clinton Sanders, *Customizing the Body: The Art and Culture of Tattooing* (Philadelphia, Penn.: Temple University Press, 1989).
4. Ibid., 18.
5. Ibid., 19.
6. Queer radicalism, for instance, has emphasized anti-assimiliationism not for its own sake, but as part of resisting stigma and pathologization in heteronormative society. As Steven Epstein puts it, queer activism since the 1980s has engaged in a "politics of provocation" in which social tolerance for anomalously gendered and pleasured bodies is constantly pushed. See Epstein, "A Queer Encounter: Sociology and the Study of Sexuality," *Sociological Theory* vol. 12, no. 2 (1994), 195.
7. Katherine Dunne, "Introduction," in Jim Rose, *Freak Like Me* (London: Indigo, 1996), 10.
8. Fakir Musafar in "Body Play: State of Grace or Sickness?," epilogue in Armando Favazza, *Bodies Under Siege: Self-Mutilation and Body Modification in Culture and Psychiatry* (Baltimore, M.D.: Johns Hopkins University Press, 1996), 326.

9. Another magazine, *Piercings Fans International Quarterly*, is less fascinated with tribal practices, but equally interested in the modified body's sexual potential outside the heteronormative mainstream.

10. Pat Califia, *Public Sex: The Culture of Radical Sex* (San Francisco: Cleis Press, 1994).

11. V. Vale and Andrea Juno, *Modern Primitives* (San Francisco: Re/Search Publications, 1989), 105.

12. Musafar in Favazza, 1996: 326. Favazza describes writing *Bodies Under Siege* as a trying experience because of the repulsion of editors and colleagues—psychiatrists!—to the very topic of self-mutilation. The publication of the book, however, in 1987 (in paperback in 1992), was highly successful, especially as body modification became a hot topic for study. What is fascinating is how this book, which pathologizes body modification practices even as it gives a somewhat sympathetic account of the link between body modification and religious and cultural rituals, became marketable via the body modification generation. The 1996 reprint of this book (substantially the same book, with a new preface and an epilogue written by Fakir Musafar) was marketed in places like Tower Records as well as university bookstores, with a new cover—a provocative, sexy picture of a woman's branding—and a new subtitle: *Bodies Under Siege: Self-Mutilation* and Body Modification *in Culture and Psychiatry* (emphasis mine).

13. Paul Sweetman, "Only Skin Deep? Tattooing, Piercing, and the Transgressive Body," in *The Body's Perilous Pleasures: Dangerous Desires and Contemporary Culture*, ed. M. Aaron (Edinburgh: Edinburgh University Press, 1999).

14. Anthony Shelton, "Fetishism's Culture," in *The Chameleon Body*, ed. Nicholas Sinclair (London: Lund Humphries, 1996).

15. James Gardner, *The Age of Extremism: Enemies of Compromise in American Politics, Culture and Race* (Toronto: Carol Publishing, 1997), 186.

16. See Daniel Rosenblatt, "The Antisocial Skin: Structure, Resistance, and Modern Primitive Adornment in the United States," *Cultural Anthropology* vol. 12, no. 3 (1997), 287–334; Valerie Eubanks, "Zones of Dither: Writing the Postmodern Body," *Body and Society* vol. 2 no. 3 (1996), 73–88; Vale and Juno, 1989.

17. Rosenblatt, 1997: 298.

18. See Abby Wilkerson, *Diagnosis: Difference: The Moral Authority of Medicine* (Ithaca: Cornell University Press, 1998).

19. Maria Lowe writes in her book on female bodybuilding that ethnographic approaches allow researchers to "document the lived experiences of the actors being studied and ascertain their definitions of situation" (*Women of Steel: Female Body Builders and the Struggle for Self-Definition*, New York: New York University Press, 1998, 168). I would add that what we docu-

ment are the *performances* of actors and bodies, their *representations* and creations of meaning, and our interpretive gaze upon these. Throughout, I have been aware of the Othering possibilities of my researcher's gaze, and so I have tried to avoid exposing research subjects in ways that exploit the "differences" of their marked bodies. Readers may notice, then, that my presentation of individual subjects often privileges interview material over my descriptions of their visibly marked selves.

20. Between 1996 and 2001, I toured over two dozen body modification studios, mostly in four cities in the United States (greater Boston, New York, San Francisco, and Philadelphia), but also elsewhere, including a few European cities (London, Amsterdam, Berlin, Dublin). I also attended body art demonstrations and performances at venues such as women's pro-sex bookstores, fetish clubs, and art installations.

21. Five of them were also professional body modification artists who operated out of either body piercing studios or tattoo parlors and have collectively pierced, branded, and scarred many hundreds of body modifiers. The interviews were taped, transcribed, semi-structured, and open-ended. I began by asking about the affective dimensions of the practices, the structure of body modification rituals, the specific body modifications undertaken by a subject, the decision processes in acquiring them, and the perceived responses of others to a subject's modified body. However, the interviews went far beyond these general topics. I content-analyzed interview transcripts and focused on the repetition of themes and lexicon across interviews, as well as on the individual self-representation of body marks.

22. I found my first interviewees during an observation of a public scarring, a demonstration at a women's pro-sex bookstore in Boston. Demonstrations are educational sessions led by experienced body modification artists, which attract enthusiasts who are there to watch, enjoy, lend support to the person undergoing modification, and to display their own modifications. There and at later events, I observed multiple scarrings, brandings, tattooings, and piercings.

23. Earl Babbie, *The Practice of Social Research,* sixth edition (Belmont, Calif.: Wadsworth, 1992).

24. Lowe, 1998: 169.

25. Kim Hewitt, *Mutilating the Body: Identity in Blood and Ink* (Bowling Green, Ohio: Popular Press, 1997); C. Moser, J. Lee, and P. Christensen, "Nipple Piercing: An Exploratory-Descriptive Study," *Journal of the Psychology of Human Sexuality* vol. 62 (1993), 51–61.

26. Eubanks, 1996; Aidan Campbell, *Western Primitivism: African Ethnicity* (London: Cassell, 1998).

27. There are other limitations. Since I began my study, it has become apparent that male fraternities have been using brandings as hazing practices.

My study does not address fraternity hazing (except through the views of my non-fraternity participants), although I think this is a fascinating topic, an important one for masculinity studies.

28. Other participants, including urban and suburban youth who have been enthusiastic supporters of some forms of body modification, are neglected, although as Fred Davis points out, subcultural youth are often attracted to marginal practices that they perceive as having a charge of authenticity that originates elsewhere. See Fred Davis, *Fashion, Culture and Identity* (Chicago: University of Chicago Press, 1992).

29. Gardner, 1997: 186; see DeMello, 2000; Campbell, 1998; Rosenblatt, 1997; Eubanks, 1996; Vale and Juno, 1989.

30. Michel Maffesoli, *The Time of the Tribes: The Decline of Individualism in Mass Society* (London: Sage, 1996).

31. I relied most heavily on the magazines *Body Play and Modern Primitives Quarterly* (which has a subscription rate of 4,000) and *In the Flesh*, which are self-defined body modification magazines, but I also read many others. Other magazines, which cater to specialty groups such as tattooees, fetishists, piercing enthusiasts, and leatherdykes, include *Skin and Ink, Skin Deep: The European Tattoo Magazine, Piercing Fans International Quarterly, Bad Attitude!*, and *Taste of Latex*.

32. One notable exception is that few of the magazines articulated women's gender interests as strongly as women themselves did, with the exception of the lesbian magazine *Bad Attitude!*.

33. These include *Nothing But the Girl: The Blatant Lesbian Image*, ed. Susie Bright and Jill Posener; *Torture Garden: From Bodyshocks to Cybersex*, ed. David Wood; *The Chameleon Body*, Nicholas Sinclair; *The Return of the Tribal*, Rufus C. Camphausen; and *Modern Primitives*, Vale and Juno. These texts not only represent body modifiers, but they are read by them.

34. Gardner, 1997; Musafar in Favazza, 1996.

35. These include the *Washington Post*, the *San Francisco Chronicle*, the *New York Times*, the *Guardian* (London), the *Atlanta Constitution*, the *Chicago Tribune*, the *Independent* (London), the *Los Angeles Times, Newsday*, the *Boston Globe*, the *Seattle Times*, and the *Star Tribune* (Minneapolis), as well as accounts in the women's magazines *Ms.* and *Vogue*.

36. See my article "Body Modification, Self-Mutilation and Agency in Media Accounts of a Subculture," in *Body Modification*, ed. Mike Featherstone (London: Sage, 2000), for a fuller discussion.

37. See Donna Haraway's oft-reprinted work, "A Cyborg Manifesto: Science, Technology and Socialist Feminism in the Late twentieth Century," in *The Cybercultures Reader*, edited by Daniel Bell and Barbara Kennedy (London: Routledge, 2000 [1991]); see also Norm Denzin, *Interpretive Interactionism* (London: Sage, 1989).

CHAPTER 1

1. Favazza, 1996.
2. Pitts, 2000.
3. Michael Kelly, "Reviving the Lure of the Evil Weed," *Washington Post,* April 22, 1998.
4. Like other issues in relation to the body, sexuality, and perceived violence (pornography, sadomasochism), body modification debates place radical feminists and social conservatives in the same camp.
5. Hero Brown, "The Human Condition: The First Cut is the Deepest: Scarring and Branding Is the Body Modifier's Way of Saying I Love You," *Independent* (London), October 5, 1997.
6. Greg Beaubien, "Burning Question: Branding Makes its Mark as the Latest Fad in Body Modification, but Is It Art or Self-Mutilation?" *Chicago Tribune,* February 17, 1995.
7. Delicate self-harm syndrome, a widely publicized disorder, has been described as afflicting mostly females and to be associated with sexual abuse and a wide array of illnesses, including depression, borderline personality disorder, and psychosis. This form of cutting, according to the medical/psychiatric explanation, is indiscriminate and uncontrolled, promoting pain and endorphins to alleviate dissociation, sometimes resulting in a mass of scars across the limbs. It is associated with shame and thus is usually hidden from others, except in "contagion" syndrome where institutionalized individuals tend to copy each other's mutilations. As a response to sexual trauma, cutting has also been associated with post-traumatic stress disorder. Judith Lewis Herman, *Trauma and Recovery* (New York: HarperCollins, 1992). For a critical account of medical perspectives on delicate self-harm, see Nikki Sullivan's article "Fleshly (Dis)figuration, or How to Make the Body Matter," *The International Journal of Critical Psychology,* vol. 5, forthcoming.
8. Linda Grant, "Written on the Body," *Guardian,* April 1, 1995.
9. Nikki Sullivan, *Tattooed Bodies: Subjectivity, Textuality, Ethics and Pleasure* (Westport, Conn.: Praeger, 2001).
10. Janet Price and Margit Shildrick, eds., *Feminist Theory and the Body: A Reader* (New York: Routledge, 1999).
11. Ann J. Cahill, *Rethinking Rape* (Ithaca: Cornell University Press, 2001), 51.
12. Bryan S. Turner, "Recent Developments in the Theory of the Body," in *The Body: Social Process and Cultural Theory,* ed. Mike Featherstone, Mike Hepworth, and Bryan S. Turner (London: Sage, 1991), 4.
13. Ibid., 7.
14. Ibid., 9.
15. Ibid.

16. Ibid.
17. Bryan S. Turner, "The Discourse of Diet," in *The Body: Social Process and Cultural Theory;* Mike Featherstone, "The Body in Consumer Culture," in the same volume; and Alberto Melucci, *Challenging Codes* (Cambridge: Cambridge University Press, 1996).
18. Mike Featherstone, ed., "Body Modification: an Introduction," in *Body Modification* (London: Sage, 2000), 3.
19. Neal Curtis, "The Body as Outlaw: Lyotard, Kafka, and the Visible Human Project," in *Body Modification.* Also, technological invention has accomplished the circulation of bodily information in cyberspace and even human robotics—the remote control of wired-up bodily parts through using electrical stimulation powered through the Internet. See Ross Farnell, "In Dialogue with 'PostHuman' Bodies: Interview with Stelarc," in *Body Modification.*
20. Alphonso Lingus, *Excesses: Eros and Culture* (Albany, N.Y.: State University of New York Press, 1983).
21. Ibid., 25.
22. Ibid.
23. Chris Shilling, *The Body and Social Theory* (London: Sage, 1993), 5.
24. Anthony Giddens, *Modernity and Self-Identity* (Cambridge, U.K.: Polity Press, 1991).
25. Sullivan, 2001: 4.
26. In one of the first scholarly articles to describe the most recent phase of the body art movement, James Myers describes the scarification, piercing, and branding by an SM group as expressing a sense of group belonging, establishing individual identity, and rebelling against the mainstream. James Myers, "Nonmainstream Body Modification," *Journal of Contemporary Ethnography* vol. 21 (1992), 267–307.
27. Paul Sweetman, "Marked Bodies, Oppositional Identities? Tattooing, Piercing and the Ambiguity of Resistance," in *Practicing Identities: Power and Resistance,* ed. S. Roseneil and J. Seymour (London: Macmillan, 1998), 5.
28. Paul Sweetman, "Anchoring the (Postmodern) Self? Body Modification, Fashion, and Identity," in *Body Modification,* 53. Similarly, Kim Hewitt suggests that pain is used in contemporary body modification, including in tattoos, piercings, scarification and branding, for self-transformation and to "provoke awareness of bodily boundaries and self" (Hewitt, 1997: 39).
29. DeMello, 2000: 143.
30. Ibid., 3.
31. Ibid., 16.
32. Bryan S. Turner, "The Possibility of Primitiveness: The Sociology of Body Marks in Cool Societies," in *Body Modification,* 42.
33. Ibid., 43.

34. Ibid., 49.

35. Patricia Clough speaks of feminists' "profound suspicion" of postmodern theories of the body in *Autoaffection: Unconscious Thought in the Age of Teletechnology* (Minneapolis: University of Minnesota Press, 2000), 139.

36. Featherstone, 2000: 5.

37. Elizabeth Grosz, "Inscriptions and Body Maps: Representations and the Corporeal," in *Space, Gender, Knowledge: Feminist Readings*, ed. Linda McDowell and JoAnn P. Sharp (London: Arnold, 1997), 239.

38. Mike Featherstone, "The Body in Consumer Culture," in *The Body: Social Process and Cultural Theory*, ed. Featherstone, Hepworth, and Turner (1991): 176.

39. Shelton, 1996: 99. In Karmen MacKendrick's terms, "we find here [in subcultural body modification] an ironic distance from [both] the 'natural' body *and* normalizing technology." Karmen MacKendrick, "Technoflesh, or Didn't That Hurt?" *Fashion Theory* vol. 2, no. 1 (1998), 21–22, emphasis mine.

40. Stuart Hall, *Representation: Cultural Representations and Signifying Practices* (London: Open University Press, 1996), 5.

41. As Nikki Sullivan puts it, "[T]he body is one that 'does I', or performs its identity in and through its relations with others, and that both marks and is marked—ad infinitum—in and through . . . affective dramatizations of (inter)subjectivity" (2001: 8).

42. Chris Weedon, *Feminist Practice and Poststructuralist Theory* (Cambridge, Mass.: Blackwell, 1987).

43. Arthur Frank, "For a Sociology of the Body: An Analytic Review," TK 47.

44. Shelton, 1996.

45. Wilkerson, 1998; Andy Medhurst and Sally Munt, eds., *Lesbian and Gay Studies: A Critical Introduction* (London: Cassell, 1997).

46. Josephine Donovan describes post-essentialist feminism as casting doubt on the liberal Enlightenment notion of a stable, coherent self anchored in rationality; its faith in the neutrality of science and reason; and its universal and apolitical view of the body. *Feminist Theory: The Intellectual Traditions of American Feminism* (New York: Continuum, 1998).

47. Judith Butler, *Bodies That Matter: On the Discursive Limits of Sex* (New York: Routledge, 1993).

48. Anne Balsamo, "Forms of Technological Embodiment: Reading the Body in Contemporary Culture," in *Cyberspace/Cyberbodies/Cyberpunk: Cultures of Technological Embodiment*, ed. Mike Featherstone and Roger Burrows (London: Sage, 1995).

49. Grosz, 1997: 239.

50. Patricia Clough, *The End(s) of Ethnography: From Realism to Social Criticism*, second edition (New York: Peter Lang, 1998), xxii.

51. Grosz, 1997: 238.

52. Dick Hebdige, "Posing . . . Threats, Striking . . . Poses: Youth, Surveillance, and Display," in *The Subcultures Reader,* ed. Ken Gelder and Sarah Thorton (London: Routledge, 1997 [1983]).

53. Michel Foucault, *Power/Knowledge: Selected Interviews and Other Writings 1972–1977,* trans. Colin Gordon (New York: Pantheon, 1980).

54. See Mikhail Bakhtin, *Rabelais and His World,* trans. Helene Iswolsky (Cambridge, Mass.: Massachusetts Institute of Technology Press, 1984) and *The Dialogic Imagination,* trans. Caryl Emerson and Michael Holquist (Austin: University of Texas Press, 1981).

55. Dick Hebdige, *Subculture: The Meaning of Style* (London: Methuen, 1979).

56. Hebdige, 1997 [1983]: 403.

57. Barbara Babcock, *The Reversible World: Symbolic Inversion in Art and Society* (Oxford: Claredon Press, 1978).

58. Ken Gelder, in *The Subcultures Reader,* ed. Gelder and Thorton, 373–74.

59. Colleen Ballerino Cohen, "Olfactory Constitution of the Postmodern Body: Nature Changed, Nature Adorned," in *Tattoo, Torture, Mutilation, and Adornment,* ed. Frances Mascia-Lees and Patricia Sharpe (Albany, N.Y.: State University of New York Press, 1996), 63.

60. As Michael Brake put it in trying to imagine a subcultural display politics among minority groups, gay people, and feminists, "their success and continuation depends upon a series of strategies which involve . . . waging systematic, cultural, guerilla raids on the dominant morality. A struggle develops over what is and is not permitted." *Comparative Youth Culture: The Sociology of Youth Cultures and Subcultures in America, Britain, and Canada* (London: Routledge, 1985), 11.

61. Butler, 1993: 3.

62. Ibid.

63. Judith Butler, *Gender Trouble: Feminism and the Subversion of Identity* (New York: Routledge, 1990), 137.

64. Melissa Klein, "Duality and Redefinition: Young Feminism and the Alternative Music Community," in *Gender Through the Prism of Difference,* ed. Maxine Baca Zinn, Pierrette Hondagneu-Sotelo, and Michael Messner (Boston: Allyn and Bacon, 1999), 454.

65. Ibid., 457–58.

66. Butler, 1993: 226.

67. Gelder, 1997; Hebdige, 1997 [1983].

68. Anne Balsamo, *Technologies of the Gendered Body: Reading Cyborg Women* (Durham, N.C.: Duke University Press, 1996), 55.

69. Epstein, 1994.

70. Peggy Phelan, *Unmarked: The Politics of Performance* (London: Routledge, 1993), 163.

71. Butler, 1993: 226.

72. Ibid.
73. Butler, 1990: 144.
74. Clough 2000: 129.
75. In Patricia Clough's view (2000), this is what Butler's work is ultimately drawn toward.

CHAPTER 2

1. Jacqueline Urla and Alan C. Swedlund, "The Anthropometry of Barbie: Unsettling Ideals of the Feminine Body in Popular Culture," in *Feminism and the Body,* ed. Londa Schiebinger (Oxford: Oxford University Press, 2000), 418.
2. Naomi Wolf, *The Beauty Myth: How Images of Beauty Are Used against Women* (New York: William and Morrow, 1991), 14.
3. Williams, 1992, in Urla and Swedlund, 2000.
4. Kaw, 1993 in Urla and Swedlund, 2000.
5. Urla and Swedlund, 2000.
6. Ibid.
7. Susan Bordo, *Unbearable Weight: Feminism, Western Culture and the Body* (Berkeley: University of California Press, 1993), 16.
8. Ibid., 16–17.
9. Irene Diamond and Lee Quinby, "American Feminism in the Age of the Body," *Signs: Journal of Women in Culture and Society,* vol. 10, no. 1 (1984), 119–125, 199.
10. Dworkin, 1974: 113–114, cited in Bordo, 1993: 17. Emphasis original.
11. Emilie Buchwald, "Raising Girls for the 21st Century," in *Transforming a Rape Culture,* ed. Buchwald, Pamela Fletcher, and Martha Roth (Minneapolis: Milkweed Editions, 1993), 197.
12. Catherine MacKinnon, "Sexuality," in *The Second Wave,* ed. Linda Nicholson (New York: Routledge, 1997), 160.
13. Andrea Dworkin, "Gynocide: Chinese Footbinding," in *Living With Contradictions: Controversies in Feminist Ethics,* ed. Alison M. Jaggar (Boulder, Col.: Westview Press, 1994).
14. MacKendrick, 1998: 6.
15. Attempts to legislate against pornography as a form of harm to women, for instance, provoked intense discussion over whether women could make more valuable, feminist pornography, and whether or not the state can be trusted with the power to regulate sexual expression.
16. Klein, 1999: 453.
17. Ibid., 454.
18. Leonora Champagne, *Out From Under: Texts by Women Performance Artists* (New York: Theater Communications Group, 1990), 2.

19. Elin Diamond, "The Shudder of Catharsis in 20th-Century Performance," in *Performativity and Performance,* ed. Andrew Parker and Eve Kosofsky Sedgwick (New York: Routledge, 1995), 164.

20. Amelia Jones, *Body Art: Performing the Subject* (Minneapolis: University of Minnesota Press, 1998), 190.

21. Klein, 1999: 452.

22. Ibid., 454.

23. MacKendrick, 1998: 21.

24. In 1996, Fakir Musafar described reclaiming as an all-too-common reason for contemporary women's modifications, a "sad commentary," he writes, "on the abusiveness and disregard for others' sacred space in our society" (writing in the epilogue to Favazza, 1996: 329).

25. As a women's body modification artist named Lamar Van Dyke puts it:

 Our bodies are one of the things that we have that nobody can take away from us. We can do whatever we want. It's a way that we can express ourselves and we can take our power back and we can put symbols on our bodies to show that in fact we have been actively involved in taking our power back.

 Further, Raelyn Gallina argues again that reclaiming is especially significant for women who have survived victimization:

 There's so many women that come to me wanting their labias pierced that they tell me that this is to reclaim their sexuality and their bodies because they were incested or raped, or some form of abuse . . . this is a healing and empowering act for them that is ritualized and marks this turning point in their life.

 All four cited from the film by Leslie Asako Gladsjo, *Stigmata: The Transfigured Body* (funded by the Rocky Mountain Film Center, Boulder, Col. and the National Endowment for the Arts, 1991).

26. See Deborah Shouse, "Mark Her Words: Daughter Attempts To Cope with History of Sexual Abuse Through Tattooing and Body Piercing," *Ms.,* vol. 7 (Sept/Oct 1996), 96; and Roberta Smith, "Body of Evidence," *Vogue,* vol. 184 (Aug 1994), 150. Some emerging research also points to the spread of "reclaiming" body projects to women in alternative communities who have survived breast cancer and mastectomy.

27. Victor Turner, *The Forest of Symbols: Aspects of Ndembu Ritual* (Ithaca, New York: Cornell University Press, 1967), 95.

28. Which places it in "interaction with the world" where it "transgresses its own limits" (Bakhtin, 1984: 281).

29. See John O'Neill, *The Communicative Body* (Evanston, IL: Northwestern University Press, 1989).

30. Fakir Musafar, "Becky's Breast Cuttings," *Body Play and Modern Primitives Quarterly* vol. 4, no. 3 (1997), 26–27.
31. All other interviewee names have been changed but Raelyn Gallina's. Raelyn requested that her real name be used in this book, and I honored that request.
32. Musafar, 1997: 27.
33. Ibid.
34. Ibid.
35. This is a Native American symbol widely recognized in non-native U.S. culture. Jane's choice of the dreamcatcher symbol and her choice of the scarification ritual reflect the neotribal nature of much contemporary body modification. I pursue the political implications of this in chapter 4.
36. Rob Shields, *Places on the Margin: Alternative Geographies of Modernity* (London: Routledge, 1991), 89.
37. Turner, 1967, cited in Shields, 1991: 89.
38. Lisa's invoking of native practices, like those of the other women, raises some interesting and problematic issues about the representational politics of ethnicity that I address in chapters 3 and 4.
39. Shields, 1991: 269. Even in indigenous rites of passage, as Victor Turner describes, marginality is often regarded as polluting or unclean, but the marginal position of the liminal person is necessary for symbolic transformation to become social reality.
40. Ibid., 84.
41. Kathy Davis, "My Body Is My Art: Cosmetic Surgery as Feminist Utopia?" *European Journal of Women's Studies* vol. 4 (1997), 23–37, 34.
42. Shields, 1991: 277.
43. Eubanks, 1996: 81.
44. Jeffreys, 1994: 21, quoted in Nikki Sullivan, "Fleshing Out Pleasure: Canonisation or Cruxification?," *Australian Feminist Studies* vol. 12, no. 26 (1997), 283–291, 286.
45. Sullivan, 1997: 287. For a study of newspaper accounts of body modification, see Pitts, 2000. Sometimes, body modifications have also been identified as political acts.
46. *Boston Globe* editorial, "Turn Down the Stereotypes," July 31, 1997.
47. MacKendrick, 1998: 5.
48. Pitts, 2000.
49. Leslie Heywood, *BodyMakers: A Cultural Anatomy of Women's Bodybuilding* (New Brunswick, N.J.: Rutgers University Press, 1998), 7. Yet, she finds a positive function of women's bodybuilding: through engaging with and resisting dominant cultural expectations for their bodies, women are "recuperating to-be-looked-at-ness" from a position of passivity and oppression to one of self-definition (158).

50. See Sarah Thorton, "The Social Logic of Subcultural Capital," in *The Subcultures Reader,* ed. Gelder and Thorton, 200.
51. Jones, 1998: 11.
52. Susan Bordo, "Feminism, Postmodernism, and Gender-Skepticism," in *Feminism/Postmodernism,* ed. Linda J. Nicholson (New York: Routledge, 1991), 145. I address this issue again in the final chapter on cyberpunk, which sometimes posits the technologized body as a limitless "frontier."
53. E. Seaton, "Profaned Bodies and Purloined Looks: The Prisoner's Tattoo and the Researcher's Gaze," *Journal of Communications Inquiry* vol. 11 (1987), 17–25, 21.
54. Advertisement from *In the Flesh* vol. 2, no. 5 (1997).
55. Phelan, 1993: 6.
56. Jones, 1998: 24.
57. Michel Foucault, *Madness and Civilization: A History of Insanity in the Age of Reason,* trans. Richard Howard (New York: Vintage, 1973 [1965]), 276.
58. Sullivan, forthcoming.

CHAPTER 3

1. For discussions of and references to the link between body modification subculture and gay and lesbian SM subculture, see: Myers, 1992; Moser and Christensen, 1993; Pat Califia, *Public Sex: The Culture of Radical Sex* (San Francisco: Cleis Press, 1994); Shiela Jeffries, "Sadomasochism, Art and the Lesbian Sexual Revolution," *Artlink* vol. 14, no. 1 (1994); Favazza, 1996; David Alan Mellor, "The Chameleon Body," in *The Chameleon Body: Photographs of Contemporary Fetishism,* ed. Nicholas Sinclair; Valerie Steele, *Fetish: Fashion, Sex and Power* (New York: Oxford University Press, 1996); Shelton, 1996; Rosenblatt, 1997; Hewitt, 1997.
2. Tamsin Wilton, "Temporality, Materiality: Towards a Body in Time," in *Women's Bodies: Discipline and Transgression,* ed. Jane Arthurs and Jean Grimshaw (London: Cassell, 1999), 51.
3. Laura Gowing, "History," in *Lesbian and Gay Studies: A Critical Introduction,* ed. Medhurst and Munt, 60.
4. Ibid., 57.
5. Lisabeth During and Terri Fealy, "Philosophy," in *Lesbian and Gay Studies,* ed. Medhurst and Munt, 116.
6. Cath Sharrock, "Pathologizing Sexual Bodies," in *Lesbian and Gay Studies,* ed. Medhurst and Munt, 361.
7. Ibid., 361.
8. Ibid., 359.
9. Ibid.
10. Ibid., 358.

11. In addition, while "certain medical claims about homosexuality have been re-tracted . . . judgments of the inferiority of homoeroticism can still be found in medicine" and in other authoritative discourses (Wilkerson, 1998: 43).
12. Eve Kosofsky Sedgwick, *The Epistemology of the Closet* (Berkeley: University of California Press, 1990), 28.
13. Wilton, 1999: 55.
14. Affrica Taylor, "A Queer Geography," in *Lesbian and Gay Studies,* 12. Their tactics include kiss-ins, "queering the mall" events, and agit-propaganda.
15. Mary McIntosh, "Class," in *Lesbian and Gay Studies,* 235.
16. What "queer practice" means is far from certain given the complexity and contradictions of queer theory, but at the broadest level, queer practice has been theorized as necessarily embodied. For instance, Steven Epstein describes bodily rebellion, anti-assimilation, and deconstruction as integral to queer practice. Queerness includes a "politics of provocation" in which "the limits of liberal tolerance are constantly pushed" (Epstein, 1994: 195). Although many of the body modification rituals described below involved both gay men and lesbian women, there are clearly differences in men's, women's, and transgendered experiences of the practices, and there is no monolithic meaning to gay, queer, or lesbian body modification. Rather, these diverse narratives use both personal language and a shared, recognizable subcultural discourse, the latter of which imbues body modification with agency, rebellion, and political import.
17. David Wood, *Torture Garden: From BodyShocks to Cybersex* (London: Creation Books, 1996), 4.
18. Ted Polhemus, cited in Wood, 1996: 9.
19. Shelton, 1996: 90.
20. Epstein, 1994: 195.
21. In my review of newspaper coverage of body modification, nearly 25 percent of the articles focused on sadomasochism or "deviant" sex by gay men or lesbians. In both celebratory and critical writings, body modification was associated with sex deviance—for example, with "raucous transgressions of sexual mores," "gender reassignment," decadence, "sexual anarchy," sex activism, porn, bondage, and sex "romps" (see Pitts, 2000).
22. Also, in 1990, an NEA "porn" controversy in Congress was sparked by a gallery's photographs of gay body modifiers. V. Vale and Andrea Juno, "Art Controversy Is About Freedom of Expression," *San Francisco Chronicle,* March 23, 1990.
23. Mary Abbe, "Walker's Erotic Torture Heated Up National Debate," *Minneapolis Star Tribune,* December 28, 1994; Jan Breslauer, "The Body Politics," *Los Angeles Times,* July 2, 1994.
24. See Amelia Jones (1998) for a discussion of Athey's artistic contribution to AIDS discourse.

25. Lois Bibbings and Peter Alldridge, "Sexual Expression, Body Alteration, and the Defense of Consent," *Journal of Law and Society* vol. 20, no. 3 (1993), 356–70.

26. Ibid., 357.

27. According to Sweetman, genital body piercings "can significantly affect bodily sensations during sex or otherwise, potentially re-mapping the body's 'erotogenic sensitivity,'" and ethnographer James Myers describes queer cuttings, brands, and piercings as "celebrations of sexual potency" (Sweetman 1998; 13, Myers 1992: 299). Cathie Lee Prochazka also describes the intimacy of erotic cutting between women in *Nothing but the Girl*, Susie Bright and Jill Posener's photo essay book about "the blatant lesbian image":

> Right after we had sex, I looked at [my lover] and said, "Oh, cut me." She would slap me on my chest and it would send passion through my body. It would bring the blood to the surface, and I wanted that to pour out; I would want to share blood . . . it was like all of a sudden I became her canvas, and that's what hooked us as a couple into SM.

> Susie Bright and Jill Posener, *Nothing But the Girl: The Blatant Lesbian Image* (London: Freedom Editions, 1996), 91.

28. Califia's terms "ritual SM" and "latex shamanism" reflect the influence of modern primitivism in queer SM communities.

29. DeMello, 2000: 143. Tamsin Wilton's worries about queer body inscriptions are based on her assertion that we need to recognize the body *itself* "as an event situated in time and continuously subject to the co-constitutive dialectic of the organic and social" (1997: 59). What Wilton argues is that bodies are not only surfaces of representation, but are also sites of desire, pleasure, pain, sickness, and other embodied experiences. Surface representations that fail to engage in the body as it is lived and experienced are limited, she argues, in their impact on sexuality and gender identity, because in her estimation, it is the process of living in the body and contending with the social pressures around bodily "events"—menstruation, ejaculation, menopause, breast cancer, fertility—that are part of what make the body so significant for sexuality and gender. She sees this position as different from an essentialist view, because it emphasizes the phenomenological aspects of embodiment over the fixed ones. I find this an interesting argument but believe that it needs more theorization to rescue it from its essentialist implications.

30. MacKendrick, 1998: 21.

31. Kaja Silverman, *Male Subjectivity at the Margins* (New York: Routledge, 1992), 185.

32. Ibid., 190.

33. Ibid., 206, emphasis mine.

34. A number of writers have suggested that piercings, scars, and brands presented in a certain aesthetic context have become recognizable insignia of queerness (Mellor, 1996; Suzanna Walters, "From Here to Queer: Radical Feminism, Postmodernism, and the Lesbian Menace," *Signs: Journal of Women in Culture and Society* vol. 21, no. 4 (1996), 830–869; Califia, 1994), even though in other contexts they may suggest other identities.

35. Mellor, 1996: 11.

36. Gilles Deleuze quoted in Silverman, 1992: 190.

37. Lee Monaghan, Michael Bloor, Russell Dobash, and Rebecca Dobash, "Bodybuilding and Sexual Attractiveness," in *The Body in Qualitative Research,* ed. J. Richardson and A. Shaw. (Aldershot, U.K.: Ashgate, 1998), 53.

38. Epstein, 1994: 195.

39. Angus Vail, "Slinging Ink or Scratching Skin?: Producing Culture and Claiming Legitimacy among Fine Art Tattooists," *Current Research on Occupations and Professions* 11 (1999).

40. Sandra Harding, *Whose Science? Whose Knowledge? Thinking from Women's Lives* (Ithaca, N.Y.: Cornell University Press, 1991).

41. Hebdige, 1979.

42. Califia, 1994.

43. Bell and Valentine, 1995: 149, cited in Taylor, 1997: 15.

44. Taylor, 1997: 15.

45. Sedgwick, 1990: 247.

46. Myers, 1992: 299.

47. See Drew Leder, *The Absent Body* (Chicago: University of Chicago Press, 1990).

48. Sweetman, 1998: 15.

49. MacKendrick, 1997: 10,16.

50. Bordo 1993, 262; emphasis mine.

51. See Henry Giroux, *Disturbing Pleasures: Learning Popular Culture* (New York: Routledge, 1994); Andrew Ross, "Tribalism in Effect," in *On Fashion,* ed. Shari Benstock and Suzanne Ferris (New Brunswick, N.J.: Rutgers University Press, 1994); Phelan, 1993; Davis, 1992; Hebdige, 1997 [1983].

52. Califia, 1994: 237.

53. Kathy Ferguson, "Writing 'Kibbutz Journal': Borders, Voices, and the Traffic In Between," in *Talking Gender,* ed. Nancy Hewitt, Jean O'Barr, and Nancy Rosebaugh (Chapel Hill: University of North Carolina Press, 1996), 91.

54. Califia, 1994: 238.

55. Ibid.

56. Ibid., 240.

57. Ibid., 238.

Chapter 4

1. Lingus, 1983: 22.
2. This term is from Rosemarie Garland Thompson, ed., *Freakery: Cultural Spectacles of the Extraordinary Body* (New York: New York University Press, 1996).
3. Ibid., 10.
4. Anne Fausto-Sterling links the discursive production of primitivism as far back as the scientific revolution and the expansion of European exploration in "Gender, Race, Nation: The Comparative Anatomy of 'Hottentot' Women in Europe, 1815–1817," in *Feminism and the Body*, ed. Londa Shiebinger (Oxford and New York: Oxford University Press, 2000).
5. Bernth Lindfors, "Ethnological Show Business: Footlighting the Dark Continent," in *Freakery: Cultural Spectacles of the Extraordinary Body*, ed. Thompson.
6. Ibid., 210–211.
7. Fausto-Sterling, 2000: 206.
8. Ibid., 218.
9. Ibid., 223.
10. Ibid., 204.
11. Thompson, 1996: 2.
12. Lindfors, 1996: 217.
13. Christopher Vaughn, "Ogling Igorots: The Politics and Commerce of Exhibiting Cultural Otherness, 1898–1913," in *Freakery: Cultural Spectacles of the Extraordinary Body*, ed. Thompson, 220–221.
14. Deborah Root, *Cannibal Culture: Art, Appropriation, and Commodification of Difference* (Boulder, Col.: Westview Press, 1996), 32.
15. Catherine Lutz and Jane Collins, *Reading National Geographic* (Chicago: University of Chicago Press, 1993).
16. Campbell, 1998: 14.
17. Root, 1996: 32.
18. Ibid., 33.
19. Ibid.
20. Gargi Bhattacharyya, "Who Fancies Pakis?: Pamella Bordes and the Problem of Exoticism in Britain," in *Feminism and Cultural Studies,* ed. Morag Shiach (Oxford and New York: Oxford University Press, 1999), 468. As Root describes, later in the twentieth century films became the favorite medium for disseminating colonial or imperial messages to the masses, while ethnologists explored, often much more sympathetically, the social structures of indigenous groups with an eye toward clarifying social laws. However, even though scholarly ethnological texts advocated a more relativist approach than popular films, Root argues that they worked together.

Films reinforced views of the exoticism of cultural Others, while scholarship promoted "a notion of expertise and of the professionals who are believed to be qualified to elucidate different cultures" (Root, 1996: 34).

21. This is my transcription of Musafar's hanging, presented in the video *Bizzare Rituals: Dances Sacred and Profane* by Mark and Dan Jury, producers and directors (Gorgou Video, 1987).

22. The large, bulging scar Jane wears across her chest, for instance, is in the shape of a dreamcatcher, a symbol that represents her affinity with Native Americans. Lisa's shoulder scars were inspired by "pictures of African women in *National Geographic*."

23. Some studios are intended to be "a haven for modern primitives" which create a "nonclinical" environment for body modification. One such studio, Nomad, is described in *BP&MPQ* as a "rainforest" for its greenery and a "museum" for its archives of tribal art and adornments. Fakir Musafar, "Nomad: A Body Piercing Studio, A Rainforest, A Museum, A Haven for Modern Primitives," *BP&MPQ* vol. 2, no. 4 (1994), 26.

24. Gardner, 1997; Steele, 1996; Eubanks, 1996. The body modification movement is represented in its texts as overwhelmingly white, but of course many people of color have embraced the new practices. One significant example is the embrace of body modification by black fraternities as a hazing practice. Some reports in modern primitivist texts suggest that the use of body modification by African Americans is a "return to their tribal heritage." Fakir Musafar, "Vama Vajra's African Lip Disk," *BP&MPQ* vol. 2, no. 4 (1994), 24–25. See also Julius Harris, "A Bond Beyond: Black Fraternity Branding," *ITF*, premiere issue (1995). However, the use of branding in male groups is not limited to black fraternities, but also to white fraternities and sports teams.

25. Fakir Musafar, "Exploring a Primitive Lifestyle," *BP&MPQ* vol. 2, no. 2 (1993), 27.

26. Derek Ridgers, "Metal Guru," *Skin Two*, no. 19 (1996), 76.

27. The term "erotic pioneers" is from William Henkin, "Editorial #2," *BP&MPQ* vol. 2, no. 1 (1993), 5.

28. Editorial, *ITF* vol. 1 no. 2, May 1996.

29. DeMello, 2000.

30. Ibid., 183, emphasis mine.

31. Campbell, 1998.

32. Marianna Torgovnick, "Piercings," in *Late Imperial Culture*, ed. Roman De La Campa, E. Ann Kaplan, and Michael Sprinkler (London and New York: Verso, 1995).

33. Mike Featherstone, *Undoing Culture: Globalization, Postmodernism and Identity* (London: Sage, 1995).

34. Lauralyn Avallone, "How Redefining Our Perception of Beauty Can Change American Culture as We Know It," *Proof Downtown*, vol. 1 (1997).

35. Indigenous cultures are understood by modern primitives to promote a stronger sense of group belonging, while tribal practices of the body are seen as both more natural and more spiritual. Tribal groups are even understood to promote less gender and sexual oppression. For instance, modern primitivist discourse asserts, in the somewhat critical words of Pat Califia, that "hunter-and-gatherer cultures were great places to be queer or female" (1994: 240; see also Rosenblatt, 1997: 312).
36. Maffesoli, 1996: 16.
37. Fakir Musafar, "Radical Moderns Sid and Lily," *BP&MPQ* vol. 2, no.4 (1994), 14–17.
38. Gladsjo, 1991.
39. Campbell, 1998: 19.
40. Featherstone, 1995: 128.
41. Ibid., 1.
42. Eubanks, 1996: 75; Vale and Juno, 1989: 5; see also Rosenblatt, 1997.
43. Vale and Juno, 1989: 4.
44. Ibid.
45. Harding, 1991.
46. Hebdige, 1979: 90.
47. Ibid., 105.
48. Simon Gottschalk, "Uncomfortably Numb: Countercultural Impulses in a Postmodern Era," *Symbolic Interaction* vol. 16, no. 4 (1993), 351–378, 354.
49. Marcos Becquer and Jose Gatti, "Elements of Vogue," in *The Subcultures Reader,* ed. Gelder and Thorton, 447.
50. Targovnick, 1990.
51. Fakir Musafar, "Idexa: Radical Primitive She/Boy," *BP&MPQ* vol. 2, no. 2 (1993), 8–13.
52. Ibid.
53. Ibid.
54. Phelan, 1993: 13.
55. Ibid.
56. For another example of this discourse, see Amanda Dice, "You Really Are What You Eat," *ITF* vol. 2, no. 5 (1997), 28–29.
57. Shelton, 1996: 205; his notion of subjectivity "on trial" comes from Julia Kristeva, *Revolution in Poetic Language* (New York: Columbia University Press, 1984).
58. Bequer and Gatti, 1997: 447.
59. Patricia Hill Collins, *Black Feminist Thought: Knowledges, Consciousness and the Politics of Empowerment* (New York: Routledge, 1991), 69.
60. Root, 1996: xii.
61. Further, neotribalism also promotes a nostalgia that imagines that non-Western cultures are static, and privileges traditional over emerging cul-

tural forms in those societies. Helen Gilbert and Joanne Tompkins, *Post-Colonial Drama: Theory, Practice, Politics* (London: Routledge, 1996).

62. See Campbell, 1998. This is reflected by the fact that, for example, Africa has over 800 languages (Gilbert and Tompkins, 1996).
63. Christian Kleese, "'Modern Primitivism': Non-Mainstream Body Modification and Racialized Representation," in *Body Modification,* ed. Featherstone, 26.
64. Ibid.
65. Ibid., 27.
66. Fakir Musafar, "Labrets For Pierced Lower Lip Beauty," *BP&MPQ* vol. 2, no. 4 (1994), 18–23.
67. Fakir Musafar, "Midori: Eurasian Fetish Fashion Diva," *BP&MPQ* vol. 3, no. 4 (1995), 10. The appearance of Western body modifiers of color in magazines like *BP&MPQ, ITF,* and *Skin and Ink* is rare, but they also tend to be highly fetishized. African Americans, for example, have been presented as representing their own tribal heritage and as looking more "authentic" in their use of body modifications. Native American reservations are presented as sites of pilgrimage for body modifiers.
68. Collins, 1991: 69. That modern primitivism appeals to those who are resisting their own oppression—women and gay people, for example—does not erase this problem.
69. *ITF* vol. 1 no. 2, May 1996. From letters to the editor ("Love Letters and Hate Mail.")
70. Ibid.
71. Elin Diamond, *Performance and Cultural Politics* (London: Routledge, 1996).
72. Fakir Musafar, "Idexa's Suspension Hindered by Physical and Psychic Distractions," *BP&MPQ* vol. 4, no. 2 (1996), 18.
73. Fakir Musafar, "Paul Flies Like a Bird," *BP&MPQ* vol. 4, no. 2 (1996), 16–17.
74. Ibid., 11.
75. Editorial, *ITF* vol. 1, no. 2, May 1996.
76. Ibid.
77. Ted Polhemus, *Streetstyle: From Sidewalk to Catwalk* (London: Thames and Hudson, 1995); see Campbell, 1998; Ross, 1994; Davis, 1992.
78. Vale and Juno, 1989: 5.
79. Giroux, 1994: 15.
80. Rufus Camphausen, *Return of the Tribal: A Celebration of Body Adornment* (Rochester, Vt.: Park Street Press, 1997), 5.
81. Jose Esteban Munoz, "The White to be Angry: Vaginal Davis's Terrorist Drag," *Social Text* 52/53, vol. 15, no. 3–4 (1997), 81–90, 81.
82. Balsamo, 1995: 225. She is referring to the English-language American magazine.

83. Ibid.
84. Ibid., 226.
85. Steele, 1996.
86. Mascia-Lees and Sharpe, 1992: 2.
87. Editorial, *ITF* vol. 1, no. 2, May 1996.
88. Chandra Mohanty and Jacqui Alexander, *Feminist Genealogies, Colonial Legacies, Democratic Futures* (New York: Routledge, 1997), xvii.

CHAPTER 5

1. William Gibson, *Neuromancer* (New York: Ace Books, 1984), 59. David Brande's article first directed me to this passage. See David Brande, "The Business of Cyberpunk: Symbolic Economy and Ideology in William Gibson," *Configurations* vol. 2 no. 3 (1994), 511.
2. Brande, 1994: 510.
3. Ibid., 511.
4. See Andrew Ross, "Hacking Away at the Counter-Culture," in *The Cybercultures Reader,* ed. Bell and Kennedy, 2000.
5. Katherine Hayles, 1990: 266, cited in Brande 1994: 510.
6. Ross, 2000: 258.
7. Timothy Leary, "The Cyberpunk: The Individual as Reality Pilot," in *The Cybercultures Reader,* 530.
8. Ibid.
9. Ross, 2000: 259.
10. Ibid., 266.
11. Tiziana Terranova, "Post-Human Unbounded: Artificial Revolution and High-Tech Subcultures," in *The Cybercultures Reader;* Mike Featherstone and Roger Burrows, eds., *Cyberspace/Cyberbodies/Cyberpunk: Cultures of Technological Embodiment* (London: Sage, 1995).
12. *Extropian Manifesto,* cited in Terranova, 2000: 273.
13. Ibid., 270.
14. *Extropian FAQ,* cited in Terranova, 2000: 273.
15. "EP3.0," http://www.extropy.org.
16. Ibid.
17. For Donna Haraway, technology, power, and consciousness are interconnected, and the advancement of a more pluralist culture depends not only upon the former but also the latter.
18. See, for instance, Mary Flanagan and Austin Booth, eds., *Reload: Rethinking Women + Cyberculture* (Cambridge, Mass.: Massachusetts Institute of Technology Press, 2002).
19. Caroline Bassett, "Virtually Gendered: Life in an On-Line World," in *The Subcultures Reader,* ed. Gelder and Thorton, 1997: 549.

20. Ibid. See also Howard Rheingold, *The Virtual Community: Finding Connection in a Computerized World* (London: Secker and Warburg, 1994).
21. Haraway, 2000 [1991]: 315.
22. Clough, 1998: xxii.
23. Chela Sandoval, "New Sciences: Cyborg Feminism and the Methodology of the Oppressed," in *The Cybercultures Reader.*
24. Clough, 1998: xxv.
25. Ibid., xxii.
26. Ibid., xxv.
27. Jane Goodall, "An Order of Pure Decision: Un-Natural Selection in the Work of Stelarc and Orlan," in *Body Modification,* ed. Featherstone, 2000: 151.
28. Ibid., 168.
29. This draws interesting parallels to the more culturally reverential flesh hangings used by modern primitives.
30. Mark Dery, "Ritual Mechanics: Cybernetic Body Art," in *The Cybercultures Reader,* 578.
31. From Zurbrugg's interview with Stelarc, 1995: 46, cited in Nicholas Zurbrugg, "Marinetti, Chopin, Stelarc and the Auratic Intensities of the Postmodern Techno-Body," in *Body Modification,* 109.
32. Stelarc, interview in Farnell, 2000: 144.
33. Dery 2000: 580.
34. Stelarc, interview in Farnell, 2000: 134.
35. Ibid., 131.
36. Dery, 2000: 583.
37. Davis, 1997: 29, emphasis mine.
38. Shelton, 1996: 107.
39. Orlan, interview with Robert Ayers, "Serene and Happy and Distance: An Interview with Orlan," in *Body Modification,* 182.
40. Ibid., 177.
41. Ibid., 180.
42. "Interview with Shannon Larratt," by Raven, *Body Modification Ezine* (*BME*), http://BME.FreeQ.com/culture/wb/wb/wb000.html-wb014.htm.
43. Although the body modifiers on *BME* are highly tolerant, these are usually the focus of the hate mail that *BME* receives from outsiders.
44. "Interview with Shannon Larratt," *BME.*
45. Personal correspondence between the author and Shannon Larratt, September 1998.
46. "Interview with Shannon Larratt," *BME.*
47. Shannon Larratt, "Editorial: Extreme Modifications: Why?," *BME.*
48. Ibid.
49. David Bailey and Stuart Hall, "The Vertigo of Displacement," *Ten.8* vol. 2 no. 3 (1992), 15.

50. Gelder, 1997: 374.
51. Munoz, 1997: 81.
52. Vail, 1999: 271.
53. As Orlan says in an interview: "The fashion industry has now caught up with me. My work appeals to many fashion designers. One in particular uses it in a very literal way—perhaps you saw it in his catalogues?—and there is one who pays tribute to my work by making up his models with the same bumps as me" (interview in Ayers, 2000: 180).
54. Ibid., 182. She also argues here that she is "not in favor of fashion and its dictates."
55. In body modification's subcultural discourse, "real" body modifiers are contrasted to kids, rock stars, and supermodels. Although it is clear by now that there *isn't* a clear line between fashion and subcultural style, that practices might carry symbolic weight either as authentic subcultural practices or as inauthentic commercial knock-offs might reveal how members "classify themselves" in relation to "how much they give in to outsiders." Howard Becker, "The Culture of a Deviant Group: The Jazz Musician," in *The Subcultures Reader,* 57.
56. Shannon Larratt, "Rejection of Current Trends in 'Pop Culture,'" *BME.*
57. The visibility, risk, and quantity of body modifications in cyberpunk is not universally embraced among all subcultural body modifiers, of course, but has subcultural capital among those whom Raelyn Gallina, in her interview with the author, identified as a "certain subset . . . taking this to the farthest extreme, to the edges . . . It's already an edge thing, as now they're taking it even further. . . . There are those edges that are going so extreme that it's . . . like the image is breaking up."
58. "Interview with Shannon Larratt," *BME* (emphasis mine).
59. Isa Gordon, "The Psymbiote Speaks: On Generating a Cyborg Body," http://www.isa@psymbiote.org.
60. Ibid.
61. Ibid.
62. Ibid.
63. Ibid.
64. Ibid.
65. Ibid.
66. Stelarc, interview in Farnell, 2000: 130.
67. Ibid., 131.
68. Ibid., 142–43.
69. *Webster's New Collegiate Dictionary* (Springfield, Mass.: G & C Merriam Co., 1959); *Oxford English Dictionary* (Oxford: Oxford University Press, 1978).
70. Goodall, 2000:167.
71. Stelarc, interview in Farnell, 2000: 136.

72. And Isa defends the body: "I do not agree with . . . the Extropian camps who say we can download our consciousness into a box or translate its electrical signals into a program thereby capturing our essence in some immortalized form so that we can exist in the complete absence of body. I feel that our consciousness, memories, perceptions, ideas, emotions, desires, etc., are not phenomena localized to the brain, but exist throughout this complex system. When we extend or modify the system, it is likely these things will transform too, but I see no point in replacing or even dampening the system itself. For me, the Cartesian mind body split is completely bankrupt" (Gordon, "The Psymbiote Speaks," http://www.isa@psymbiote.org).

73. Ibid.

74. Melucci, 1996: 182.

75. Featherstone, 1995: 128.

76. MacKendrick, 1998: 16.

77. Eugene Thacker, "The Science Fiction of Technoscience: The Politics of Simulation and a Challenge for New Media Art," *Leonardo* vol. 34 no. 2 (2001), 155.

78. Balsamo, 1995: 225.

Conclusion

1. Featherstone, 1995: 128.

2. As Donna Haraway (1991) has argued, our bodies and selves have always been technologized, since there have always been various means by which we have materially as well as representationally constructed and shaped them.

3. Here Balsamo (1995: 223) is citing from Arthur Kroker and Marilouise Kroker, *Body Invaders: Panic Sex in America* (New York: St. Martin's Press, 1987).

4. Balsamo, 1995: 216.

5. Ibid., 223.

6. Ibid.

7. Clough, 1998: xxii.

8. Price and Shildrick, 1999: 10.

9. Melucci, 1996: 24.

10. See Michel Foucault, "The Subject and Power," Afterword in Hubert Dreyfus and Paul Rabinow, *Michel Foucault: Beyond Structuralism and Hermeneutics* (Chicago: University of Chicago Press, 1982).

11. Melucci, 1996: 182.

12. Clough, 2000: 135.

13. Ibid.

14. In a different sense, Orlan's high-tech body projects can be also read as social and connective. While Orlan's projects are highly abstract and conceptual compared to women's reclaiming rituals, her appropriation of major iconic images of feminine beauty constructed in the male art world might also be seen as linking her body to the bodies of others. Such appropriation links her art to a larger history of gendered relations of beauty. I suggested earlier that it is this historical dimension that can support claims that her work is "feminist," because the historical references to normative standards of beauty are what situate her work in a social and political and thus potentially critical context. On the other hand, Orlan-as-artist maintains a fierce individualist stance; she scoffs, for instance, at the "punks" who are engaging in body modifications to "conform" to subcultural membership. Her insistence on the uniqueness of her vision is, I think, in tension with what I see as the feminist aspects of her work. Her personal agency is predicated on publicity, self-promotion, and the spectacular individualization of her body-self.

15. I would also place the AIDS grieving ritual (described in chapter 3), a group-designed body modification and performance event aimed at a collective expression of loss and healing, as highly connective. The anti-assimilative practices of radical queers are both social and highly rebellious. They are more individualist than the deeply connective practices of women's reclaiming projects, but they are political in creating dialogic struggles with the powerfully heteronormative social order. The in-your-face tactics of queer body modification, in particular those of the gay and transgendered men I described in chapter 3, are responses to the stigmatizing gaze of experts on "normative" sexuality, and they both engage with and simultaneously reject the latter. Of course, desire and pleasure also play a part in sexualized body modification practices. Pleasures range from the mutual to the individual and fall along a connection/isolation continuum at many different points. However, in many examples, such as the public branding event at an SM club (Matthew) and that at a sex-positive bookstore (Dave), it is difficult to unlink pleasure and rebellion, desire and stigma. The blatant, public nature of the events was part of the desire, and the meaningfulness, of the performance. The inversion of stigma, the claiming of rights to unorthodox pleasures, politicized the experiences as anti-assimilative gestures.

16. Melucci, 1996: 142.

17. Ibid., 182.

18. Or, that we all transnationally share the same vision of democracy, citizenship, and individual rights, as liberal global feminists have been accused of assuming. See, for instance, Clough, 2000; Chandra Mohanty, "Under

Western Eyes," *Boundary* nos. 2 and 3 (1984), 333–58; and Nira Yuval-Davis, "Gender and Nation," in *Space, Gender, Knowledge: Feminist Readings,* ed. Linda McDowell and Joanne P. Sharpe (London: Arnold, 1997), 403–408.

19. Even though we often use ideas of individual rights and meritocracy to defend the economic system that contributes to these problems, I believe that we in the West allow ourselves some comfort in the status quo partly based on deeply held ideas biases about cultural Others and what they need and deserve. If I am right, then this is another reason to be worried about notions of the "primitive" that are operating throughout popular culture.

20. I mean composure in the sense of both following an orchestrated script and in the sense of the self's composure in the doings of social interaction. This dual definition of composure comes from Stevi Jackson and Sue Scott, "Putting the Body's Feet on the Ground: Towards a Sociological Reconceptualization of Gendered Embodiment," in *Constructing Gendered Bodies,* ed. Kathryn Backett-Milburn and Linda McKie (London: Palgrave, 2000), 9–24.

21. See Clough (2000) for more on queering technology.

BIBLIOGRAPHY

Abbe, Mary. 1994. "Walker's Erotic Torture Heated Up National Debate." *Minneapolis Star Tribune,* December 28.

Avallone, Lauralyn. 1997. "How Redefining Our Perception of Beauty Can Change American Culture as We Know It." *Proof Downtown* 1.

Ayers, Robert. 2000. "Serene and Happy and Distance: An Interview with Orlan." In *Body Modification,* ed. Mike Featherstone. London: Sage.

Babbie, Earl. 1992. *The Practice of Social Research.* Sixth Ed. Belmont, Calif.: Wadsworth.

Babcock, Barbara. 1978. *The Reversible World: Symbolic Inversion in Art and Society.* Oxford: Claredon Press.

Baily, David, and Stuart Hall. 1992. "The Vertigo of Displacement." *Ten.8* 2 (3): 15.

Bakhtin, Mikhail. 1984. *Rabelais and His World,* trans. Helene Iswolsky. Cambridge, Mass.: Massachusetts Institute of Technology Press.

————. 1981. *The Dialogic Imagination,* trans. Caryl Emerson and Michael Holquist. Austin: University of Texas Press.

Balsamo, Anne. 1996. *Technologies of the Gendered Body: Reading Cyborg Women.* Durham, N.C.: Duke University Press.

————. 1995. "Forms of Technological Embodiment: Reading the Body in Contemporary Culture." In *Cyberspace/Cyberbodies/Cyberpunk: Cultures of Technological Embodiment,* ed. Mike Featherstone and Roger Burrows. London: Sage.

Bassett, Caroline. 1997. "Virtually Gendered: Life in an On-Line World." In *The Subcultures Reader,* ed. Ken Gelder and Sarah Thorton. London: Routledge.

Beaubien, Greg. 1995. "Burning Question: Branding Makes its Mark as the Latest Fad in Body Modification, but Is It Art or Self-Mutilation?" *Chicago Tribune* February 17.

Becker, Howard. 1997 [1963]. "The Culture of a Deviant Group: The 'Jazz' Musician." In *The Subcultures Reader,* ed. Gelder and Thorton.

Bequer, Marcos, and Jose Gatti. 1997. "Elements of Vogue." In *The Subcultures Reader,* ed. Gelder and Thorton.

Bell, David, and Barbara M. Kennedy, eds. 2000. *The Cybercultures Reader.* London: Routledge.

Bhattacharyya, Gargi. 1999. "Who Fancies Pakis?: Pamella Bordes and the Problem of Exoticism in Britain." In *Feminism and Cultural Studies,* ed. Morag Shiach. Oxford and New York: Oxford University Press.

Bibbings, Lois, and Peter Alldridge. 1993. "Sexual Expression, Body Alteration, and the Defense of Consent." *Journal of Law and Society* 20 (3): 356–370.

Bilmes, Jack, and Allan Howard. 1980. "Pain as Cultural Drama." *Anthropology and Humanism Quarterly* 5: 10–12.

Body Modification Ezine, http://www.BME.FreeQ. com.

Bordo, Susan. 1991. "Feminism, Postmodernism, and Gender-Skepticism." In *Feminism/Postmodernism,* ed. Linda J. Nicholson. New York: Routledge.

———. 1993. *Unbearable Weight: Feminism, Western Culture and the Body.* Berkeley: University of California Press.

Brake, Michael. 1985. *Comparative Youth Culture: The Sociology of Youth Cultures and Subcultures in America, Britain, and Canada.* London: Routledge.

Brande, David. 1994. "The Business of Cyberpunk: Symbolic Economy and Ideology in William Gibson." *Configurations* 2 (3): 509–536.

Breslauer, Jan. 1994. "The Body Politics." *Los Angeles Times,* July 2.

Bright, Susie, and Jill Posener, eds. 1996. *Nothing But the Girl: The Blatant Lesbian Image.* London: Freedom Editions.

Brown, Hero. 1997. "The Human Condition: The First Cut is the Deepest: Scarring and Branding Is the Body Modifier's Way of Saying I Love You." *Independent* (London). October 5.

Buchwald, Emilie. 1993. "Raising Girls for the 21st Century." In *Transforming a Rape Culture,* ed. Buchwald, Pamela Fletcher, and Martha Roth. Minneapolis: Milkweed Editions.

Butler, Judith. 1993. *Bodies That Matter: On the Discursive Limits of Sex.* New York: Routledge.

———. 1990. *Gender Trouble: Feminism and the Subversion of Identity.* New York: Routledge.

Cahill, Ann J. 2001. *Rethinking Rape.* Ithaca, N.Y.: Cornell University Press.

Califia, Pat. 1994. *Public Sex: The Culture of Radical Sex.* San Francisco: Cleis Press.

Campbell, Aidan. 1998. *Western Primitivism: African Ethnicity.* London: Cassell.

Camphausen, Rufus. 1997. *Return of the Tribal: A Celebration of Body Adornment.* Rochester, Vt.: Park Street Press.

Champagne, Leonora, ed. 1990. *Out From Under: Texts by Women Performance Artists.* New York: Theater Communications Group.

Clough, Patricia. 2000. *Autoaffection: Unconscious Thought in the Age of Teletechnology.* Minneapolis: University of Minnesota Press.

———. 1998. *The End (s) of Ethnography: From Realism to Social Criticism.* Second Ed. New York: Peter Lang.

Cohen, Colleen Ballerino. 1996. "Olfactory Constitution of the Postmodern Body: Nature Changed, Nature Adorned." In *Tattoo, Torture, Mutilation, and Adornment,* ed. Frances Mascia-Lees and Patricia Sharpe. Albany: State University of New York Press.

Collins, Patricia Hill. 1991. *Black Feminist Thought: Knowledges, Consciousness and the Politics of Empowerment.* New York: Routledge.

Curtis, Neal. 2000. "The Body as Outlaw: Lyotard, Kafka, and the Visible Human Project." In *Body Modification,* ed. Featherstone.

Davis, Fred. 1992. *Fashion, Culture and Identity.* Chicago: University of Chicago Press.

Davis, Kathy. 1997. "My Body Is My Art: Cosmetic Surgery as Feminist Utopia?" *European Journal of Women's Studies* 4: 23–37.

De Certeau, Michel. 1984. *The Practice of Everyday Life,* trans. S. Rendell. Berkeley: University of California Press.

DeMello, Margo. 2000. *Bodies of Inscription.* Durham, N.C.: Duke University Press.

Denzin, Norm. 1989. *Interpretive Interactionism.* London: Sage.

Dery, Mark. 2000. "Ritual Mechanics: Cybernetic Body Art." In *The Cybercultures Reader,* ed. Bell and Kennedy.

Diamond, Elin, ed. 1996. *Performance and Cultural Politics.* London: Routledge.

Diamond, Elin. 1995. "The Shudder of Catharsis in 20th-Century Performance." In *Performativity and Performance,* ed. Andrew Parker and Eve Kosofsky Sedgwick. New York: Routledge.

Diamond, Irene, and Lee Quinby. 1984. "American Feminism in the Age of the Body." *Signs: Journal of Women in Culture and Society* 10 (1): 119–125.

Dice, Amanda. 1997. "You Really Are What You Eat." *ITF* 2 (5): 28–29.

Donovan, Josephine. 1998. *Feminist Theory: The Intellectual Traditions of American Feminism.* New York: Continuum.

Dunne, Katherine. 1995. "Introduction." In Jim Rose, *Freak Like Me.* London: Indigo.

During, Lisabeth, and Terri Fealy. 1997. "Philosophy." In *Lesbian and Gay Studies: A Critical Introduction,* ed. Andy Medhurst and Sally Munt. London: Cassell.

Dworkin, Andrea. 1994. "Gynocide: Chinese Footbinding." In *Living With Contradictions: Controversies in Feminist Ethics,* ed. Alison M. Jaggar. Boulder, Col.: Westview Press.

Epstein, Steven. 1994. "A Queer Encounter: Sociology and the Study of Sexuality." *Sociological Theory* 12 (2): 188–202.

Eubanks, Valerie. 1996. "Zones of Dither: Writing the Postmodern Body." *Body and Society* 2 (3): 73–88.

Extropy Institute, www.extropy.org.

Farnell, Ross. 2000. "In Dialogue with 'PostHuman' Bodies: Interview with Stelarc." In *Body Modification,* ed. Featherstone.

Fausto-Sterling, Anne. 2000. "Gender, Race, Nation: The Comparative Anatomy of 'Hottentot' Women in Europe, 1815–1817." In *Feminism and the Body,* ed. Londa Shiebinger. Oxford and New York: Oxford University Press.

Favazza, Armando. 1996. *Bodies Under Siege: Self-Mutilation and Body Modification in Culture and Psychiatry.* Baltimore, Md.: Johns Hopkins University Press.

Featherstone, Mike, ed. 2000. *Body Modification.* London: Sage.

————. 1995. *Undoing Culture: Globalization, Postmodernism and Identity.* London: Sage.

————. 1991. "The Body in Consumer Culture." In *The Body: Social Process and Cultural Theory,* ed. Mike Featherstone, Mike Hepworth, and Bryan S. Turner. London: Sage.

Featherstone, Mike, and Roger Burrows, eds. 1995. *Cyberspace/Cyberbodies/Cyberpunk: Cultures of Technological Embodiment.* London: Sage.

Ferguson, Kathy. 1996. "Writing 'Kibbutz Journal': Borders, Voices, and the Traffic In Between." In *Talking Gender,* ed. Nancy Hewitt, Jean O'Barr, and Nancy Rosebaugh. Chapel Hill: University of North Carolina Press.

Flanagan, Mary, and Austin Booth, eds. 2002. *Reload: Rethinking Women + Cyberculture.* Cambridge, Mass.: Massachusetts Institute of Technology Press.

Foucault, Michel. 1982. "The Subject and Power." Afterword in Hubert Dreyfus and Paul Rabinow, *Michel Foucault: Beyond Structuralism and Hermeneutics.* Chicago: University of Chicago Press.

————. 1980. *Power/Knowledge: Selected Interviews and Other Writings 1972–1977,* trans. Colin Gordon. New York: Pantheon.

————. 1979. *Discipline and Punish,* trans. Alan Sheridan. New York: Vintage.

————. 1978. *The History of Sexuality, Volume 1: An Introduction,* trans. Robert Hurley. New York: Pantheon.

————. 1973 [1965]. *Madness and Civilization: A History of Insanity in the Age of Reason,* trans. Richard Howard. New York: Vintage.

Frank, Arthur W. 1991. "For a Sociology of the Body: An Analytic Review." In *The Body: Social Process and Cultural Theory,* ed. Featherstone, Hepworth, and Turner.

Gardner, James. 1997. *The Age of Extremism: Enemies of Compromise in American Politics, Culture and Race.* Toronto: Carol Publishing.

Gelder, Ken. 1997. "The Birmingham Tradition and Cultural Studies." In *The Subcultures Reader,* ed. Gelder and Thorton.

Gelder, Ken, and Sarah Thorton, eds. 1997. *The Subcultures Reader.* London: Routledge.

Gilbert, Helen, and Joanne Tompkins. 1996. *Post-Colonial Drama: Theory, Practice, Politics.* London: Routledge.

Gibson, William. 1984. *Neuromancer.* New York: Ace Books.

————. 1988. *Mona Lisa Overdrive.* Toronto: Bantam Books.

Giddens, Anthony. 1991. *Modernity and Self-Identity.* Cambridge: Polity Press.

Giroux, Henry. 1994. *Disturbing Pleasures: Learning Popular Culture.* New York: Routledge.

Gladsjo, Leslie Asako. 1991. *Stigmata: The Transfigured Body.* Film funded in part by the Rocky Mountain Film Center, Boulder, Col., and the National Endowment for the Arts.

Goodall, Jane. 2000. "An Order of Pure Decision: Un-Natural Selection in the Work of Stelarc and Orlan." In *Body Modification,* ed. Featherstone.

Gottschalk, Simon. 1993. "Uncomfortably Numb: Countercultural Impulses in a Postmodern Era." *Symbolic Interaction* 16 (4): 351–378.

Gowing, Laura. 1997. "History." In *Lesbian and Gay Studies: A Critical Introduction,* ed. Medhurst and Munt.

Grant, Linda. 1995. "Written on the Body." *Guardian* (London). April 1.

Grosz, Elizabeth. 1997. "Inscriptions and Body Maps: Representations and the Corporeal." In *Space, Gender, Knowledge: Feminist Readings,* ed. Linda McDowell and JoAnn P. Sharp. London: Arnold.

———. 1994. *Volatile Bodies: Towards a Corporeal Feminism.* Bloomington: Indiana University Press.

Hall, Stuart. 1996. *Representation: Cultural Representations and Signifying Practices.* London: Open University Press.

Haraway, Donna. 2000 [1991]. "A Cyborg Manifesto: Science, Technology and Socialist-Feminism in the Late 20th Century." In *The Cybercultures Reader,* ed. Bell and Kennedy.

Harding, Sandra. 1991. *Whose Science? Whose Knowledge? Thinking from Women's Lives.* Ithaca, N.Y.: Cornell University Press.

Harris, Julius. 1995. "A Bond Beyond: Black Fraternity Branding." *ITF* 1 (1): 49–52.

Hart, Lynda and Joshua Dale. 1997. "Sadomasochism." In *Lesbian and Gay Studies: A Critical Introduction,* ed. Medhurst and Munt.

Hebdige, Dick. 1997 [1983]. "Posing . . . Threats, Striking . . . Poses: Youth, Surveillance, and Display." In *The Subcultures Reader,* ed. Gelder and Thorton.

———. 1979. *Subculture: The Meaning of Style.* London: Methuen.

Henkin, William. 1993. "Editorial #2." *Body Play and Modern Primitives Quarterly (BP&MPQ)* 2 (1): 5.

Hewitt, Kim. 1997. *Mutilating the Body: Identity in Blood and Ink.* Bowling Green, Ohio: Popular Press.

Herman, Judith Lewis. 1992. *Trauma and Recovery.* New York: HarperCollins.

Hewitt, Nancy, Jean O'Barr, and Nancy Rosebaugh, eds. 1996. *Talking Gender.* Chapel Hill: University of North Carolina Press.

Heywood, Leslie. 1998. *BodyMakers: A Cultural Anatomy of Women's Bodybuilding.* New Brunswick, N.J.: Rutgers University Press.

Jackson, Stevi and Sue Scott. 2000. "Putting the Body's Feet on the Ground: Towards a Sociological Reconceptualization of Gendered Embodiment." In *Constructing Gendered Bodies,* ed. Kathryn Backett-Milburn and Linda McKie. London: Palgrave.

Jeffries, Sheila. 1994. "Sadomasochism, Art and the Lesbian Sexual Revolution." *Artlink* 14 (1).

Jones, Amelia. 1998. *Body Art: Performing the Subject.* Minneapolis: University of Minnesota Press.

Jury, Mark, and Dan Jury. 1987. "Bizzare Rituals: Dances Sacred and Profane." Film by Gorgou Video. Produced and directed by Mark and Dan Jury.

Kaw, Eugenia. 1993. "Medicalization of Racial Features: Asian American Women and Cosmetic Surgery." *Medical Anthropology Quarterly* 7 (1): 74–89.

Kelly, Michael. 1998. "Reviving the Lure of the Evil Weed." *Washington Post,* April 22.

Kleese, Christian. 2000. "'Modern Primitivism': Non-Mainstream Body Modification and Racialized Representation." In *Body Modification,* ed. Featherstone.

Klein, Melissa. 1999. "Duality and Redefinition: Young Feminism and the Alternative Music Community." In *Gender Through the Prism of Difference,* ed. Maxine Baca Zinn, Pierrette Hondagneu-Sotelo, and Michael Messner. Boston: Allyn and Bacon.

Kristeva, Julia. 1984. *Revolution in Poetic Language.* New York: Columbia University Press.

Kroker, Arthur, and Marilouise Kroker, eds. 1987. *Body Invaders: Panic Sex in America.* New York: St. Martin's Press.

Larratt, Shannon. n.d. "Editorial: Extreme Modifications: Why?" *Body Modification Ezine (BME),* http://BME.FreeQ. com.

———. n.d. "Rejection of Current Trends in 'Pop Culture.'" *BME.*

Leary, Timothy. 2000. "The Cyberpunk: The Individual as Reality Pilot." In *The Cybercultures Reader,* ed. Bell and Kennedy.

Leder, Drew. 1990. *The Absent Body.* Chicago: University of Chicago Press.

Lindfors, Bernth. 1996. "Ethnological Show Business: Footlighting the Dark Continent." In *Freakery: Cultural Spectacles of the Extraordinary Body,* ed. Rosemarie Garland Thompson. New York: New York University Press.

Lingus, Alphonso. 1994. *Foreign Bodies.* New York: Routledge.

———. 1983. *Excesses: Eros and Culture.* Albany: State University of New York Press.

Lowe, Maria R. 1998. *Women of Steel: Female Body Builders and the Struggle for Self-Definition.* New York: New York University Press.

Lutz, Catherine, and Jane Collins. 1993. *Reading National Geographic.* Chicago: University of Chicago Pres.

MacKendrick, Karmen. 1998. "Technoflesh, or Didn't That Hurt?" *Fashion Theory* 2 (1): 3–24.

MacKinnon, Catherine. 1997. "Sexuality." In *The Second Wave,* ed. Linda Nicholson. New York: Routledge.

Maffesoli, Michel. 1996. *The Time of the Tribes: The Decline of Individualism in Mass Society.* London: Sage.

Mascia-Lees, Frances, and Patricia Sharpe, eds. 1996. *Tattoo, Torture, Mutilation and Adornment: The Denaturalization of the Body in Culture and Text.* Albany: State University of New York Press.

McIntosh, Mary. 1997. "Class." In *Lesbian and Gay Studies: A Critical Introduction,* ed. Medhurst and Munt.

Medhurst, Andy, and Sally Munt, eds. 1997. *Lesbian and Gay Studies: A Critical Introduction.* London: Cassell.

Mellor, David Allan. 1996. "The Chameleon Body." In *The Chameleon Body: Photographs of Contemporary Fetishism,* ed. Nicholas Sinclair. London: Lund Humphries.

Melluci, Alberto. 1996. *Challenging Codes.* Cambridge: Cambridge University Press.

Mohanty, Chandra. 1984. "Under Western Eyes." *Boundary* 2 and 3: 333–358.

Mohanty, Chandra, and Jacqui Alexander, eds. 1997. *Feminist Genealogies, Colonial Legacies, Democratic Futures.* New York: Routledge.

Monaghan, Lee, Michael Bloor, Russell Dobash, and Rebecca Dobash. 1998. "Bodybuilding and Sexual Attractiveness." In *The Body in Qualitative Research,* ed. J. Richardson and A. Shaw. Aldershot, U.K.: Ashgate.

Moser, C., J. Lee, and P. Christensen. 1993. "Nipple Piercing: An Exploratory-Descriptive Study." *Journal of the Psychology of Human Sexuality* 62: 51–61.

Munoz, Jose Esteban. 1997. "The White to be Angry: Vaginal Davis's Terrorist Drag." *Social Text* 52/53, 15 (3–4): 81–90.

Musafar, Fakir. 1997. "Becky's Breast Cuttings." *BP&MPQ* 4 (3): 26–27.

———. 1996. "Epilogue: Body Play: State of Grace or Sickness?" In Armando Favazza, *Bodies Under Siege: Self-Mutilation and Body Modification in Culture and Psychiatry.* Baltimore, Md.: Johns Hopkins University Press.

———. 1996. "Paul Flies Like a Bird." *BP&MPQ* 4 (2): 16–17.

———. 1996. "Idexa's Suspension Hindered by Physical and Psychic Distractions." *BP&MPQ* 4 (2): 18.

———. 1995. "Midori: Eurasian Fetish Fashion Diva." *BP&MPQ* 3 (4): 10.

———. 1994. "Nomad: A Body Piercing Studio, A Rainforest, A Museum, A Haven for Modern Primitives." *BP&MPQ* 2 (4): 26.

———. 1994. "Vama Vajra's African Lip Disk." *BP&MPQ* 2 (4): 24–25.

———. 1994. "Radical Moderns Sid and Lily." *BP&MPQ* 2 (4): 14–17.

———. 1994. "Labrets For Pierced Lower Lip Beauty." *BP&MPQ* 2 (4): 18–23.

———. 1993. "Exploring a Primitive Lifestyle." *BP&MPQ* 2 (2): 27.

———. 1993. "Idexa: Radical Primitive She/Boy." *BP&MPQ* 2 (2): 8–13.

Myers, James. 1992. "Nonmainstream Body Modification." *Journal of Contemporary Ethnography* 21: 267–307.

O'Neill, John. 1989. *The Communicative Body.* Evanston, Il.: Northwestern University Press.

Phelan, Peggy. 1993. *Unmarked: The Politics of Performance.* London: Routledge.

Pitts, Victoria L. 2000. "Body Modification, Self-Mutilation and Agency in Media Accounts of a Subculture." In *Body Modification,* ed. Featherstone.

Polhemus, Ted. 1995. *Streetstyle: From Sidewalk to Catwalk.* London: Thames and Hudson.

Price, Janet, and Margrit Shildrick, eds. 1999. *Feminist Theory and the Body: A Reader.* New York: Routledge.

Rheingold, Howard. 1994. *The Virtual Community: Finding Connection in a Computerized World.* London: Secker and Warburg.

Ridgers, Derek. 1996. "Metal Guru." *Skin Two* 19: p. 76.

Root, Deborah. 1996. *Cannibal Culture: Art, Appropriation, and Commodification of Difference.* Boulder, Col.: Westview Press.

Rosenblatt, Daniel. 1997. "The Antisocial Skin: Structure, Resistance, and Modern Primitive Adornment in the United States." *Cultural Anthropology* 12 (3): 287–334.

Ross, Andrew. 2000. "Hacking Away at the Counter-Culture." In *The Cybercultures Reader,* ed. Bell and Kennedy.

———. 1994. "Tribalism in Effect." In *On Fashion,* ed. Shari Benstock and Suzanne Ferris. New Brunswick, N.J.: Rutgers University Press.

Sanders, Clinton. 1989. *Customizing the Body: The Art and Culture of Tattooing.* Philadelphia, Penn.: Temple University Press.

Sandoval, Chela. 2000. "New Sciences: Cyborg Feminism and the Methodology of the Oppressed." In *The Cybercultures Reader,* ed. Bell and Kennedy.

Sawicki, Jana. 1991. *Disciplining Foucault: Feminism, Power and the Body.* London: Routledge.

Seaton, E.1987. "Profaned Bodies and Purloined Looks: The Prisoner's Tattoo and the Researcher's Gaze." *Journal of Communications Inquiry* 11: 17–25.

Sedgwick, Eve Kosofsky. 1990. *The Epistemology of the Closet.* Berkeley: University of California Press.

Sharrock, Cath. 1997. "Pathologizing Sexual Bodies." In *Lesbian and Gay Studies: A Critical Introduction,* ed. Medhurst and Munt.

Shelton, Anthony. 1996. "Fetishism's Culture." In *The Chameleon Body,* ed. Nicholas Sinclair. London: Lund Humphries.

Shields, Rob. 1991. *Places on the Margin: Alternative Geographies of Modernity.* London: Routledge.

Shilling, Chris. 1993. *The Body and Social Theory.* London: Sage.

Shouse, Deborah, 1996. "Mark Her Words: Daughter Attempts To Cope with History of Sexual Abuse Through Tattooing and Body Piercing." *Ms.* 7 (September/October 1996).

Silverman, Kaja. 1992. *Male Subjectivity at the Margins.* New York: Routledge.

Smith, Roberta. 1994. "Body of Evidence." *Vogue* 184 (August 1994).

Steele, Valerie. 1996. *Fetish: Fashion, Sex and Power.* New York: Oxford University Press.

Sullivan, Nikki. Forthcoming. "Fleshly (Dis)figuration, or How to Make the Body Matter." *The International Journal of Critical Psychology* 5.

————. 2001. *Tattooed Bodies: Subjectivity, Textuality, Ethics and Pleasure.* Westport, Conn.: Praeger.

————. 1997. "Fleshing Out Pleasure: Canonisation or Cruxification?." *Australian Feminist Studies* 12 (26): 283–291.

Sweetman, Paul. 2000. "Anchoring the (Postmodern) Self? Body Modification, Fashion, and Identity." In *Body Modification,* ed. Mike Featherstone.

————. 1999. "Only Skin Deep? Tattooing, Piercing, and the Transgressive Body." In *The Body's Perilous Pleasures: Dangerous Desires and Contemporary Culture,* ed. M. Aaron. Edinburgh: Edinburgh University Press.

————. 1998. "Marked Bodies, Oppositional Identities? Tattooing, Piercing and the Ambiguity of Resistance." In *Practicing Identities: Power and Resistance,* ed. S. Roseneil and J. Seymour. London: Macmillan.

Taylor, Affrica. 1997. "A Queer Geography." In *Lesbian and Gay Studies,* ed. Medhurst and Munt.

Terranova, Tiziana. 2000. "Post-Human Unbounded: Artificial Revolution and High-Tech Subcultures." In *The Cybercultures Reader,* ed. Bell and Kennedy.

Thacker, Eugene. 2001. "The Science Fiction of Technoscience: The Politics of Simulation and a Challenge for New Media Art." *Leonardo* 34 (2): 155–158.

Thompson, Rosemarie Garland, ed. 1996. *Freakery: Cultural Spectacles of the Extraordinary Body.* New York: New York University Press.

Thorton, Sarah. 1997. "The Social Logic of Subcultural Capital." In *The Subcultures Reader,* ed. Gelder and Thorton.

Torgovnick, Marianna. 1995. "Piercings." In *Late Imperial Culture,* ed. Roman De La Campa, E. Ann Kaplan, and Michael Sprinkler. London and New York: Verso.

Turner, Bryan S. 2000. "The Possibility of Primitiveness: The Sociology of Body Marks in Cool Societies." In *Body Modification,* ed. Featherstone.

————. 1991. "Recent Developments in the Theory of the Body." In *The Body: Social Process and Cultural Theory,* ed. Featherstone, Hepworth, and Turner. London: Sage.

————. 1991. "The Discourse of Diet." In *The Body: Social Process and Cultural Theory,* ed. Featherstone, Hepworth, and Turner.

Turner, Victor. 1967. *The Forest of Symbols: Aspects of Ndembu Ritual.* Ithaca, N.Y.: Cornell University Press.

Urla, Jacqueline, and Alan C. Swedlund. 2000. "The Anthropometry of Barbie: Unsettling Ideals of the Feminine Body in Popular Culture." In *Feminism and the Body,* ed. Londa Schiebinger. Oxford: Oxford University Press.

Vail, D. Angus, 1999. "Slinging Ink or Scratching Skin?: Producing Culture and Claiming Legitimacy among Fine Art Tattooists." *Current Research on Occupations and Professions* 11.

Vale, V., and Andrea Juno. 1990. "Art Controversy is About Freedom of Expression." *San Francisco Chronicle.* March 23.

————. 1989. *Modern Primitives*. San Francisco: Re/Search Publications.

Vaughn, Christopher. 1996. "Ogling Igorots: The Politics and Commerce of Exhibiting Cultural Otherness, 1898–1913." In *Freakery: Cultural Spectacles of the Extraordinary Body,* ed. Thompson.

Walters, Suzanna D. 1996. "From Here to Queer: Radical Feminism, Postmodernism, and the Lesbian Menace." *Signs: Journal of Women in Culture and Society* 21 (4): 830–869.

Weedon, Chris. 1987. *Feminist Practice and Poststructuralist Theory.* Cambridge, Mass.: Blackwell.

Wilkerson, Abby L. 1998. *Diagnosis: Difference: The Moral Authority of Medicine.* Ithaca, N.Y.: Cornell University Press.

Wilton, Tamsin. 1999. "Temporality, Materiality: Towards a Body in Time." In *Women's Bodies: Discipline and Transgression,* ed. Jane Arthurs and Jean Grimshaw. London: Cassell.

Wojcik, Daniel. 1995. *Punk and Neo-Tribal Body Art.* Jackson: University Press of Mississippi.

Wolf, Naomi. 1991. *The Beauty Myth: How Images of Beauty Are Used against Women.* New York: William and Morrow.

Wood, David. 1996. *Torture Garden: From BodyShocks to Cybersex.* London: Creation Books.

Young, Katherine, ed. 1993. *Bodylore.* Knoxville: University of Tennessee Press.

Yuval-Davis, Nira. 1997. "Gender and Nation." In *Space, Gender, Knowledge: Feminist Readings,* ed. Linda McDowell and Joanne P. Sharpe. London: Arnold.

Zurbrugg, Nicholas. 2000. "Marinetti, Chopin, Stelarc and the Auratic Intensities of the Postmodern Techno-Body." In *Body Modification,* ed. Featherstone.

INDEX